P9-APG-780

F.V.

WITHDRAWN

UNSEEN
WARHOL

UNSEEN
WARHOL

John O'Connor and Benjamin Liu

RIZZOLI
NEW YORK

First published in the United States of America in 1996 by

RIZZOLI INTERNATIONAL PUBLICATIONS, INC.
300 Park Avenue South
New York, New York 10010

Library of Congress Cataloging-in-Publication Data
Unseen Warhol : interviews by Jim O'Connor and Benjamin Liu.
 p. cm.
 ISBN 0-8478-1967-1
 1. Warhol, Andy, 1928- —Criticism and interpretation.
 2. Warhol, Andy, 1928- —Psychology. 3. Art—Interviews.
 I. O'Connor. John T. (John Timothy) II. Liu, Benjamin, 1952-
N6537.W28U58 1996
709' .2—dc20 96-19379
 CIP

Design by John O'Connor
Printed in Hong Kong

For my parents, Madeleine and Charles P.,
for their principle of "freedom" in letting me do my own thing.

For Michael J. Raglin, aka Rags,
for sharing his earthy sophistication and life experience.

For Victor Hugo,
who fired my imagination and broadened my horizons
by encouraging me to move to Manhattan.

Benjamin Liu

For Steve and Greg,
two people who have made a great difference in my life.

For Andy,
you are sorely missed by your extended family.

John O'Connor

Contents

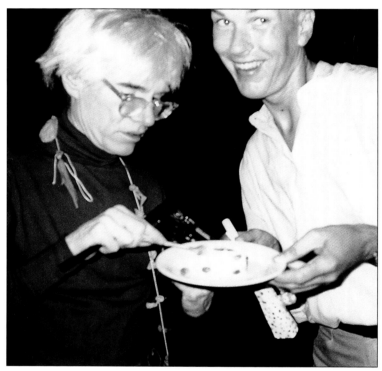

Andy Warhol and Michael Raglin at a birthday for Warhol at his Montauk house.

As a recent immigrant attending school in the
San Francisco Bay area in 1967,
I made forays into the big city searching for "hippie" culture.
The sudden modernization of my aesthetics occurred when I came across
a two-page black-and-white photo spread of the Factory members and Andy
posing nonchalantly in *Esquire* magazine.
Secretive, after-midnight viewings of Warhol's *Lonesome Cowboys*
and *Bike Boy* at obscure art theaters released my adolescent libido.

All this would become part of my life education:
I met the man in 1977, started to work with him in 1982, gave him a wig trim in 1983,
and ate a bowl of Campbell's soup in the kitchen of his townhouse in 1984.

Andy provided the raw ingredients for our psyches.

Benjamin Liu
New York, 1996

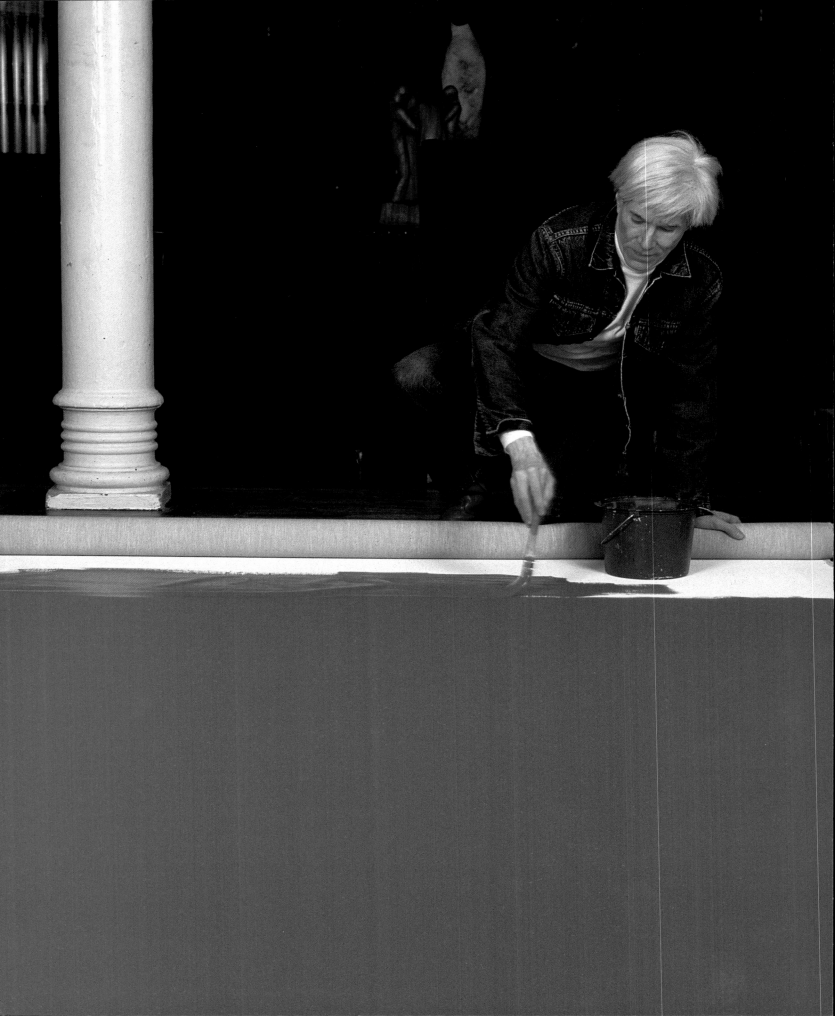

A Portrait of the Portrait Artist

by Glenn O'Brien

"I can only understand really amateur performers or really bad performers, because whatever they do never really comes off, so therefore it can't be phony."

—Andy Warhol

Andy Warhol was the *real* realist. He was so realistic about everything that people thought he wasn't real; they thought his art was artless or fake. But Andy's commercial jobs and portraits were a part of what he called "bringing home the bacon."

Andy brought home vast sides of bacon. The paintings paid the bills – for the movies, for the magazine, for the TV show, and for the ever-growing number of workers at the Factory.

Of everything Andy produced, the Factory (or the Studio, as he preferred after the '60s) was one of his most important works of art. The Factory created a model for art to survive in a world dominated by the corporation, although so far it seems nobody has picked up on it. The corporation is bigger than the individual. The Factory was bigger than life. It was the first fine-artist corporation.

People still don't get it, and that's why the art world is shrinking like that wet witch in Oz. People didn't even understand the Factory back then. I remember some German visitors thought the place was a commune. They asked, "And where do you all sleep?" But the Factory was a business. Everyone else was running around acting like art was a religion. Andy was the only one realistic enough to treat it like a business.

Andy said, "Every painting is the same painting. The subject (be it Taylor, Kennedy or Monroe) is not significant." But Andy was always looking for subject matter. He was always asking people what he should paint. He would say, "I was never embarrassed about asking someone, literally, 'What should I paint?' because pop comes from the outside, and how is asking for ideas any different from looking for them in a magazine?" As one of the most objective, realistic artists of all time, he liked forceful, subjective "unrealistic" subjects.

Andy Warhol painting background canvas at 860 Broadway, c. 1983.

Campbell's soup and Brillo were that—outré, beyond the pale, the closest Andy could get to painting nothing. But, being a watcher, the ultimate fly on the wall, he liked subject matter that approached him. Like the superstars. Like the portraits. They were something to paint and then paint again —fifty *Ethel Scull* paintings when one was more than enough.

Andy's earliest films were moving pictures in the original sense: photos that moved. They were portraits: Robert Indiana eating an apple, Henry Geldzahler smoking a cigar. Or they were landscapes: *Empire*. Pretty soon action arrived. *Blow Job* recorded the range of emotion registering on a face of a felatee. And finally, the films evolved into movies. Still, they never lost their original mission of portraiture. In fact, they resurrected and elevated the ancient idea of portraiture with the available technology.

The Factory as a film studio had a simple philosophy: it was all about stars. Paul Morrissey, Andy's director, was always a vocal opponent of the "auteur theory" and the glorification of the director. In the same way that punk rock was a reaction against the artification and technologizing of a popular medium, the Factory films were punk movies, taking the cinema back fifty or sixty years to when it had been about faces and personalities and a camera.

Andy liked hanging around with power people and cultivated a relationship with the Ford White House during a period when the President's son Steve seemed fascinated with Studio 54 and Bianca Jagger. And so Andy, director of *Blow Job* and *My Hustler* and *Vinyl*, got to eat at the White House. Some people thought Andy was going right wing. Bob Colacello, two-time editor of *Interview* and Andy's most active portrait solicitor, did have a definite fascination with the right. (Nelson Lyon called Bob and Fred Hughes "the headwaiters.") Bob put interviews with Imelda Marcos and Farah Diba, the Empress of Iran, in *Interview*, as well as those with the slightly famous children of very famous dictators. It seemed that Bob had taken Fred Hughes's snobbism and Paul Morrissey's convoluted conservatism and evolved it into a sort of neo-royalist disco-fascist stance.

With Andy it was never about politics. He thought too much from scratch to subscribe to any party line. If he had to choose, he always said he was a Democrat because he liked the Kennedys (which probably meant Jackie and Lee Radziwill). When solicited for a contribution to the George McGovern presidential campaign, Andy moaned a lot about doing something for free; then he did do a portrait of Nixon emblazoned with the slogan "Vote for McGovern." That was Andy's politics. The best thing McGovern had going for him was Nixon. With Andy there was always a twist. His silkscreen style was based on printing out of register, on things not quite matching up. When Andy did the Shah's portrait, I thought he had really gone too far. But after the Shah was deposed, Andy mentioned to me that in the portrait the Shah's head was detached from his body. The composite Shah was assembled from two different Polaroids. He didn't say anything more than that, just noted that he had detached the Shah's head from the body.

Some art observers consider the portraits Andy's lesser work, as if they were painted out of pure greed. Certainly, Andy was happy to do work that was presold, to have subject matter that didn't have to appear in a flash over his head like a light bulb, but that actually volunteered itself check in hand. But the portraits were as radical as anything Andy ever did. Andy painted commissioned portraits after the form had been long dead in anything resembling the art world. Not just dead but buried and filed in the archives under the politically incorrect. I think Andy reveled not only in the money that the portraits brought in but also in the fact that he had revived the most dead and buried tradition in painting. Andy

was a Renaissance man. His portraits are direct descendants of those ancient masterpieces of Italy. Because no matter what commission Andy accepted, his eye and hand always had the last word.

Andy's idea of art included the art of socializing and the art of conversation and what some non-artists coined "the art of the deal." When I first worked for Andy in the early '70s, I was surprised to hear him talk about his social life as work. Andy would moan when it was time to go to a party, "OK, time to go to work." Or at a party he would moan, "Ohh, this is such hard work." That was long before people talked about "networking" or even "working the room," but Andy was always working. Every word, every answer to every question. It was all art. And it was all bringing home the bacon.

With Andy, it was also the art of being. He wasn't, at least not until late in his life, into what you would usually call the art of living. (Initially, his idea of a great meal was a box of chocolates; ten years later, it was a plate of steamed spinach.) Andy's life was always art and always work. Everything he did was to be funny. But Andy himself was his greatest artwork. He had learned how to be himself, always watching and doing. All the wigs and poses and dissembling answers and faux non-sequiturs and superstars and artwork and the Factory itself were parts of the shell that kept that exquisite creature alive and whole. People have the mistaken notion that Andy was a misanthrope, misogynist, or introvert. Actually, Andy loved people. With a kind of generalized, arm's-length, non-committal love but a genuine love nevertheless—a love of life, beauty, charm, wit, and the picturesque extremities of personality. Twenty years before playing Andy on the screen, David Bowie described him as a silver movie screen. Part of that blankness, Andy's pop Zen shyness, was a device to draw out whomever he confronted: his portrait sitter, superstars, the press. Andy knew

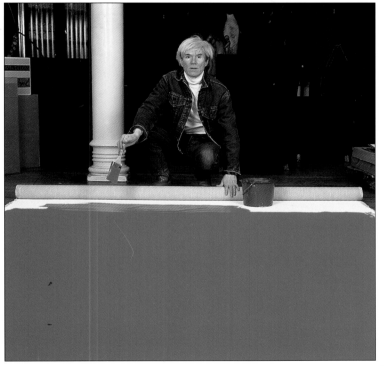

that a vacuum was a great device for drawing people out of themselves.

Benjamin Liu and John O'Connor say that Andy always wanted to do a show called *The Worst of Warhol.* Andy had a remarkably normal sense of good and evil, but he had a very "different" sense of good and bad. (Pause to watch the movie, *Andy Warhol's BAD.*) As much as I greatly admired Andy's work, I used to think that some of it was really bad. The Mercedes Benz paintings or the Endangered Species portfolio or the Jews of The Twentieth Century portfolio he did for the Jewish Museum or the mass production Mick Jagger series that sell in galleries that move a lot of Erté. I forgave that bad work because I thought it was important to Andy bringing home the bacon, to making the whole operation as big as possible. I actually liked the fact that Andy would accept any job, any commission, and then really make something out of it. It was alchemy, in the purest sense of the word. Turning shit into Shinola. But now, with Andy unreachable by phone, I find I like all his work. I find it all good, all well done, all beautiful. Every last thing that came off that pale, thin hand.

Andy was the only one who fought the law and won. He didn't disregard the system; he toyed with it. He worked outside the accepted parameters of the art world and got away with it. He made paintings and editions and movies and TV commercials and produced a rock band (and tried to play in one). He did album covers and wrote a novel and produced a play. He started a magazine and a cable TV show. He became a photographer and signed with a modeling agency and appeared on *The Love Boat.* And he made it all art. He showed the art world how it could survive in the future. Apparently, it wasn't paying attention.

Working With Warhol

by John T. O'Connor

Unseen Warhol started out as a project Andy had spoken of on several occasions. Always throwing the metaphorical curveball at his critics and detractors, of whom there were many, Andy had wanted to put on a show called *The Worst of Warhol*. Theoretically, this would have been a curated show of works selected by the artist that he felt were failures. He first mentioned this project to Paige Powell, his friend and advertising sales associate at *Interview*. He had also asked for my help as assistant curator as well as in art-directing the invitations and catalog for the show. He went so far as to include this show as a "scheduled project" when writing a recommendation on my behalf for Harvard's Graduate School of Design.

Although Andy passed away before anything firm was planned, the idea says it all. Here was an artist already fully ensconced in the annals of art history, happy to deprecate his own work—as well as, he hoped, sell it—in order to confound the established art community and create yet another Warholian stir. If it's true that Warhol made fame famous, then it should also hold true that Andy made eccentricity acceptable and even desirable.

The original idea, then, was to continue on with that project in book form, but with the artist himself gone, the selection process of which works to include could not happen. Benjamin Liu and I, both having worked for Warhol at his 860 Broadway and 33rd Street Factories, knew of many works that would have been a perfect fit in *The Worst of Warhol* had it ever come together. But more importantly, we were aware of scads of other interesting works that the public rarely, if ever, got a chance to see.

From the beginnings of his career in the 1950s until his death, Andy was nothing if not prolific. And if Andy had his mind made up to create, that meant his staff had better be ready to work as well. Warhol was infectious in that manner. Many of us at the Factory would inadvertently pick up his

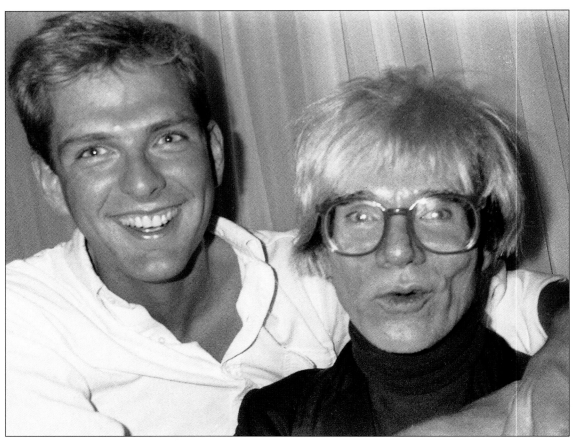

John O'Connor and Andy Warhol at the 33rd Street Factory, April 1984.

mannerisms, his dress, even his highly idiosyncratic speech patterns. We'd look at a page layout for *Interview* or a painting in progress, and someone would invariably say something in Warholian vernacular, "Oh, oh gee, well I mean, is that the look?" This infectiousness would spread to the office work ethic as well. Bob Colacello, former editor at *Interview*, once said his job was chief editor/social secretary/headwaiter. This type of ever expanding list of minimum requirements spread to certain others at the office as well. If Andy liked your company, you could step over the invisible lines between his art studio,

Interview magazine, *Andy Warhol's TV*, or any of his other ventures. When I was asked by him to step over those lines, he made it very clear that "work" was the order of the day. I once thought that if Andy had written my job description it would have read something like this:

Wanted: Energetic, slightly wacky, well-educated individual for art assistant position. Must understand typography and layout. Must be able to work weekends painting while boss directs from nearby phone. Experience dealing with temperamental photographers,

advertising executives, and editors desirable. Must be able to appear right- and left-wing simultaneously, enjoy "work-related" seated, black-tie dinners at the Metropolitan, as well as "work-related" rock and roll parties on Avenue A. Candidate should have relentless ambition and unbridled enthusiasm for out of office "work-related" activities at Xenon, Studio, Area, Regine's, Palladium, or wherever boss may dictate. Excellent health benefits, generous Christmas bonuses, work-related meal plan available from Mr. Chow, Odeon, and Nippon. Starting salary 10k.

In the midst of all this, work got done — *lots* of work. Fred Hughes, Andy's right hand for so many years, was fond of saying that no one who worked for Andy at 860 Broadway or 33rd Street referred to those spaces as the Factory. We all referred to it as the office. This is true, but those spaces, especially the latter really were true to the factory production line aesthetic of the silver-foil-covered space of the early to mid-'60s.

Andy's last workspace was huge. Had it been in black and white, it would have been straight out of Fritz Lang's *Metropolis*. The five-story "T" shaped building stretched from 32nd Street to 33rd Street as well as a wing connecting to Madison Avenue. It encompassed a (finally) ballroom-sized painting space for Andy, spaces for stretching oversized paintings, video studio and screening room, expanded offices for a newly profitable *Interview*, two kitchens, an elevator, dining room, multiple bathrooms — some with granite showers, and a roof deck with electric doors. So fantastic was the space, it was chronicled in *House and Garden* even before it was occupied. But what really made Andy happy about that megalith of a building were the possibilities for *storage*.

Hundreds of paintings could be stored, along with prints, unfinished projects, his Time Capsule series,

and, most importantly, his own acquisitions. Many of us thought Andy's real aspiration was to become Charles Foster Kane. Box after box, bag after bag, furniture, paintings, fixtures, everything was "collected." What didn't make it up to his house on East 66th Street ended up at the office.

It was in this final Factory that you could see what had become of the man who began careening down his road to artistic stardom by asking Nathan Gluck to help him with watercolor work in 1950, and moved on to require multiple assistants when his painting and filmmaking career blossomed. This final Factory, if you could slice through and view it from the side through glass like a giant ant farm or beehive, would best reveal all the different activities he was involved in. But Andy's hive would have no queen — only another worker racing from project to project.

Whether painting backgrounds for his *Toys* silkscreens after-hours, or carefully working on a canvas of the *American Bald Eagle* for the Endangered Species series, or pouring and folding for his *Rorschach* paintings on weekends, I always managed to pick up pointers on painting technique as well as learn a little more about the boss close-up. Warhol was so complex that perhaps his best *unseen* work was himself.

The special side of Andy for me was not the mythic figure who turned cookie jars into a commodity, but the man who loved his dachshunds, Amos and Archie; the friend who would lunch with Robert Mapplethorpe and Diana Vreeland and then, during the cab ride home from work, tell you what *really* happened; or best of all, the artist of constant encouragement who gently pushed me into a life of painting, writing, and above all, happy eccentricity.

Vito Giallo

On Working with Warhol in the Early Years

Born in Brewster, New York, Vito Giallo came to Manhattan in 1949 to attend the Franklin School of Professional Arts. He worked as a commercial artist from 1952 until 1957 when he began working for designer Jack Beck. Giallo worked as Andy Warhol's assistant in 1958 and 1959. He opened Vito Giallo Antiques, most recently located on Madison Avenue, in 1966 and ran the shop for twenty years. He now rents objects and period furniture for television and movie productions.

How far back did you want to go?

Start at the beginning. Tell us about your gallery.

In the '50s, I worked for this well-known graphic designer, Jack Wolfgang Beck. I was his only assistant. Jack had this long loft studio on East 49th Street between First and York. It's still standing there. And it was on the top floor naturally – a five flight walk-up. We had all this extra space – we just needed a small room to do our work. So Jack said, "What can we do with this space?" I said, "Well, what about an art gallery?" He liked the idea, and we decided to call it the Loft Gallery. Jack rented the space, and he let me run the gallery.

So I got myself, Jack, Nathan Gluck, and his friend Clint Hamilton to show work at the gallery. And then Nathan said, "Well, let's have Andy." And I said, "Oh great." So Andy exhibited with us as well. We were all illustrators, but we wanted to be fine artists. Actually, that's one of the comments that the famous critic who was also a painter, Fairfield Porter, made when he came and reviewed our first group show. He was very nice, and he stayed for about an hour. But then when the review came out he said we were just a bunch of commercial artists who wanted to be painters.

How did the gallery operate?

Well, the first show was a group show, and then we would have all these one-man shows in between other group shows. We printed out invitations to the shows ourselves – Jack had a very nice little printing press. We would have an opening, invite people, and have wine and cheese and crackers – that was all. The gallery closed down when I left to be Andy's assistant. We only operated for about two or three years.

I started working for Andy in 1958. He convinced me to try freelance work, and I left the gallery. So he hired me freelance for about a year as his assistant.

There was no furniture in his apartment, literally no furniture. He and his mom slept on mattresses on the floor. There were no beds.

How much did Andy pay you at the time? Can you recall?

He paid me minimum wage at that time in the '50s; I can't remember exactly how much now. It wasn't very much. I think he was helping out his family with all his money at the time.

I'd come in at around 9 o'clock; Andy would have already been up for hours. The apartment was strange, a railroad flat on the top floor on 34th Street and Lexington.

Andy said Bricktop used to perform downstairs in a nightclub in the same building. She was a black high-society darling. She

Andy Warhol and Julia Warhola, *Untitled (Screen)*, c. 1956–59. Ink on primed cardboard over wood screen, 64½ x 45 in.

had an incredible voice and sang things from the '20s through the early '60s.

There was no furniture in his apartment, literally no furniture, and he and his mom slept on two mattresses on the floor. There were no beds. There was one drawing table, maybe two chairs, a television, and all of these cats, more than twenty of them. Andy

He often said much later in life, "Oh, just make it up." He said, "It sounds so much more interesting, just make it up." But in the early years, he never talked like that.

gave me my first Siamese cat, who lived to be twenty two years old. And I think he told me that he got the mother and the father from Gloria Swanson. I don't know whether that's true or not. He often said much later in life, "Oh, just make it up." He said, "It sounds so much more interesting, just make it up." But in the early years, he never talked like that.

I would always use the drafting table; Andy hardly ever used the table. He just sat in a chair and crossed his legs with a pad, watching TV at the same time and eating Campbell's tomato soup. I think that's really why he chose that image—tomato soup was his favorite.

He always had soup for lunch. His mother was there to make soup and a sandwich. Lettuce, tomato sandwiches, very simple. His mom would go in the kitchen and bring back whatever she had there. She did all the shopping. And she climbed five flights of steps. One day I said, "Don't you think we should help her shop?" I said, "Five flights with all those groceries." He said, "Oh, she loves it."

What was his mother like?

One thing I remember was when Andy created illustrations for I. Miller shoes, she would try the shoes on. It was so funny to see her standing in a room with these I. Miller shoes on. She couldn't get into them; she had these huge peasant feet. I think she used to work in the fields in Czechoslovakia. And the first thing she did when she came home was take her shoes off. You never saw her in shoes. But she'd try to get her feet into these I. Miller shoes, which was funny.

His mother would sign his work a lot. I think he liked it, the style of the childlike writing. His mom absolutely worshiped him. And I was quoted by Steve Aronson, I think, in one of his articles, as saying, "Gee, Mrs. Warhola, did you sleep well last night?" And she replied, "Oh no, I was up all night. I watched Andy sleep."

She'd sit up all night watching him sleep. I have often wondered if that's where he got that idea of having a camera watch that person sleep for the movie *Sleep*.

Can you tell us about Andy's first show. It was at the Loft Gallery, wasn't it?

That's right. He first showed these pen and ink line drawings, all simple, all outlines. They were just pinned up to the wall, about eight by ten inches, nothing framed at all. He used this blotting technique. Everybody tried to figure out how he got his line. And everybody had their theory—wax paper, all kinds of things. It was a blotting technique. We would take a piece of paper, generally Strathmore, fold it in half, and then Andy would do his pencil drawing on the left half of the paper. Next he'd take the pen and just go over it and get a perfect registration. And then you could vary the blotting, the heaviness of the line; the more ink you put on the line, the harder you press down on the pen, the heavier the line. So he had a lot of control over it actually. I never realized it was so simple.

When I finished the blotting, he'd sign the resulting print. He'd throw the original in the middle of the floor where there were piles of drawings; just piles and piles.

That's what was so amazing about Andy—it was just so simple, and mechanical—an assembly-line kind of thing that we could both work on. So when I finished the blotting, he'd sign the resulting print. He'd throw the original away in the middle of the floor where there were piles of drawings; just piles and piles. He never stopped.

What about Andy's second show, the Origami show. It sounds interesting because it was so abstract.

He didn't *call* it Origami at all. But that's the best description of it. He would start with a square piece of paper. He would take the paper, and then he would fold it, and somehow he got a lot of pyramids out of it. Then he would open it up one way or another, and some pyramids would be sticking out. Next, he would do drawings of heads and people on parts of the pyramids, and he did a lot of marbleizing, oil on water. Finally, he'd hang them up so that they were sticking out from the wall. We used pushpins to hang them up, and they kept falling down; I must have picked those pieces up a hundred times.

Untitled (Shoe), 1956–58. Tempera paint on wood, 5 x 8⅞ x 2¾ in.

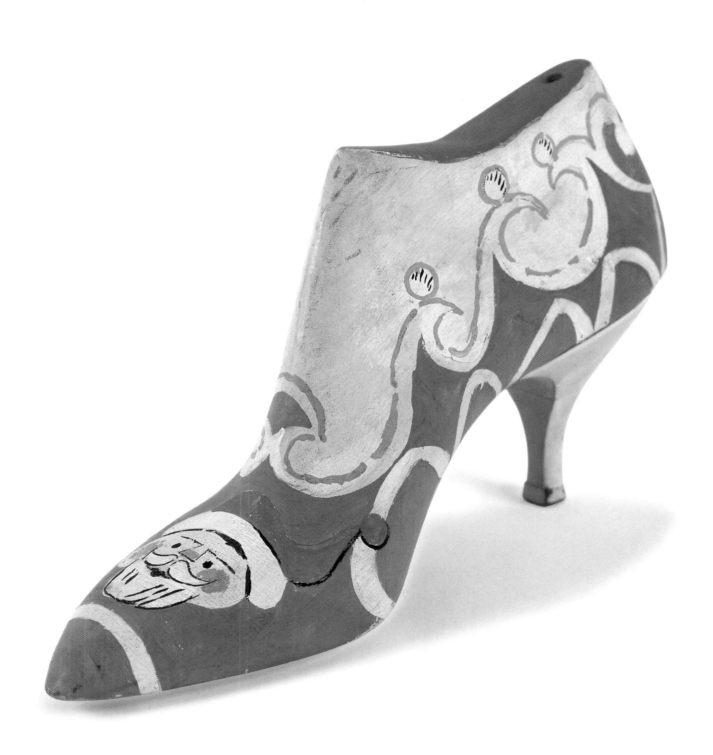

What happened to all of them?

I think he threw them all out. He never sold anything at the gallery. Very few of us did. But I know nobody even looked at this show. I thought it was fascinating. I was amazed. It was his turn to do a one-man show, and I thought it would be drawings and paintings, something straightforward. And then when these things came in I was just shocked.

Did Andy have any other shows at the Loft Gallery?

Well, Andy's third show was in fact all drawings—of John Butler, the dancer. John came to see the exhibit; very few people did. But I remember John coming up, and I thought, "Oh, my God, John Butler!" I was so excited because I liked his work so much. And the whole room was nothing but drawings of him. I think they were from memory. Dance poses, portraits.

Speaking of drawing from memory, I also know that Andy had a light box at home, and I know he did a lot of work underneath the light box. In other words, he didn't have to get a photostat; after all, there weren't that many photostat places then. Andy would go through magazines for ideas, *Life* magazine for instance. And then he'd tear something out and put it in the light box and make a drawing from there. Or trace over it. The image would become

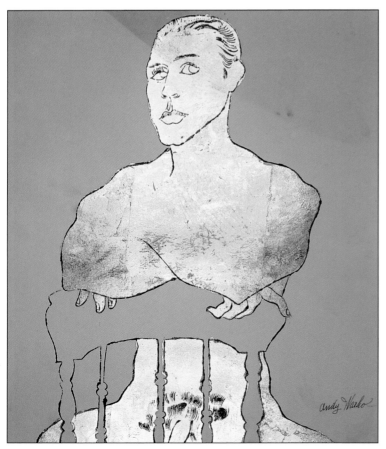

Untitled (Seated Male Nude), c. 1957. Gold leaf and ink on paper, 20 x 15 in.

transparent. He would take a piece of Strathmore paper, place an image underneath, turn on the lightbox, and then trace the image. The image would be taken almost directly from the photograph, but he would never literally trace it. He would always embellish it

His mother would sign his work a lot. I think he liked it, the style of the childlike writing. His mom absolutely worshiped him.

with his style. He would make the hands a little different. That's why if he was doing something from a photograph, I couldn't seem to get his style. He'd have to do it in pencil, then I of course could follow the pencil line. But I couldn't do it in his style.

Were you part of the crowd that frequented the restaurant Serendipity III at that time? Andy was said to sometimes give away his drawings there.

No, I wasn't. Andy had certain groups, and he didn't mix those groups. I never knew why. Now I was in his group with Nathan and Lee Lease, who's now a doctor. It was a very small group. I never saw anybody at the apartment; for say, five, six, seven hours, nobody ever came up. The phone would ring, but it was always an art director, it was always a business call. And then we went to parties very often, just Andy and me. But there was never a group like this later on in his life. I never saw that.

Andy would always want to do what *he* wanted to do. In other words, I'd have to go to this party or see this person or that. Once, he was taking sex lessons. There was a woman named Valerie and she had a sailor boyfriend. Every Wednesday night, Andy said he would go over for "sex lessons." They would give him lessons in how to have sex. I guess they would just show him what they did and how they did it. He loved to watch. He wanted me to go with him one time. I refused, and he got very upset. So I didn't hear from him for a long time.

Andy had this habit of dropping people just like that. Then you'd see him ten years later, and it would be like nothing had happened. It's interesting. Once, years later, he was in my antique shop on Madison Avenue and some person on drugs who knew Andy ran in. I don't know who he was. Andy wouldn't tell me. And Andy told this guy, "Now, if you don't leave this shop immediately, I'll never speak to you again." And the guy went right out. He was probably a close friend in the early days of the Factory period. But Andy wouldn't discuss it.

What do you think it was that made Andy so self-conscious? Was he always that way when you knew him?

Untitled (Two Figures), c. 1955. Mixed media on canvas, 18½ x 11⅞ in.

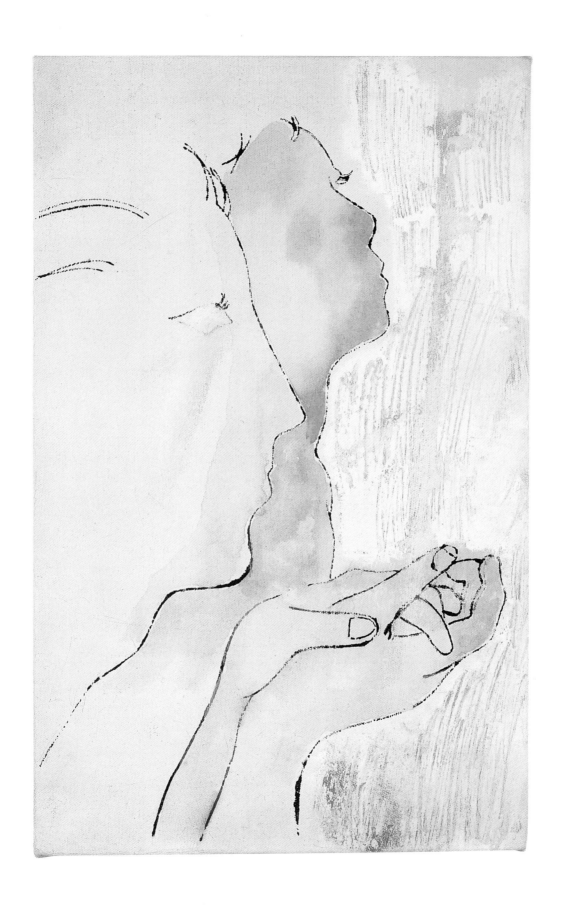

Well, I think it was his skin; he had a tremendous amount of problems with it. He couldn't expose it to the sun, and it would always get blotchy. He was always very, very white. When I knew him, he had hair. So it wasn't his hair that made him feel self-conscious. Also, he was always afraid of being touched. You couldn't hug him or grab him. He would always just shy away. Of course, a lot of people are like that, for what reason I don't know. Yet at that time, he had this very nice boyfriend, Carl. He and Carl were very

In my Madison Avenue shop, opened in 1979, I had everything from unset gems, to French furniture, Deco, Victorian, everything. He bought it all.

close. And Andy would show me a lot of beautiful nude paintings he did of Carl. The paintings were very large, almost life size. The colors would all be bleeding in the background, almost like watercolor washes, but they probably were oils, I would think. They were like the colors Rothko used in his bleeding effect, red and orange together. Carl would be across the canvas in this blotted line. He was combining the blotted line with paint. It was abstract looking. If you didn't have the realistic drawing, it would have been an abstract painting. It was a combination of the two.

After you went off on your own, did you ever visit Andy in his spaces afterwards?

No, I never saw Andy during that whole Factory period. I didn't see him until twenty years later on Madison Avenue. I was just sitting there, and he comes breezing in to my shop and says, "Wow, you must be on Easy Street."

Then Andy started coming round my shop constantly. My first shop was uptown – Third Avenue and 94th Street, cheap rent. It was right in the middle of all of the artists from the New York School. So I got to know people like Rothko, Franz Klein, Robert Motherwell, and Lee Krasner very well. And Andy was of course always fascinated by that. All those artists were just on the verge of becoming really great. I think you could buy a Rothko for maybe $25,000 or $35,000 then, I'm not sure.

One interesting thing – I went to Rothko's house to deliver something; he had a brownstone on 94th Street. And he said, "I'll take you around and show you my paintings. They're all in this living room on the walls." And all over the floor were these beautiful Oriental rugs. And I said, "Oh, you have the most wonderful rugs." And he said, "That's where my inspiration comes from. Look at the rug and then look at the painting." These orange and red hues

were woven together in the rug. And he would take a section and blow it up almost. I always thought that was so fascinating. Rothko said, "If I had my way I would only have bentwood furniture and Oriental rugs." Andy liked Rothko; he liked all the New York School, all those artists – whether it's because they were famous or he really felt something for them, I don't know.

What would Andy buy from your shop?

He used to come up to the 94th Street and Third Avenue shop in 1960 with his good friend Charles Lisanby. I'd sit them down on a sofa, we'd go through magazines, and Andy would point, "Oh, I like this style," or "I like that style." Then I would try to find things like that. That was when he started buying real furniture. But I think Charles had a big influence on him.

In my Madison Avenue shop, opened in 1979, I had everything from unset gems, to French furniture, deco, Victorian, everything. He bought it all, even the stones. He wanted to become a jeweler, as you know. And so he bought hundreds of stones from me. And I would spend two nights getting all the stones ready, having the exact weight and description. One time, he came into the shop in the morning. I had the whole table covered with about a hundred boxes, and he looked in one box. He said, "Oh, I like this, I'll take them all." I said, "You don't want to look at all of these stones?" He said, "No, no." If he wasn't at the shop that day, he would always call. He'd say, "What came in?" I'd say, "Well, I just got a nice load of Majolica." He'd say, "Oh, pick out all the best ones and wrap them up." And I always felt so guilty. I said, "Don't you want to look at them?" And he said, "No, I don't have to." And you know he got those food molds from me. He was going to paint them. I don't know if he ever did. But I said, "Why do you want all these molds?" He said, "Oh, I'm going to paint them. I'm going to paint pictures, do something inside the mold itself."

…He came into the shop in the morning. I had the whole table covered with about 100 boxes. Andy looked in one box. He said, "Oh, I like this, I'll take them all."

What were some of the other things Andy collected early on?

In the early 1960s, the first thing he collected was probably from the restaurant Serendipity – advertising tins. They were old, late nineteenth century. That phase didn't last for long. I think when he bought his house he got more serious. Later on Andy would consult with Fred Hughes a lot before he would buy things.

A lot of times Fred would have to come up and say yes or no.

Andy came to my Madison Avenue shop nearly every day for about eight years – from 1979 up until his death. I have some of the first sales slips. And I have the last one. The last thing he bought was a box of long-stemmed clay pipes. They probably were Dutch.

Once Lee Radziwill called up, and she wanted me to buy a lot of things from her. Andy said, "I'll buy everything, don't show it to anybody." He just bought it automatically.

They were complete, the stem and the bowl, and they had faces on them. I still have them. He was more fascinated by the box itself and the string that was used to tie the box up. And he wanted to know about the old lady I got it from – who she was and why she had this box. And he said, "Oh, don't take the string off, leave the string." And I said, "Should I put these pipes in another box?" He said, "Oh no, I want that box so badly." He never actually took it away, though; it was the last thing he said to me, "I'll send you a check." And then he went into the hospital.

The funny thing about Andy was that he wouldn't buy things from someone he didn't like. He was buying a tremendous amount of books from me. And my friend, a Philippine boy, Louie Acosta, was great at finding books; he had hundreds of books. I would have another stack of books from William Kingsland, who was an art historian. Andy never liked William for some reason. And I would never lie. I always thought he'd catch me some day and that would be the end of it. So Andy would say, "Now who owns these books?" There were around five hundred books. I would say, "Those are Louie's." "Oh I want them," he'd say. Then I'd say, "These are wonderful art books, Andy." He'd say, "Who owns them?" "These are William's." "Oh, I don't want them." For no reason. That was a peculiar trait of Andy's that I could never understand.

Did Andy have any other particular idiosyncrasies that struck you?

A lot of funny things would happen. He would be in the shop when somebody he knew came in, and he'd say, "Oh, quick tell me, what is that person's name?" I would tell him, and he'd say, "Oh, hi so and so." Virginia or whatever. He could never remember people's names.

Another funny thing: we had a mutual friend, Gray Foy, who was Leo Lerman's friend. Gray loathed Andy for what he stood for,

for his art, for everything. I always thought it was jealousy on Gray's part. I would watch Gray's face when Andy walked in. Sometimes Andy wouldn't come in; he'd always look in the shop first. And if he saw Gray, he wouldn't come in. But on occasion he wouldn't see him, and he'd come in. Gray's face would turn a bright red. I've never seen anything like it. It was just horrible. One day Andy came to me almost in tears. He said, "Why doesn't Gray like me? We're always at the same parties. He never says hello to me." He said it really hurt him so much. And I thought, "Gee that's odd; I never thought he would care." He would never usually tell you anything personal about himself, and to me that was very personal.

Another thing about Andy's personality in the early days was that he always loved to match up people. And he would always be more or less right. Of course, we all know he loved gossip. He'd call me up when he wasn't at the shop and he'd say, "What happened, who came in, what did she say? What was she wearing?" Once Lee Radziwill called up, and she wanted me to buy a lot of things from her. And Andy said, "I'll buy everything, don't show it to anybody." He just bought it automatically. Andy wanted *everything* from her.

Did you perceive any other changes in his personality? You started working with him in the '50s, then twenty years later, you started seeing him again. Had he changed?

Yes, I think so. I think in the early days he was friendlier. Later he became a little more aloof. He wasn't so enthralled with wealth

I think in the early days he was friendlier. Later he became a little more aloof. He really wasn't so enthralled with wealth in the early days.

in the early days. You could be poor and he would still want to know you. But later on, I could see that he was more fascinated with wealth. Once I introduced him to my close friends, the Barnetts from New Orleans, who are very wealthy, and that's all I had to say to Andy. I said, "They're very wealthy." And he wanted to meet them.

I wonder what brought that on?

Well, I think Andy was probably always fascinated with people's fame and success. All his life, he wanted to be famous – I'm sure of that. When he got a touch of it, it just overtook him.

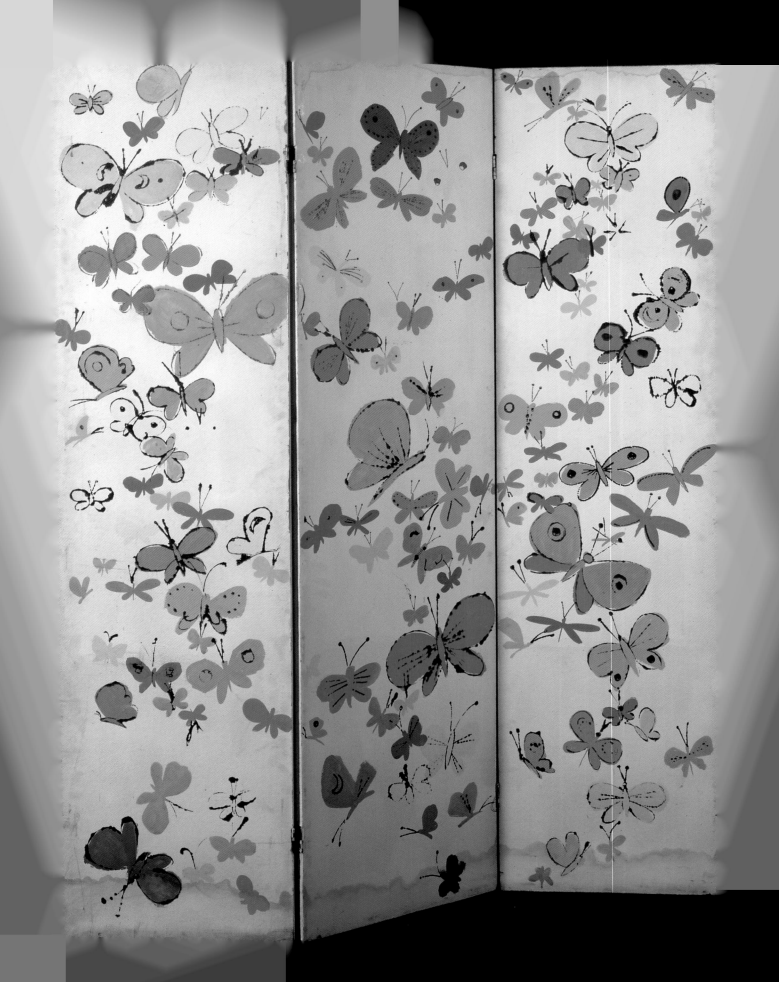

When Andy began to position himself in the company of other great painters in the early '60s, who did he most align himself with or speak of most positively? You mentioned the New York School.

Well, Andy would always praise other people's work. I never saw him put down anybody; he always would give encouragement. But I think he really did like the New York School artists. We would never, for some reason, get involved in talking about art. I don't know why. I thought he was so caught up in commercialism that he was not that interested in fine art. Maybe he wasn't, I don't know. He admired the New York School, but he would never discuss it.

Can you remember any of Andy's unfinished projects that would be of particular interest?

He was going to design part of the addition I was planning for my house on 83rd Street between Second and Third Avenues. He was going to design the whole space for me. My house has a "wedding cake" effect. On top of an upper terrace, this little house was going to be built. My architect, Steve Bingle from New Orleans,

Vito Giallo, c. 1959

I think Andy was probably always fascinated with people's fame and success. All his life, he wanted to be famous — I'm sure of that.

said, "Well, why don't we get an artist. I know you know Andy Warhol – let's ask him if he will decorate this room." And I said, "Oh, he'll never consent to that."

First, the plans were approved by the city. Then Steve went down to see Fred Hughes and Andy and brought the model and his drawings. They liked the idea, and Andy said, "I'll do it." And I thought, My God. I was just amazed. Then Steve called Adele Chatfield-Taylor, who was the head of the Design Arts program at the National Endowment for the Arts in Washington. She was fascinated by the project. She said, "Oh, we want to know every step you do, and we will pay for Andy's work if he wants. We will fund it."

Unfortunately, Andy died and I never did the addition. But I had everything ready; everything was approved. Andy would come to the shop and say, "Well, what do you want, what do you want me to do? You could do the same thing." I said, "If I did it, it wouldn't be a Warhol. No, I want you to do it." I said, "I like flowers, I like animals. You can do whatever you want."

So he said, "Well I've got to think about it." He had the drawing, it was just an empty space with a fireplace in the middle. The space wasn't that big – it would have been about fifteen feet wide

and twenty feet deep. There was a lot of glass in the room, so there wasn't that much space. But he was going to work on the supporting columns and on the fireplace wall. Steve thought it would have been the first time since the nineteenth century – I don't know if he's right about this – that an artist had worked that closely with an architect.

Andy did say, "I don't see how you're going to get a house built; I can't even get a fence in the backyard." And there was a lot of truth to that because it was a very difficult thing to get contractors. They wanted a half a million dollars to do this one little room. A total rip-off. The entire house cost a hundred thousand dollars when I bought it in 1970. And then Barbaralee Diamonstein, who was on the board of the Landmarks Commission at that time, came to the house and said, "Oh, you can't do this, you can't do that." I said, "Barbaralee, I've had it approved already." And when I told her what Andy was going to do, she was just beside herself.

So we never got beyond the discussion stage. But I was amazed that Andy would want to get feedback from me. He often would ask people, "What can I paint, what should I do?" And he would sift out the good ideas from the bad. I think he loved people to comment and tell him what to do. It always amazed me. I don't know of any other artist who would ask other people, even if they weren't artists, what they should paint. I always thought he was putting people on, but I don't think he was.

Untitled (Screen), c. 1956–59. Ink and ink wash on primed cardboard over wood screen, 64½ x 45 in.

Nathan Gluck

The Transition from Commercial Art to Pop Art

Before his association with Warhol, Nathan Gluck worked on the creative end of the George Kahn advertising agency and traveled extensively in Europe. After his collaboration with Warhol, Gluck continued freelance design and art direction, creating window displays for Bonwit Teller, and was commissioned to design cards for the Museum of Modern Art and Tiffany's, among others. In 1977, he began work with the American Institute of Graphic Artists as competition coordinator. Presently he works with the Art Directors Club in New York.

You knew Andy from his earliest days in New York. Tell us what he was up to then.

I met him when he first came to New York. It must have been maybe 1950. He had gone to see a friend of mine. And this friend said Andy's work was interesting, so Andy came over and showed it to me. At that time, he was starting to freelance. We became friends. Have you heard about the coloring parties he had in those days?

No, We haven't. Can you describe what they were like?

Well, everybody would come and sit around a table, and they'd be given Doctor Martin's concentrated colors. He'd take a saucer, mix up colors, and have them handcolor the black ink drawings or prints that Andy and I would make. Andy was very fussy about how you would put the color down. He didn't want the color in an even wash. He wanted it concentrated, then thinned it out so it had an uneven quality.

Did he have Mom around helping?

No, she wasn't helping, but she was there. Just hide her was how he felt.

But I thought they lived in a tiny apartment.

Well, the first apartment was like a railroad flat, a top-floor brownstone. He also rented the second floor because he wanted to be more social. That was the one he was going to fix up. He had the Serendipity guys come in and redecorate it. But Andy got weary after a while. It was the same thing uptown—he had the house, he was going to redecorate it, and then he gave up on it.

Did the painting parties happen in this newly decorated space or in the old apartment?

He had already started acquiring things for the second floor. At first, he collected things like the Tiffany lamps. Then he ended

Andy's fame was really based on those fabulous shoe ads. They attracted a lot of attention because they had a lot of white space and the drawing was so beautiful.

up buying a Jasper Johns *Light Bulb*. He bought a Picasso etching as well.

Back in those days, Andy was considered a premier commercial illustrator.

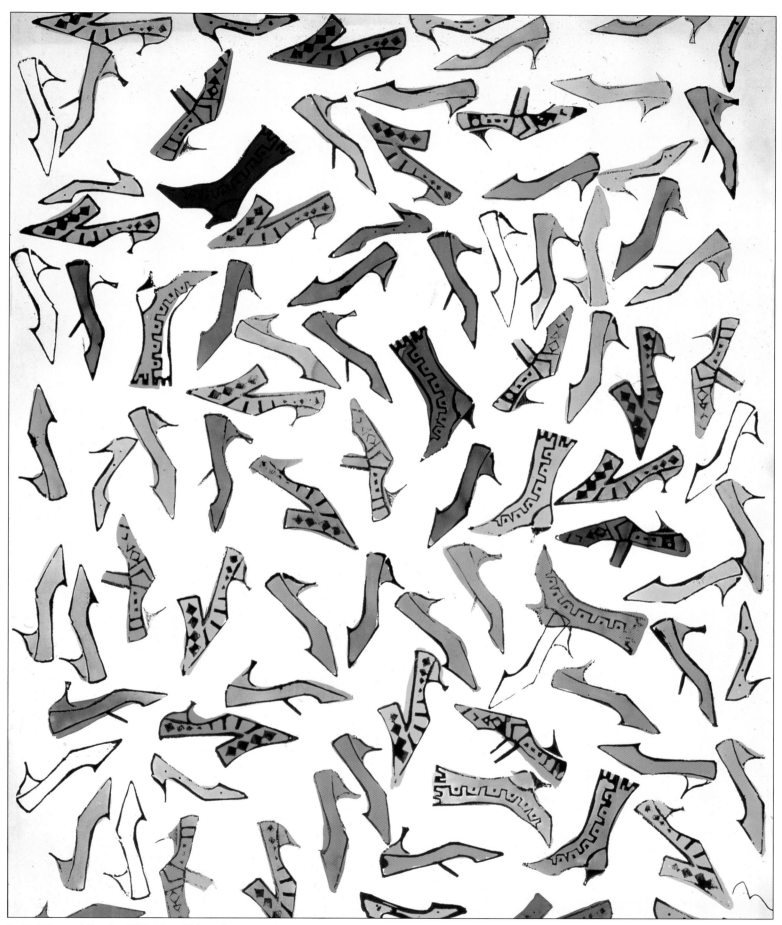

Untitled (Stamped Shoes), c. 1959. Ink and ink wash on paper, 23¾ x 17⅞ in.

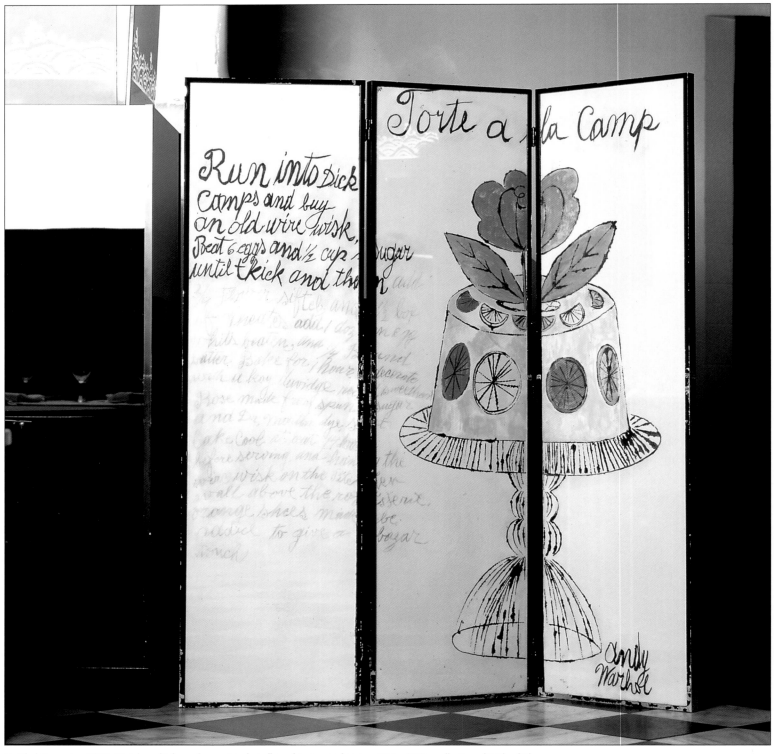

Untitled (Screen), c. 1956–59. Ink and ink wash on primed cardboard over wood screen, 64½ x 45 in., collection of Michael Chow.

Andy's fame was really based on those fabulous shoe ads. They attracted a lot of attention because they had a lot of white space and the drawing was so beautiful. Those shoe ads really created a stir.

In those days, even though Andy's work was sought after, he was still going around with a younger crowd, a gayer crowd. It wasn't until he met Charles Lisanby that he began to move in more elevated circles. Charles had a subscription to the opera, and Andy would ask me what the story of the opera was twenty minutes ahead of curtain. Andy had never read much, and he would stumble over things. He'd call *Ariadne auf Naxos* "Ariadne Obnoxious."

I think through Lisanby he got to meet people like Julie Andrews, Tony Walton, Paul Cadmus. Some of these people had been opera goers for ages. Poor Andy, I mean, not *poor* Andy, but I keep

wondering what on earth he could have said to the Rothschilds. First of all, he never spoke any languages other than Czech and English. His whole background was so different. That's one of the reasons why Andy used to stall and say, "Hm, uh huh, yes."

Which was a bigger part of his life – television or movies?

He loved to watch soaps.

Andy had never read much, and he would stumble over things. He'd call *Ariadne auf Naxos* "Ariadne Obnoxious."

Did you see Andy's show of his illustrations based on Truman Capote's writing?

Yes, it was at the Bodley Gallery; they were beautiful drawings. Nothing sold. I'm not sure whether Capote was there or not, although I think that somebody said he did go. I don't think he knew Capote at the time he did the drawings. Maybe immediately after, because I remember being with Andy once in the first Serendipity store, which was on a lower level on 58th Street. Capote happened to drop in, and Andy spoke to him, and then Capote left.

Vito Giallo told us about the Loft Gallery, where you and Andy and other artists showed your work. What are your memories of that gallery?

Andy had the show with the marbleized paper there. I taught him how to marbleize paper. All you do is sprinkle thinned-out oil paint on water and then lay paper down on top of it or simply immerse it. And that's marbling; except when you want a very definite pattern, you use a solvent that can hold the pattern. I had learned to marbleize paper when I was a little kid in school. On Father's Day, we marbleized some paper and pasted it on little pads so that we could give our fathers presents. I started marbleizing like mad. A friend of mine did the same thing: I told her how to do it, and she covered her whole bedroom ceiling with eight by ten typewriter sheets of marbled paper. There are lots of people marbling now, but there weren't very many then. Back in those days, there was a British man named Cockerell, and you could buy his paper at Andrews Nelson Whitehead, a paper supplier. But Andy did these strange marbled things, and then he crumpled them up and just left them around on the floor.

They were on the floor? I thought they were pinned to the wall but they kept falling to the floor.

Oh, that's a theory. But I thought Andy had installed them on the floor. Well, maybe by the time you came to see the show it was all on the floor. Andy had a very informal approach to a lot of things, and I think that approach carried on throughout his career. The blotting technique was basically a forerunner of silkscreen – in other words, he moved from one kind of a multiple to a more professional kind of multiple.

Speaking about silkscreening, can you tell us about the registration flaws in Andy's portrait of Marilyn Monroe?

Andy was silkscreening, and I'd look at Marilyn and there was blue eyeshadow where eyeshadow shouldn't be and the lips way up here. I said to him, "Andy, if you want to get more precise registration, put a little pin here, a pin here, and a pin here, and when you set the screen down, keep setting them within that perimeter, and you'll get perfect registration." Andy replied, "Well, I kind of like it this way." There's a series of French popular prints from the nineteeth century. The prints cover everything from religious subjects to instructional things. They were always handcolored with stencils. Of course, the stencils were always a little off-register.

I'm curious who actually taught him how to silkscreen?

An interesting question, but I don't know. The first silkscreens were done by some friends of his, only one of them is still around, Floriano Vecchi. They ran a place called Tiber Press, and they printed up some Christmas cards that Andy had done.

The blotting technique was a forerunner of silkscreen — in other words, he moved from one kind of a multiple to a more professional kind of multiple.

They did a lot of silkscreening. I think they only did a certain size, and I guess they must have put him on to a professional who made the screens.

Andy didn't make the screens. He had a constant retinue of people who wandered in all the time and helped him, and then disappeared, never to be seen again.

It's interesting that you say that being off-register didn't matter to Andy or that he even preferred it. I think that early on, archival quality wasn't always on his mind, either. If it looked good, it was finished.

That's true in a sense, except that Andy used good materials. I remember once going down to the Andy Warhol Foundation, and a guy wanted a bunch of drawings that somebody had gotten from somewhere authenticated. Jay Shriver, Vinnie Fremont, and I sat

Andy didn't make the screens. He had a constant retinue of people who wandered in all the time and helped him, and then disappeared, never to be seen again.

around a table looking at them. I said, "I don't understand it, because Andy worked on good quality paper. Here are these things, and the paper's all turned brown."

Full of acid.

Yes. And I didn't think Andy would have done anything on such cheap paper, although the drawings were actual replicas of things Andy had done. Of course, Jay was there taking his measurements, and something would be a millimeter off in size from the original drawing. That's how he knew it wasn't authentic.

That seems to come up again and again. Someone will reproduce a Warhol, and it will be just a tiny bit off.

Well, in a show at the Ingber Gallery, there was a drawing of a dachshund. Now, I know that drawing because a friend had this dachshund, and Andy did the drawing. The original drawing is dedicated "To Truccio" and to Richard Forman and Gene Quint. The dog's name was Petruccio. But this print didn't have that dedication so I knew that it had to be a fake, a Xerox or a photostat.

With Andy, nothing lined up. He took liberties with accidents, but that's part of the artistic temperament. Didn't he want his mother to do the cat books because of all her misspellings?

Oh God, yes. She also did a record album, and she would misspell words and start over again, and the writing would start small and get bigger and slant upwards. And finally, Andy told her just to do it; then he cut the whole thing apart and pasted it up so that it made some bit of sense. *She* got an Art Directors Club award for it. The award didn't have "Julia Warhola" engraved on it. It read "Andy Warhol's mother"!

Julia was a real character in her own right. You spent so much time around her. Could you describe her a bit?

She was very simple woman. She never learned to speak English too well. She had little quirks in pronunciation. And she was devoted to Andy and her other sons and to her relatives in Czechoslovakia. She was endlessly making up packages and sending them up to these little places in Yorkville that forwarded gifts and clothing to Czechoslovakia. She'd send them taped messages. She also used to tape herself singing Czech folk songs. Somebody showed her how she could sing along with herself. So you would have these two voices, one a little lower than the other.

She came to New York and saw that Andy wasn't taking care of himself and the place was sloppy, so she stayed on and became a housekeeper. Andy would come down and say, "Mom, what'd you do with my necktie, where did you put my shoes, no, I won't be here for lunch, I'll be here for dinner, I won't be here for dinner."

Now, she was very religious. How did that rub off on Andy?

I understand that Andy went to church on Sundays. And then of course, after he died, it was revealed that he used to go to these various places and serve food to the homeless. So it rubbed off on him in that respect.

Andy's mother did sit and chat with me, and she'd tell me Bible stories, which were very funny because they were all so confused

Andy's mother did sit and chat with me, and sometimes she'd tell me Bible stories, which were very funny because they were all so confused. They made me think of a Czech Br'er Rabbit. For instance, Moses was found in the bull instead of the bullrushes.

Did she ever feed you when you were working?

She would have mushroom soup, mushroom and barley soup, or she would give me a baloney sandwich or a cheese sandwich. She would serve me stuffed cabbage.

It seems as if there were only men among your circle of friends. Were there any women?

There was a girl named Imilda who Andy used to pal around with. I think she was one of his friends from Pittsburgh who eventually ended up in New York. But then, of course, there weren't really many girls that he was pals with until later on during his movie and pop eras. If a girl ever did come to the house, his mother would whisper, "Andy is coming down with his girlfriend."

Untitled (House of Flowers), c. 1954. Ink on paper, 16⅝ x 13¾ in.

Untitled (Girl Sucking Forefinger), c. 1959. Mixed media on canvas, 48 x 41 in.

She was sweet on having him fixed up.

Oh God, yes. She was truly very naive about homosexuality, and I guess she just assumed that Andy *had* to get married at some point.

How did his old friends feel about Andy's switch to pop? The friends who, as you have put it, were shunted downstairs when the new group arrived?

I think Andy just drifted away from them. Some of them denigrated pop work. I'm not that partial to it, but I think it's a part of the phenomena of our time. I'm still sort of old-fashioned – push around a brush or a pencil. Still, I think what he did was such an

innovation, although I'm not sure that I agree with all the people who say that he taught us how to see commonplace objects as

I'm not sure that I agree with all the people who say that he taugh us how to see commonplace objects as works of art. To me, a soup can is still a soup can.

works of art. To me, a soup can is still a soup can. But the idea of somebody having the chutzpah to do it up big on a canvas – that's

wonderful. My favorite story is how when he wanted to do his box sculptures, he sent me across to the A&P and said, "Get me some boxes." I came back with things that were very artsy, maybe a Blue Parrot pineapple box or something like that. And he said, "No, no, no. I want something very ordinary, very common." So he went back and got a Brillo box.

Did you ever work in the East 87th Street studio where Andy did a lot of his early pop silkscreening – the one that was in the old firehouse?

No, but I would go over there sometimes to see what was going on. He had all these weird people floating around. It was a great big firehouse with a staircase. It had a great big hole in the middle of the floor, so you had to be careful or you'd fall through.

Early, early on, he would hand people birdseed and tell them to plant the seeds and they would grow into birds.

At that point, his commercial work was tapering off. He lost the I. Miller account, and most of the time he was doing things for Fleming Joffré, leather goods. Then there was a woman who every year would ask him to do a manila folder, Vanity Fair Lingerie. Of course, you'd tell everyone about Vanity Fair, and they would assume it was the magazine. But it wasn't. Andy would make a decoration that he'd sign, and then he'd print it up, and the company would give it to their clients for Christmas.

Most artists send samples of their work for promotion. What did Andy do in those early years?

Early, early on, he would hand people birdseed and tell them to plant the seeds and they would grow into birds.

Birds would grow from the seeds – oh, that's good, bird seeds. So that was promotional?

Oh yes, that was a promotion. It was fun. That whole decade was a period of stunts. For instance, someone at *Vogue* magazine said she was having a baby. She was asked what she hoped it would be – meaning a boy or a girl. And she said, "Oh, I hope it's a fun baby." *Vogue's* idea of what to do for the summer in the early '60s was hysterical. It read something like this: rub your heels hard in the sand, get up at 5 in the morning and see the secret part of the day, and let your children do something wild, run barefoot!

When did you and Andy stop interacting?

In about 1962 or so, when he stopped doing his commercial work. I had been to Europe and had collected all kinds of little bits and pieces of ephemera from Europe and I was making collages, so I got some stuff from Andy, except I had never touched them. He used to save bills, etcetera from his trip around the world with Charles Lisanby.

Did you ever see Andy in later years?

I would run into him. I remember running into him once at the Guggenheim. He was always friendly. Even though he didn't see any of his old crowd regularly, he certainly didn't go around snubbing them.

In later years especially, he was known for his insatiable collecting. Did you know this part of him?

Yes, it was very interesting. When he passed away and Sotheby's had the series of auctions of his personal collections, a lot of things never showed up that I knew he had. Evidently he must have traded them up for something more valuable at some point or sold them, I guess.

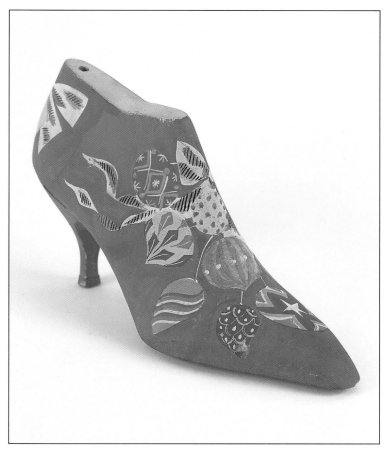

Untitled (Shoe), 1956–58. Tempera paint on wood, 5 x 8⅞ x 2¾ in.

Billy Name

On the Importance of Being Andy

Before coming to the Factory in 1967, Billy Name was a lighting designer for the Judson Dance Company in New York. After leaving Warhol's studio in 1970, Name completed what he refers to as a "concrete poetry canon." He is now house photographer at the arts-oriented Gershwin Hotel in New York. His most recent exhibition was at New York's Gavin Brown Gallery in November 1995. He is currently working on a one-man photography exhibit for the Parco Gallery in Tokyo.

What was your relationship with Warhol like?

In the beginning, my relationship with Andy was an example of that bohemian period where older artists would "keep" younger artists. But then when he started to become famous and we had so much work to do, we became more interested in the work, and we really synchronized well together. I was skilled in lighting and sound and set design, so we just had fun doing work. The personal relationship was no longer as important. That was happening in the New York scene at large, too. The avant-garde bohemian world where you nurtured young artists and fell in love with them and kept them and made them artists faded.

This was also the period when technology was really developing; in tape and video especially, things you could easily get your hands on. So the new tech wave moved in and took over from the abstract painters and their romanticism. People like Andy and Lichtenstein and Claes Oldenburg and Jasper Johns and Robert Rauschenberg were the transition. Art was no longer about only paint on canvas. It was like Duchamp said, "Get off the canvas and do the whole space."

The transition artists weren't resented really by the old-style action painters because they still did brushstrokes on canvas. But once you got into people like Roy Lichtenstein with his Benday dot art, the cartoon stuff, and Andy with his silkscreening, there was a big reaction from the older generation. "Hey, we're the kings here. Don't come out with this new wave, we're lasting forever." After all, the abstract artists were the ones who made New York the center of the art world.

Was it the technological aspect that those artists resented?

Both the mechanical and technological aspect of it. The abstract painters could really knock you out, though. I remember going to the first big Rothko show, standing there, it was magnificent. But after ten or twenty years, people were no longer excited about it or buying it. And what I think happened naturally was a neorealism, called pop art, that used recognizable images. It

…Once you got Roy Lichtenstein with his Benday dot…and Andy with his silkscreening, there was a big reaction from the older generation.

wasn't purely representational painting, but it used primary color and stuck concrete images in it. So it was sort of a neorealistic response to a couple of decades of abstraction. And Andy and Roy especially were a joyful relief to the previous seriousness.

Now how do you think Andy and Roy viewed those older artists of the generation that came before them?

Of course, they respected and admired them because they performed such a great feat in creating a school of art that became the dominant school of art. That was the last dominant school of art. For centuries from the time of the Renaissance to the Paris heyday, there has always been a dominant school of art. If you didn't follow that dominant style, you were labeled either provincial or naive.

You were a rebel.

Not really a rebel. You're speaking about the rebels who start the next wave. There were other painters who would paint in other styles, and they were either provincial or naive. But the ones who would start the next wave were always *radical*. They knew what was needed, what had to be fresh. Today, instead of a dominant style, we now have an eclectic spectrum; you can choose from the whole spectrum of styles and media. And as long as your talent comes through and people think you're authentic, it doesn't matter what style you use anymore as long as you do it well and it works.

New York did that. It said, "We're America, we're the fresh face. And no high school principal is going to tell us how we have to paint. We're young and audacious, and we're going to do what we feel like doing." Claes Oldenburg and Andy and Roy Lichtenstein swept away abstraction and said, "No, we want *our* iconography." Claes's hamburgers and soft toilets, and Andy's Campbell's Soup

Cans and Marilyns, and Roy's Benday-dot cartoons were so American. And it was an inner realism technically speaking – a response to the old abstraction to bring in a fresh dance.

Andy, I believe, went to Leo Castelli's gallery and saw some paintings by Roy Lichtenstein. Is that true?

Yes. He saw them, and he said, "Hey, I'm doing cartoons." He had already done the Dick Tracy and Superman paintings. "Hey, there is another artist working on this same kind of imagery." In fact, that's one of the reasons why Leo wouldn't take Andy on immediately – he already had someone who was using the same iconography. You don't want to bring a competing artist into the same stable, so to speak.

But Leo did eventually take Andy on. Andy's last show at the Stable Gallery was the box show, the Brillo Boxes, the sculptures. At that point, Andy was getting so much coverage in the media that he was obviously a valuable property, and it didn't make any difference anymore if other artists in the gallery were similar to him or not. There was space enough for him.

So Leo sent a truck over to the Factory and loaded all the silkscreens. We had to store them in the Factory, and we were concerned about their continued existence. Leo took them and put them in proper storage; he really cared for them. He started doing an inventory of the paintings, whereas Eleanor Ward, who owned

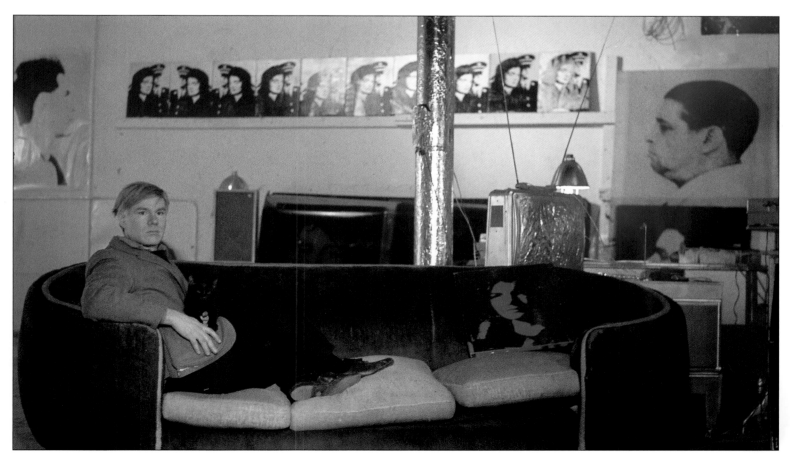

Andy at the 47th Street Factory on the couch used in the film *Couch*, c. 1964.

the Stable gallery, never did anything except to say, "Send the work over when it's ready and I'll show it."

So things changed a lot once you moved to Leo's gallery?

It was class. Whereas before we were still struggling along in an amateurish way, suddenly everything got more professional. Leo

The multiple thing, which seemed to be a contradiction of innovation or embellished style or technique, was really a strong beat in New York.

instilled style in his operation, and you really felt someone knew how to take care of things. People would like to be with the Leo Castelli Gallery because he was such a great operator. He was elegant, a gentleman, he had great tact, but he knew the best stuff, and he knew how to sell it.

Tell us about some of Andy's shows at the Castelli Gallery.

The first show was the flower show; the very huge ones, which were about ten feet by ten feet, all the way down to the little ones, which were six-inch squares. The next show was the *Cow* wallpaper and the silver pillows—it wasn't painting.

Did the Cow *wallpaper and the silver pillows ever sell?*

They didn't initially, no. They are collectibles today and the wallpaper still sells well. The pillows really stemmed out of the experiments in art and technology of the day. Andy was introduced to Billy Kluver, who worked for Bell Labs. The first satellite called Telestar was his creation. He told us about mylar balloons. There was mylar that you could make into any shape you wanted with a heat presser, so we said, "Let's do something with that."
The *Cow* wallpaper started with a show that was going to be in the Whitechapel in London. The show never happened, but Andy had asked Henry Geldzahler what he should paint for the show. And Henry said, "Well, one of the favorite traditional things in English painting is bovine pastorals." So out of the idea of a bovine pastoral scene came the *Cow* wallpaper which was supposed to end up as that entire exhibition.

Where did the actual image come from?

It was a Dairy Association of America brochure.

Warhol Superstar Ivy Nicholson photographed by Billy Name, c. 1964.

Now why wallpaper as opposed to traditional canvas?

Because it was a better idea. It was more innovative and more audacious.

And the multiples?

The multiple thing, which seemed to be a contradiction of innovation or embellished style or technique, was really a strong beat in New York. For instance, I remember going with Andy to an avant-garde experimental music concert and I remember being in the elevator with John Cage talking to Andy about Eric Satie, the composer. In the music, instead of just assuming the base beats are always there, it was a time to recognize the basis and see it. To repeat the base so it becomes recognized before you even get into embellishment.

At that point in time, was Andy only interested in painting and printmaking?

In 1963, Andy first became interested in making films. He had a Honeywell Pentax 35-millimeter SLR camera, and then he bought this 16-millimeter Bolex silent movie camera and said to me, "You keep the still camera and do the still photography, I'm

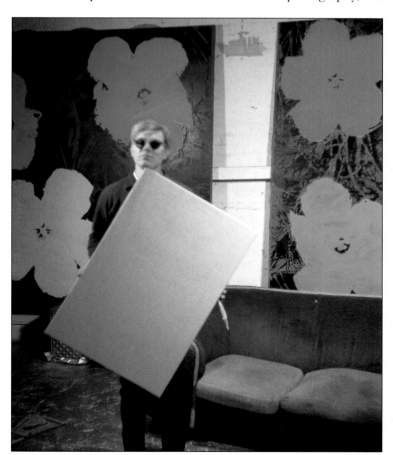

Warhol in 1964 with *Flowers* paintings and an unfinished *Campbell's Soup* canvas.

39

going to start making films." So I went to Peerless and got the booklet for the camera, the manual, read it, and figured out how to really use it well. Eventually I got the *Kodak Darkroom Guide* and set up a darkroom in the Factory.

Andy was really open-minded about what he should do in terms of making film. He hadn't gelled a style or a concept of what he wanted to do yet.

What was Andy's attitude toward filmmaking in the beginning?

Andy was really open-minded about what he should do in terms of making film. He hadn't gelled a style or a concept of what he wanted to do yet. And so we would go to Jack Smith's shoots on Lower East Side rooftops so that Andy could get a sense of how you really operate making a film. The first feature Andy did was *Tarzan and Jane* with Taylor Mead and Naomi Levine. It was more a Jack Smith-style scenario—orgiastic, crazy, let things happen, use really fantastic people.

Andy wasn't satisfied. It wasn't his creation so to speak. He didn't come up with his own way of doing things. He stopped doing that style and said, "No, no, I don't like this hand-held movie stuff. I don't like the story stuff." He got a tripod and just put the camera on the tripod and said, "We're going to find out what the camera does first." He started getting into the minimalist-type thing with *Kiss, Thirteen Most Beautiful Boys and Girls,* and the *Screen Tests.* He wanted to be relaxed about the whole thing and to stop trying to come up with ideas. Just relax and learn more about the camera and see how it works. This led to Andy's self-education about how the camera "sounds," the pace of it, what it does.

Andy always knew that if he did something at too deliberate a pace, his bubble would eventually pop. He worked with more of an intuitive than an intellectual strategy. He wasn't very articulate, but he was very, very intuitive. So he progressed in his filmmaking with an intuitive approach.

Did Andy get a lot of press for his movies?

Well, actually, at that time Andy was starting to get coverage in newspapers and magazines because of the Campbell's Soup Cans and the Brillo Boxes. Previously, American magazines like *Life* and *Time* had never really covered American artists. The first time they did it was when they covered Jackson Pollock. *Life* magazine did a five-page spread on him. But he was only seen as a joke. All the curators and the critics were saying, "This is the great American artist. And all he did was drip paint on canvas!" Still, Jackson Pollock was the first American artist to gain international recognition as a great master artist.

The press couldn't do that again until Andy came. He was doing portraits of Marilyn Monroe and Elvis Presley; Campbell's soup cans, Brillo boxes. They could say, "You see for yourselves. The critics and the artists say it's great art. Do you think so, too?" They could put it down but still cover it.

Andy really broke the mold of the artist as hero. He didn't turn his back on society and say, "Don't ask me about art." He didn't know how to articulate, so he took the Duchamp approach of turning the mirror on the press and public, saying, "Why don't you give me the answer to the question and I'll just repeat it back to you."

He wasn't a culture hero, really, he was a culture zero! He was transparent; you could see right through him. He had a kind of charismatic invisibility that let the iconography come through and let the stars be the stars. He was the means by which stardom was made into fine art. People were devoted to stardom, to Marilyn Monroe and Elvis Presley. And he also allowed people to see the things they were devoted to daily—like Campbell's soup cans and Brillo boxes—made into fine art.

But once he achieved recognition as a fine artist, as an American master, he sort of lost interest in it because things had reached their pinnacle. He was still interested in making great, beautiful paintings, but he was getting more into the color and the structure of the painting. He shifted his focus to the films. I remember talking to him about this; he told me he wanted to be able to make it as big in the film genre as he had in the painting genre. That never

He wasn't a culture hero, really, he was a culture zero! He was transparent; you could see right through him.

happened. His films were accepted in the art world, but they didn't make it big in the popular world.

Do you think he chose to use the Self-Portrait *painting to display at Expo '67 in Montreal because he was thinking more about advertising himself as a person as he was moving into film, or was that just the best image?*

I don't exactly know why Andy did self-portraits. He knew photographers like Ed Wallowich who would do portraits of him, and he would use those photos to make silkscreens for the self-portraits. I think it was part of an artistic tradition more than a promotional idea. Andy knew that the smartest things came from artists. The artist had a real sense of what turns people on and makes people

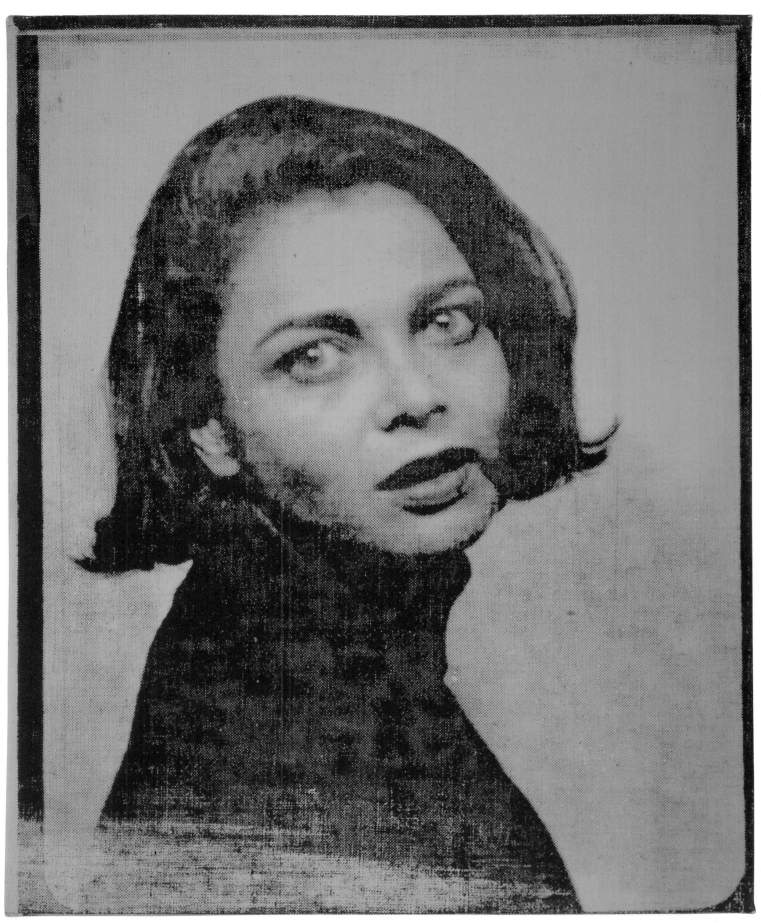

Judith Green, c. 1963. Synthetic polymer paint and silkscreen ink on canvas, 20 x 16 in.

want to see something—whether it's beauty or something fresh. Also, having worked in the business and commercial world, Andy knew that if you were going to be successful, you had to be the one who knew where the ground was rumbling not the one who knew only what the promotional concepts were.

Going back to the films, when did you realize that Baby Jane Holzer had that star quality?

She was the top fashion magazine cover girl when she did *Kiss*. We had been using Naomi Levine as our female star because she was already an established underground film actress. But she didn't have a pretty face. She had something about her and was probably good at sex and that made her popular in these films. And she was the first person I saw wear high heels with jeans. She did have this chic streak to her.

Once we saw what Baby Jane could really do on the screen, we knew that she had the type of beauty that the masses flock to. Not only people who read *Vogue* but the Hollywood-type crowds. People would look at her and say, "Isn't she magnificent, that mane of hair!"

It clicked that we should look for that magnetic type of person who radiates from within; it's some innate talent that they have. So we didn't use actors or actresses. We looked for beautiful people.

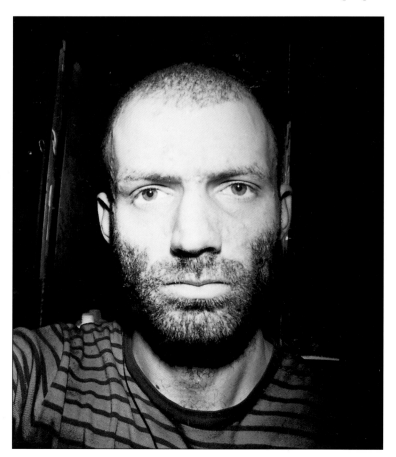

Billy Name, c. 1965.

Andy was fascinated with fascination. Why do people follow Marilyn Monroe or Elvis? Because those stars have something in them that people either want to be or want to possess. We found out that people go into an ecstasy being able to see beautiful people.

So Edie was the next star, and then there was the *Chelsea Girls* period with Susan Bottomley, Mary Woronov, Nico, and Ingrid Superstar, who was a parody of that sensibility, followed by Viva.

What about the male side of that kind of stardom?

Well, men care less about stardom and glamour unless you get some great fag who wants everything. For the girls, the glamour itself seemed to be like a food. Of our actors, Little Joe was the most glamorous. We also used Joe Dallesandro, Louis Waldon, Paul America—one of Henry Geldzahler's studs—Alan Midgette, Tom Baker, and Eric Emerson.

Now while you were doing these films, did you pay attention to popular culture, to movies and television?

We were aware of everything that went on; what was noticed and who was the latest director. Especially Andy. From his years in the commercial world, he was always aware of who was cutting edge because that's where he wanted to be. He always knew who was on top, who was the latest thing.

Which of the films did Andy consider the most successful?

Chelsea Girls was the first great successful vehicle. We were even listed on *Variety*. We brought in $20,000 at the Regency Theater in one week. We were bringing them in like a Hollywood film. That year, 1967, was aesthetically a culminating year for Andy. I think those self-portraits are really gorgeous. And *Chelsea Girls* was the integration of our aesthetic—we had multiple screens, simultaneous dual projection, and we had the integration of black and white and color reels. Also, the Velvet Underground and Nico album came out in 1967. The soundtrack of *Chelsea Girls* is supposed to be played like a symphony that can be played freshly each time, different ways. But it is a magnificent film even when it is played in the rigid form.

I think *Chelsea Girls* and *Lonesome Cowboys* are the classic Warhol films. The previous movies are really art films.

Like Empire *and* Sleep?

Empire, Sleep, the *Screen Tests,* the *Haircuts, Blow Job,* and Robert Indiana eating a mushroom. Those are still all art films for art houses. But *Lonesome Cowboys* and *Chelsea Girls* deserve to be recognized as regular American cinema. *Lonesome Cowboys* is a really great film. It was the movie in which Andy's stop action

camera technique really developed. He would stop the camera and then start it up again so that you would get the last frame and then a blank and then the next frame and then the jump in the sound. Instead of filming something with complete continuity story-wise, he would jump edit.

…Men care less about stardom and glamour unless you get some great fag who wants everything. For the girls, the glamour itself seemed to be like a food.

And it has a stunning effect. The first time you see it, you say, "What on earth is this guy doing?" Again, it's the audacity of the work. It's so stunning that it's like editing a painting; it is something nobody would *dare* to do, but Andy did it while he was making it. It's a real cinematographic innovation.

With those films, did the Hollywood establishment come knocking on your door?

Andy and Paul went to Columbia and had a meeting with producers there. But they were very hetero-type people who had Great Danes and would laugh at women's cunts. They didn't get Andy, they didn't get it! They were so concerned with the marketing factor. They got nowhere with figuring out Andy's movies. They couldn't conceive what they were going to do market-wise.

What do you see as some of Andy's other innovations?

One thing that can be attributed to the Factory scene was the unedited interview. Andy was constantly recording everyone. In *Interview* magazine, which we founded, we did unedited direct transcription of interviews with fascinating people. It was the first time people had read interviews that weren't focused by the editor or the interviewer. It was so refreshing to read interviews where you actually could feel the person and hear what they were saying because there was no editing. Everything was verbatim transcribed—it was a new, live type of interview.

Do you see Andy as being a part of a tradition, and respectful of tradition, as well as being an innovator?

We were really intelligent people and knew our world and our historical predecessors. One of the joys of being able to create and express yourself is to bring the things that you've appreciated from predecessors into it and let them play. You're not only showing respect to your predecessors, but you're also providing a continuity of cultural history for people who don't know these predecessors. "Well where did that lower case 'a' come from?" people ask. Then they find out it's from e.e. cummings for the book *a, a novel by Andy Warhol.* You get to see the cultural world as a symphony filled with elements of chamber music.

Paul was very conscious of tradition. He was into the Hollywood film genre. Andy really loved that, too. And then Paul moved it more into what you would call Hollywood "camp."

While all of this filming was going on, was there a lot of painting happening, too?

Sure. Because of the size of the first Factory, a lot of different activities could go on at the same time. People clustered. There were areas where certain functions occurred. If you have a space like that and you have layers of things going on, the space sort of organizes itself according to the functions you need, and that's what the Factory was like.

When did you decide to leave the Factory?

1970. I was feeling isolated, and felt I should find out what was going on in the rest of the world. And by this point, Paul and Fred Hughes had pretty much taken over the operations. Andy didn't need me anymore—let's put it that way.

After Andy was shot, we were traumatized. We had feelings of fear and hesitation simply because he had been hurt so badly. And so the Factory became a different place. We overcame the trauma, but we still went into a safer mode of operation, a more business-oriented one. It wasn't the type of art world I was interested in anymore. I was a serious bohemian avant-garde artist. I didn't feel like

From his years in the commercial world, he was always aware of who was cutting edge because that's where he wanted to be.

I was doing anything there anymore. So I thought, "I'll go out and see what's going on on the planet."

I left a note on the darkroom door. You know in "Popism," "Dear Andy, I'm not here anymore…" And I went out and started living in the streets. The most money I had ever had in my life up until that time was the $300 I got for the third Velvet Underground album cover. I had $300, so I said, "Well, I have $300 I can go out and see what's going on and do it!"

I started hitchhiking around. I went down to Washington, D.C. during the big revolutionary movement, and there were thousands

of people camped out in the Mall by the Washington Monument. I stayed there a couple of weeks with people in different tents. Then I went to New Orleans and stayed there for a while. Eventually, I got to San Francisco and looked up Diane DiPrima because I had worked with her years before in New York. I was so debilitated from years of not eating food and taking methamphetamine that I was really not well. I went out to the streets again and eventually got a place in a hotel and started working on concrete poetry-type things. Eventually, in 1977, I came back to my hometown, Poughkeepsie, New York.

When I came back, I called Andy and we talked. But I was into community activism here – environmental stuff and getting people food. So I joined a bunch of organizations. I went back to college and got a graduate degree in business administration because in order to get on the boards of directors of these community organizations you had to be sophisticated about budgeting and management.

Then people found out that I was Billy Name. There, in Poughkeepsie, I was Billy Linich, my real name. So, I returned to the art-world scene just before Andy died.

How did you get "Billy Name"?

I didn't become Billy Name until 1965 when I was doing college tours and club tours with the Velvet Underground and Edie and Gerard and Mary Woronov (Andy Warhol's Exploding Plastic Inevitable). We always made up a poster with everybody's name on it. "Billy Linich" did not seem to me to really be a 'star' name. There was an application form on a desk in front of me that said "name_____, address_____, name _Billy_, Billy Name. That sounds like a name that should be on a poster." So I told Andy when we were doing posters to put me down as Billy Name. And he said, "Billy, that's so smart!"

Which do you prefer?

I like Billy Name. A lot of people like me as Billy Linich; they think Billy Name is too sophisticated a name for who I really am. But I tell them I did it as a poetic thing.

I really thought that it was a very all-American sounding name, Billy Name.

It is, it's so Warhol. People are surprised that Andy didn't make it up, because it's such a pop star type of thing.

But you had the same aesthetic.

Yes. Andy and I synchronized; we could recognize what was the best thing or the right thing to do.

Installation at the Stable Gallery, New York, c. 1964.

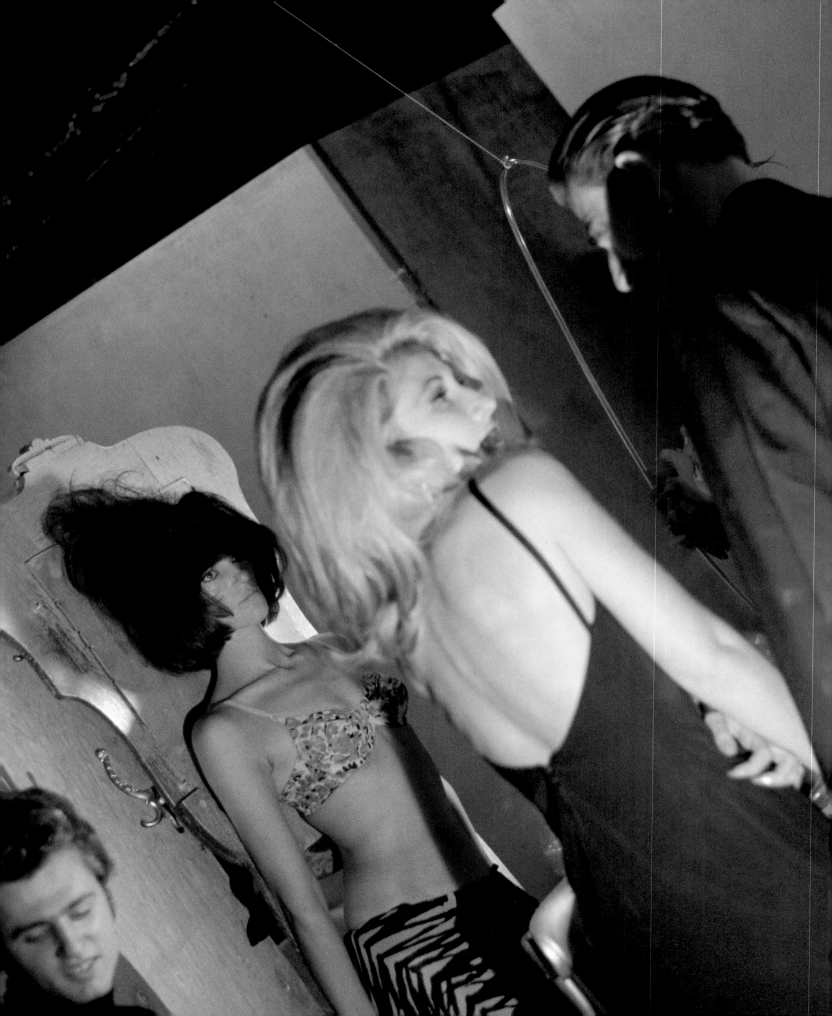

Jane Holzer

A "Superstar" Recalls Her Factory Years

After a very successful modelling career in the early '60s, Jane Holzer, nicknamed "Baby Jane" by the press, became one of the fabulous Warhol "Superstars." She appeared in many of his underground films during that period, including *Soap Opera*, *The Kiss*, and *Chelsea Girls*, and was known for her Hollywood-style beauty and magnificent mane of hair. Holzer also appeared in John Palmer and David Weisman's film *Ciao! Manhattan* with Edie Sedgwick. Later on, she opened an ice cream shop, Sweet Baby Jane's, in Palm Beach, Florida. She currently resides in New York and Palm Beach.

When Andy filmed you for what he called the "screen tests," he realized that they needed someone like you to fill the role of the charismatic, to be what he coined a "superstar." Before then the Factory had Naomi Levine and others for their underground films, but they needed someone of your stature.

Really? I didn't know that then.

So what was the screen test like to sit through?

It was great. Andy would just turn on the camera and walk away. And he'd tell you "Don't blink." That was his only "direction." How could you not blink for three minutes? I would really try not to look too weird. It's so unreal not to blink.

Where were the screen tests done?

At the Factory.

So he actually walked away and just left the camera running?

I don't remember. He would start filming, and I don't remember. Music was always playing. Sometimes Andy would be there, but it wasn't like a photographic session. "Yeah, you look great." None of that, no, no, no.

Would he have the newspaper up in front of his face, reading while the camera was rolling?

I never saw him do that.

How did you get into Warhol's underground films?

I was walking on the street with Nicki Haslem, who at that point was editor of *Show* magazine. I think Nicki might have introduced us on the corner of 59th Street, right in front of Bloomingdale's. Andy said, "Oh, I'm making a movie called *Soap Opera*. Would you want to be in it?" And I said, "Sure." Ever since then, we were friends. The next week or so, I had this amazing dinner at my father-in-law's house where I lived on Park Avenue.

So Andy came, David Bailey, Mick Jagger, Keith Richards, David McEwen, Nicki Haslem, and me. I considered it a perfect dinner. That was a famous dinner.

Wow. So then Andy invited you to be filmed at the Factory?

Yes, he did. The first thing I worked on—actually with Jerry Benjamin and Sam Green—was called *Soap Opera*.

He had some strange ideas.

Maybe at the time it may have seemed like that. There were no scripts. You made stuff up as you went along. I haven't seen those

Gerard Malanga, Ivy Nicholson, Jane Holzer, and others on the set at the Factory, c. 1965.

Little Electric Chair, c. 1964–65. Synthetic polymer paint and silkscreen ink on canvas, 22 x 28 in.

films in a long time. I haven't seen them since the '60s.

We wanted to ask you how you got the moniker "Baby Jane."

Oh God. There was this columnist called Carol Bjorkman and the Joan Crawford, Bette Davis film *Whatever Happened to Baby Jane?* had just been released. She hadn't seen it, I hadn't seen it, but I guess she thought, We'll just crown her Baby Jane. Then I went to see *Whatever Happened to Baby Jane?* and I wanted to die. But the name stuck.

What was Andy like in those days?

He was wonderful. But there was an edge to him. It was slightly different. After he was shot he came back as, I was convinced, half angel or all angel. It's also important to note that Andy ran a tab at Max's Kansas City. He would pay for any artist or person that he thought needed to eat. But he wouldn't give them cash – he gave them food. I think he was worried that they could go get drugs.

So he was a caretaker.

He was amazing.

You know they're making that movie, I Shot Andy Warhol. *I was telling a friend about it, and I said, "Listen, I know the person who got shot, it's Andy. He's the one who suffered, he's the one who, because of the bullet wounds, wore the corset until the day he passed away." I'm not sure why they're making that movie. Are they trying to sensationalize the girl who shot him?*

Who knows? People are just going to do anything and everything to make money. Everybody wants their fifteen minutes.

It's true, or their fifteen dollars.

Right, exactly.

Tell us about what happened after you did the screen test. Wasn't there another film where you're brushing your teeth for nine minutes or something completely banal?

I was eating a banana—that's a really good one. Then there was *The Kiss.* Then there were a couple of more "don't blinks." Then we filmed *Dracula.* That was hysterical. This limo came and picked us up and took us out to the Marshall Field house where Judy and Sam Peabody were spending the summer. And Andy's early star Naomi Levine was there. Ivy Nicholson was there, too.

And there were all of these wonderful proper maids in uniforms waiting on people. Naomi Levine wrapped herself in Saran Wrap with nothing on underneath. Everyone was watching the maids sort of move around ill-at-ease, pretending that Naomi was dressed. Judy and Sam were hysterical, I thought it was hysterically funny—it was great.

That sounds like a really out-to-lunch period. Were you comfortable with the Factory scene at that point?

Then, yes. But later there was a period when I wanted out of there. I mean, it got a little bit sick, it just felt that the movies got a little

…Andy ran a tab at Max's Kansas City. He would pay for any artist or person that he thought needed to eat.

bit too strange. People showed up at the Factory and I got a bad vibration from them.

That was a few years before Andy got shot, wasn't it?

It *definitely* was before he was shot.

So did you see him after the shooting?

Sure, yes. I mean, he was in recovery for about a year.

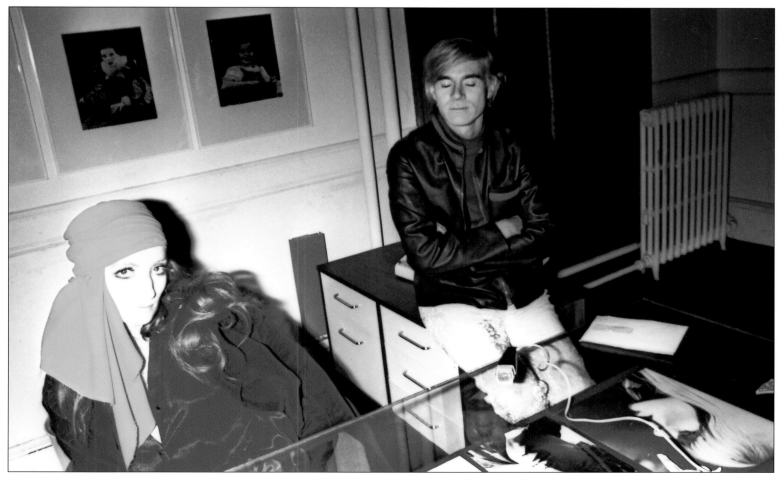

Andy Warhol with Viva, c. 1965.

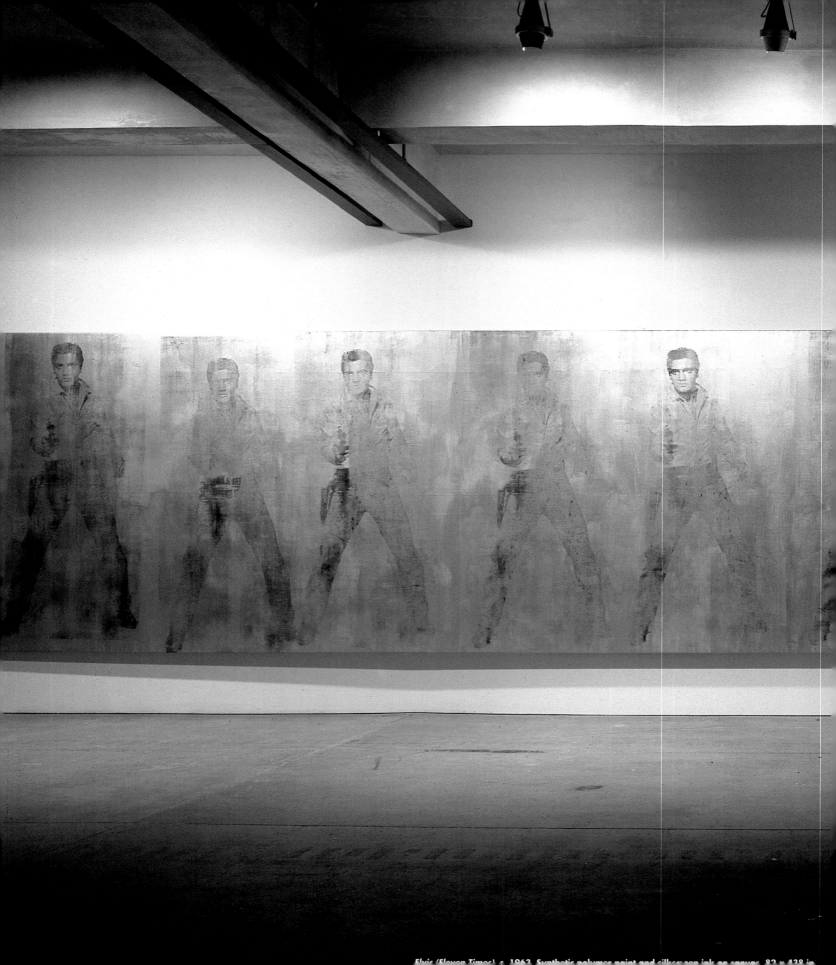

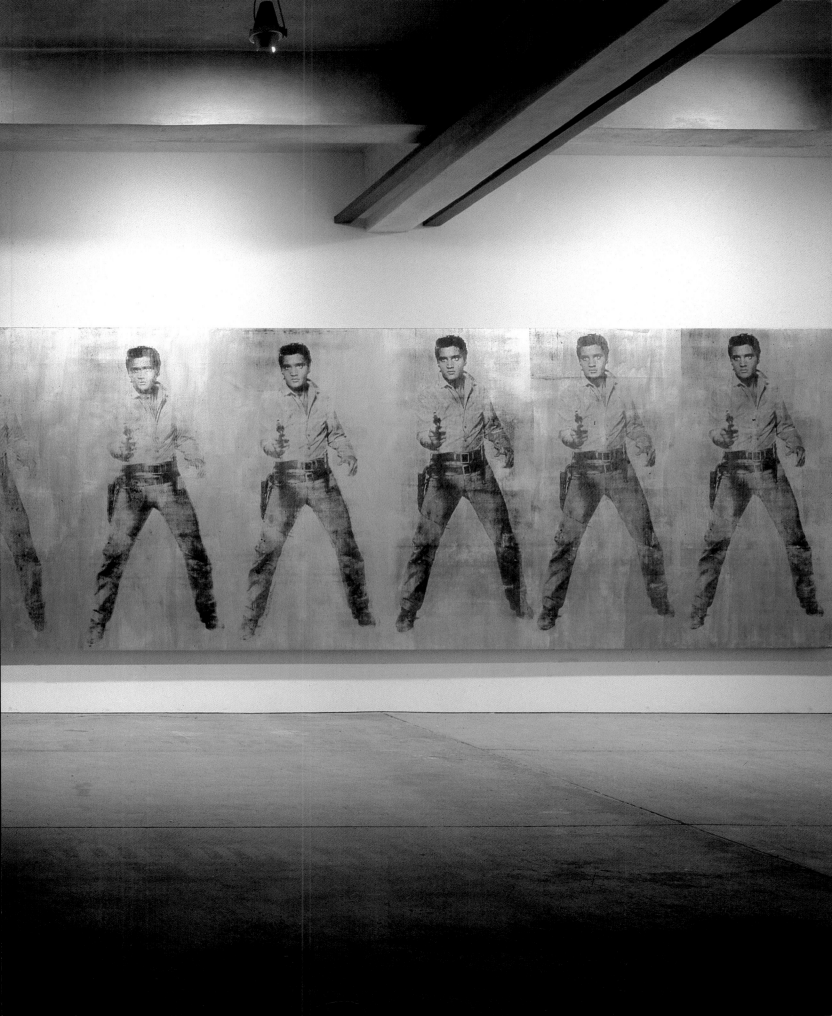

Brigid Polk, Ultra Violet, and unidentified person, c. 1965.

After the shooting, was there a big change in how he approached the Factory and the people who worked there?

Yes. It was a great change for me because then I could go back there. All of the sickos were finally out of there. Before he was shot, Andy wasn't doing drugs, but the people around him were.

What was he doing with his non-action films like Empire?

What *Empire* really was was a moving painting. That's what we found out later. What he was actually doing when he was filming *Empire* was painting.

Because it was a static image, and you could watch what happens to it as the light changed – even though the camera didn't move.

Right. Later on Andy and John Palmer got a shopping cart and that was Andy and John's roll-in and roll-out shot. They just strapped the camera to it.

I didn't think about those films as paintings until you pointed it out, but that really is what they are. I think Andy was a painter more than anything else. Tell us about your appearance in Ciao! Manhattan. *How did Andy take to your appearing in someone else's film?*

He didn't show me he minded. We never discussed it. He had Ingrid Superstar and Viva and Isabelle.

You're the one that started that whole trend. The beautiful girl trend. You were the "girl of the year" in what year? Was it in 1966?

No, I was before Edie. Edie was with this guy called Chuck Wein, and he had a bad vibe, a very bad vibe. Too many drugs.

What was it like working with Edie or Chuck in Ciao! Manhattan?

Let me give you an example. One day we went to this halfway house. And we were waiting for Edie to show up. We got there at probably 11 in the morning. At 5, Edie shows up. Can you imagine? She had just the right mix. She looked fabulous, she filmed perfectly because she was, you know, high and feeling great. But we were fit to be tied and uptight because we'd been waiting forever. What's wrong with this picture?

She had the star syndrome?

Yeah. She was amazing and beautiful.

My favorite Jane period is represented by a photo of you in your apartment wearing Giorgio Sant'Angelo gypsy clothes. That was before I met you.

Really? In that picture, I was nine-and-a-half months pregnant. Take a good look.

Really? Well maybe all those multi-layered skirts covered it. It was an amazing picture.

What *Empire* really was was a moving painting. That's what we found out later.

I gained sixty pounds, and it was all under those skirts. My son Rusty was born in 1969.

So he's twenty six now? I can't imagine that. I still see him as a student.

I can't believe it either. He grew up and went to Harvard. I had to bribe him to go to Harvard, you know. He wanted to go to Brown.

What did you do?

Taylor Mead at the Factory on 47th Street, c. 1965.

I had to buy him a horse, another horse. I did. I mean, listen, if the kid gets into Harvard, he has to go to Harvard. Come on.

So was there a long period of time during which you just stayed away from the Factory?

Do you know what? I don't remember how long it was now. It was in between Edie's arrival and when Andy got shot. Andy was shot in 1968.

It seems like Andy ended up asking everyone who was involved with the Factory in one way or another to help him with his paintings or some other project.

That's normal. I was there when he was painting the *Flowers*, and that was amazing. He had all of these canvases laid out on the floor and all these silkscreen frames. And the canvases I think were painted green with the flowers on them in different colors, and they'd squeegee the leaves in black on top.

Those were big screens.

Some of them were small. He was doing the twenty-four-inch squares as well as the bigger ones. "I went to Leo Castelli to buy some because I thought, I have to buy some." And guess what? I just got a ten-foot-by-ten-foot one last week. I just love them. They're all great.

So did you see much of Andy in the later years, in the '80s?

Yeah, a lot. I saw him everywhere. We'd go to dinner, we hung out. You know, we were really close.

You're one of those people who actually were with Andy through several decades. Did you see any changes through the decades?

Well he had gotten everything he wanted, really. You know, he really had arrived. At the best parties, he was the first one invited. I remember it used to be so embarrassing in the '60s; he and ten people would show up and crash. By the '70s, he was the first one to be invited anywhere.

Would they always get in?

Yes. After all, it's just a party.

That's true; it's supposed to be a celebration. I was going to ask you about that Broadway play you were in.

How did I get in it? I just read and got the part. I tried out, I

begged, I pleaded, and I got it. Jerry Brandt, Joe Eula, and Alan Finkelstein did this play called *Gotta Go Disco*. We were headed for Broadway with no director, it was brilliant. It was the story of Cinderella.

Irene Cara was in it.

Cinderella was black, she was my younger sister. Our mother was this red-headed actress, really funny—we rehearsed for three months but we were open for two weeks; we opened and closed basically. It would definitely open and close today, too, I'm afraid. But actually it was kind of goofy.

Before the Factory got crazy, would you spend a whole day there?

No. I'd go to the hairdresser and get there at about 3. I'd stop off at Kenneth and get my hair done if I was going to be filmed. *New 'do. And Andy would already be working?*

…As the years passed, things changed. Andy got into working during those later years. He really ran a business, he became rich.

He'd be around, yeah. Andy and maybe Gerard and Billy in the background. As the Factory became more popular, you never knew who was going to drop in. In the beginning, it was just us. We filmed sometimes with different people, but it was very intimate. And then all of a sudden the movies changed, and a lot of people started coming. The Factory became like a party.

Too out of control?

Yes, very much in that mid-'60s. But as the years passed, things changed. Andy got into working during those later years. He really ran a business, he became rich.

Had to pay the rent.

Yeah. Big time.

I've never seen a gold portrait of Jackie before like the one you have.

There are only three of them, actually four. Three like the one I have and then there was a tondo, the portrait plus a gold canvas. It was of Jackie actually smiling with the President. I could have bought it—I didn't have the money at that moment—but I should have. It's a really, really great piece.

Oxidation Painting, 1978. Mixed media on canvas, 40 x 30 in.

Ronnie Cutrone

An Artist's Take on the Work of Warhol

Born in New York, Ronnie Cutrone started his artistic career in the late '60s. He worked with Andy Warhol at the various Factories from 1972 until 1982. Cutrone showed his work at the Tony Shafrazi Gallery during the '80s along with Jean-Michel Basquiat, Keith Haring, and Kenny Scharf. In 1991 he created the *Love-Spit-Love* live performance piece of nude couples that was shown before an audience of five thousand. Currently, Cutrone is working on computer-generated portraits on canvas of various supermodels and personalities.

I started coming around the Factory and just hanging out in 1965. Not working really – I was still in high school. But in 1966, I became part of the Exploding Plastic Inevitable, the sound and light "happening," and was a dancer with the Velvet Underground, so then I was actually getting *paid* to hang out. I got a paycheck to fuck groupies and stuff. In 1968, I went off on my own for four years to teach myself how to paint. I went into isolation basically. That was the period when Jimmi Smith, a "second-story" thief and action painter banned from the Factory, was my only friend. I was way out there.

I pulled myself together and became sort of socially acceptable again and started coming around the Factory in 1972 to work on my own photos. Andy and Vincent Fremont were shooting what were known as *Soap Operas* – in other words, Andy's version of soap operas – and I was doing a photo project of my own where I shot soap-opera stars and then put different colored gels on top of the photos according to the emotion: green with envy, tickled pink, blue was sadness, red with anger, and so on. By the end of the project about three months later, Andy and Fred Hughes asked me to work for *Interview*, which had just started up in 1968. Glenn O'Brien and myself did the whole magazine alone from 1972 to

1973. Totally insane. And then in 1973, Andy and Fred pulled in Rosemary Kent, and Glenn and I decided to leave. Fred and Andy didn't want me to leave, so Andy asked me to be his assistant. I said, "Great, that's all I ever wanted to do anyway, because I'm not a magazine editor; I hate deadlines." I hate magazine deadlines, not art deadlines. I worked as Andy's assistant from 1972 to 1982.

Tell us a bit more about the soap opera pictures.

I was shooting soap opera pictures directly off the television, and then putting colored gels on top to parody emotions. Soap opera actors are so bad; they're like silent film stars. They make these exaggerated facial gestures. When everybody was all down and out, I would make a big print and then put a blue gel over. And then green with envy, when someone was screwing someone else's lover. "How dare you touch him? He's the man of my dreams."

> Andy asked me to be his assistant. I said, "Great, that's all I ever wanted to do anyway, because I'm not a magazine editor; I hate deadlines."

While I was working on this project, I found out that Andy was working on a soap opera and Vincent was shooting it. So I asked if I could come up and do some stills. I started going up three times a week to spend time on the soap opera sets with Brigid Polk, Charles Rydell, Maxine McKendry, Daryl Foyes, and that whole

Torso, 1977. Synthetic polymer paint and silkscreen ink on canvas, 50 x 42 in.

gang; they were wonderful. And then some pretty young things that Vincent or I would find to drag in and be the little heroines.

Andy did collages with torn Color-Aid paper and silkscreened over them. Did that have anything to do with the colored gels?

My gut instinct is no. The collages Andy created are more a mix between the fine line of Cocteau and the paper tearings of Matisse. Matisse was Andy's favorite artist. Collage is an easy way to make a background. It looked artsy because we didn't cut the paper, we tore it, so you get that "artsy" edge. It had all the elements that Andy was into to begin with: Matisse, Cocteau, artsy looking stuff, and easy backgrounds. The backgrounds had an immediacy to them—you didn't have to think too much or get too involved in them. You could just tear paper, and that's very impersonal.

Andy employed assistants in the early days to help him with his projects like spot-water-color work for the late 1950s butterfly prints. Did Andy ever employ you to do watercolor handwork on any of this pieces?

My first job was to hand-paint four thousand Japanese flower arrangement prints. I painted around thirty-five hundred of them or something. *Hand Tinted Flowers*, I think, was their official name. I've always been good at watercolor.

You once mentioned to us that at first, you painted a bit tentatively because you were afraid you would ruin the prints.

Well, it was Andy's art, and I was too precious about it at first. I was a little frightened by it. I didn't want to screw up his art because he was a big-time artist and I was an assistant. It scared me to paint on something that was worth a lot of money. So I was a little coy about it. I would paint slowly and carefully. Instead of giving a long, watercolor stroke (which is how you paint watercolor: you take chances and you let the paint take over intuitively), I was trying to follow the line of the silkscreen and paint up, and of course I was getting choppy little marks. Andy came in and said, "Ronnie, I've seen your work, I know you have a line. Where's your line? Just go for it." Then I loosened up and finished them the way I would paint my own work.

How did that series come about? Why was it specifically a Japanese floral arrangement?

I guess it was a variation on the theme of his earlier flower paintings. I went out and got Japanese vases and fresh flowers every day. I arranged the flowers. One of my hobbies was Ikebana, which is Japanese flower arrangement and one of my meditative hobbies for the totally insane New Yorker going to the Mud Club

every night. It was fun going out and getting beautiful fresh flowers every day. And it did center me. I had to be very exact and loose at the same time and make these flower arrangements and photograph them. Andy would come in and pass by the room and say, "Oh, look at that flower over there." And he'd move it after I had spent twenty minutes on its placement. Then I'd say, "All right,

…In Andy's psyche, abstract art was real art and what he did, or what any figurative person did for that matter, was not.

Bozo. Maybe you're right, OK." We'd play back and forth like that. And then we would make black silkscreens on white paper, and finally we would hand-tint them.

You've mentioned that Andy wanted to become an abstract artist. Can you explain that a bit?

The well-known artists who came directly before Andy were all abstract painters. They had the reputation that their art was the *real* art. So in Andy's psyche, abstract art was real art and what he did, or what any figurative person did for that matter, was not. Artists like Andy and Roy Lichtenstein rebelled against abstract art because they had to make their own territory and their own name. Every artist has some source of low self-esteem, and

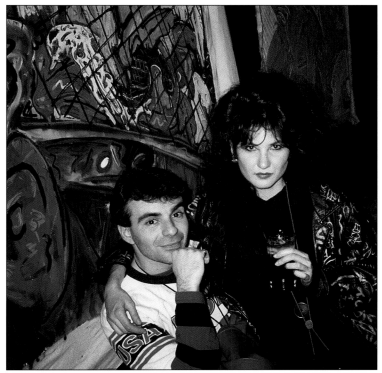

Ronnie Cutrone and Tama Janowitz, 1985.

57

Skull, 1976. Synthetic polymer paint and silkscreen ink on canvas, 15 x 19 in.

abstract art was Andy's. He always had an inner struggle between being a pop artist and being an abstract expressionist. What you rebel against you usually have to know and appreciate.

The early footprint canvases were rather abstract in their way. In 1961 or so, Andy used to walk outside of his townhouse, put down a piece of canvas, and run back into his house like a wacko. People would walk by and leave their footprints. Once he thought the composition was right, or once he was *brave* enough to run out again, Andy would come out, pick up the canvas, and take it back in. Those canvases were wild. They were like the *early* piss paintings, which were just white canvas with one stain of urine. Andy was always trying to do something abstract, which would torture Fred. In Fred's mind, if Andy did something abstract, it didn't bring home the bacon. It was time to get serious and get something we could sell to keep *Interview* going and make sure all the salaries were paid.

Do you see things like the footprint paintings as more experimental than the more popular, "salable" paintings?

Yes. There are always two sides to an artist. There is the thing that he or she gets known for and has to keep doing and doing and doing in order to survive. Then there is the other side that is constantly looking for new ideas. It's a more conceptual side, a more experimental side, a more rebellious side. It's almost like rebelling against oneself. A good artist always has to rebel against something—the previous art movement, the government, a popular vision. After a while, you just start rebelling against yourself. I think it's a healthy thing always to be questioning, to be looking for the next thing, to maintain some enthusiasm. There are so many artists that just paint by rote: they know what they do, and they paint it over and over and over again. That's good for the collectors and the public, but it's sad for the artist.

Again, you have to remember, during that period, abstract expressionism *ruled* American art. America made its dent in the art world by getting big and abstract. It moved away from European art, which was small and basically figurative. American art was another daring step for Andy to say, "Everything is art." There was only one European at the time doing that, Joseph Beuys. So Andy and Joseph Beuys were in a way counterparts—the European version and the American version.

In 1969, Andy asked me, "Who's your favorite artist?" And I think he was hoping that I would say him. But at the time, my favorite artist was Joseph Beuys. That changed—today Andy is my favorite artist. But back then—you should have seen Andy when I answered him. His face just dropped. I crushed him and I didn't mean to. I was just being honest. But it's interesting that both Andy and Beuys made a dent in the art world by saying, "Look, anybody could do it; we're all artists." In contrast, the abstract expressionists said, "I paint this because I *feel* this." The logical reaction was to say, "Oh, I don't feel anything. I'm a machine, and anybody could do this."

Andy was one of those brilliant, wonderful artists; he was an artist's artist. He was a person about whom other artists thought, Wow, he's still trying. I've heard young kids say, "I can't believe that he's as famous as he is and he's still trying." That kind of obsession, if you will, or experimentation is what keeps an artist mentally alive. Andy had that. He was a great artist.

What are some of the earlier experimental pieces that you remember in addition to the footprint paintings?

Well, in the mid-1960s, Andy had a stamp that said *Andy Warhol* in cursive writing. And I thought that was just brilliant. Andy was stamping out things, much like a Zen Buddhist or a pop icon. And the stamp itself for me was a piece of art because it was so far away from abstract expressionism, from precious art. It was a *rubber stamp*, and anything it hit, it made into art or made valid in a way. The stamp was really a continuation of what he was already doing: to stamp things, to silkscreen things, to manufacture them, to assembly-line them. It was actually the most pure extension of that idea. I think it was the predecessor to a lot of the conceptual art just to say, "I am, I'm here, I was, I exist." Just the pure name. I say it's art and, boom, it's art.

It reminds me of merchandising today, except this particular kind of merchandising is from the perspective of an artist.

Well, Andy always had his hand in the advertising world as an illustrator—from I. Miller in the 1950s to Perrier in the 1980s. So he was able to comment on American culture from that viewpoint. He was a visionary, ahead of his time. He got dissed a lot for it, but all great art appears ugly at first or difficult to understand. It

wasn't way out or kinky or crazy; it was perfectly logical. If you were going to make art from a vantage point of once having marketed for I. Miller, it's the next logical step.

There was all this great stuff around the Factory that wasn't really art. There were the inflatable silver pillows that Andy insisted he show at Leo Castelli's. I'm sure Leo was upset, because he couldn't sell them. But the show got some publicity. Andy had said he wanted to end his painting career with those silver pillows, to let them fly away from the rooftop, but they didn't really fly away. It was a grand gesture; he was a master of the grand gesture. Andy hated to paint. Painting is really hard work. Your muscles ache, your eyes blur. It's the second loneliest profession; the most lonely would be writing. Andy was a social animal, and so he hated to paint. He was an idea man: once you have the idea, then you have to execute it, and that was just a drag for him. At the same time, he had this other stuff lying around, like big four-foot to six-foot inflatable Baby Ruths, large banana stickers. Anything he liked he just went out and did. The Cow Wallpaper, which turned into art, was really just wallpaper. It had acid in it, and after a certain amount of time, it would deteriorate.

You know, using the Yellow Pages turns out to be sometimes the best art tool. The *Baby Ruths* and stuff were things that I liked to call "Done from the Yellow Pages." You call up an inflatable factory and say, "Make me inflatable Baby Ruths." Or you go to a wallpaper store on Long Island and say, "Oh, let's do this image on wallpaper." It was very exciting to go up to the Factory and know that this man has some real masterpieces. He has *Marilyn Monroe*, the *Electric Chair*, the *Flowers*, and so on. But he also has *Pee Wee's Playhouse* kind of experimentation and great stuff that is a logical extension of his art. It showed a certain intensity and expressiveness to me that I always liked about him.

Andy had said he wanted to end his painting career with those silver pillows, to let them fly away from the rooftop, but they didn't really fly away.

Andy remarked to me many times that he wished there was an outlet for all the excess stuff that he had made and collected. He wished that he could be a shopkeeper and sell it and make money. Did he ever mention that to you?

Yes, but we used to fight a bit about his stuff. I would say, "You know, you're going to end up like the Collier Brothers. And there is going to be a cave-in, and you're going to die under all your stuff. It's getting out of hand." Here he was, one of the top artists in the

Suicide (Detail), 1963. Synthetic polymer paint and silkscreen ink on canvas, 81 x 79 in.

world, and because of all his stuff, his painting space was six feet by six feet! I've never known any artist in the history of art to have a painting space six feet by six feet. He collected everything and finally out-collected his painting space. I was vying for more painting space because there were two of us on top of each other crawling over each other all the time. And I'd say, "Andy, you have to clear this stuff out." Because like me, Andy loved blank walls, empty spaces. But like me, he could never have empty space because he had too much stuff. So again, another inner struggle of empty space-age space on the one hand and the clutter of masterpieces on the other. It's always that sort of polar distinction that keeps somebody down. Andy was an extremist like me. Give me an empty room or give me a room that's filled with all of my favorite things, including big boxes of chocolates and cookies. It's that kind of insanity that some artists have to deal with.

Speaking of masterpieces, I know that in your mind there must be a particular painting that you really consider to be one of his true masterpieces.

My favorite painting by Andy is *Suicide*. It has dark and light, extremes, and the painting is divided on a diagonal. In between the good and evil, the light and dark, is a man. And in this case, he happens to be falling to his death. He's suspended between those two forces. That says it all to me.

It's the most simple painting. It's about life and death. A lot of Andy's work revolves around that subject. The Marilyn paintings are about life and death, the Flowers are with their black, menacing background. Not the watercolor flowers – there is nothing menacing about those flowers at all. I'm talking about the first Flowers from 1964 – they are a bit menacing. We kids – Andy used to call everyone a "kid" until they were eighty-five years old – all knew that. Lou Reed, Silver George Milloway, Ondine, and me – we all knew the dark side of those Flowers. Don't forget, at that time, there was flower power and flower children. We were the roots, the dark roots of that whole movement. None of us were hippies or flower children. Instead, we used to goof on it. We were into black leather and vinyl and whips and S&M and shooting up and speed. There was nothing flower power about that. So when Warhol and that whole scene made Flowers, it reflected the urban, dark, death side of that whole movement. And as decorative art, it's pretty dense. There is a lot of depth in there.

The Flowers are the weirdest decorative art I've ever seen. You have this shadowy dark grass, which is not pretty, and then you have these big, wonderful, brightly colored flowers. It was always that juxtaposition that appears in his art again and again that I particularly love.

Did you encourage Andy to do the Shadow paintings because he was still wanting to paint in an abstract manner?

Yes. Andy had a burning desire to do abstract art. Although he abandoned different experiments with it, he still wanted to do abstract art. So I said, "Look, if you're really serious about this, when I was in art school I had all these ideas that I'll never do. You know, I don't worship abstract art because I grew up in a different generation." Andy said, "Well, what are they?" And I said, "You're Andy Warhol; you should paint something that *is* something, but it's *not*." He said, "Oh, come on Ronnie. What do you mean? Come on." And I said, "Well, you should paint shadows. You love shadows anyway. They're in all your work. I've got this notebook. I've got drawings of nothing in it, drawings of shadows that things cast." Andy asked, "You mean like real objects casting

We were into black leather and vinyl and whips and S&M and shooting up and speed. There was nothing flower power about that.

shadows?" And I said, "No, that's too figurative. I'll show you. I'll cut up different things, pieces of cardboard, I'll throw shadows on white seamless and treat them for you." He said, "Oh, good, start today."

I had 150 shadow photographs on contact sheets twelve days later. We picked some of them out and then he asked me to mix the colors for them. So I mixed aubergine and chartreuse and carmine red and yellow and midnight blue, like Yves Klein blue, and white (you don't mix white but we did white paintings). Andy and I always shared the same color sensibility so that part was never difficult for me. I'm my own artist, but I would go to work for eight hours a day and think, "What color would I mix if I was Andy Warhol?" It was a game to me. The game was never to be influenced by him so that it would seep into my own work. I was very proud and protective of Andy and at the same time very loyal to him. I would always think, "What would not shame him or embarrass him? What's a good color? What's a good likeness?" But I never took the work home with me; I was always able to separate it – Warhol for eight hours and then home and my own work for six hours. Completely different work.

I was always happy that I could be part of making this great art. Because Andy was so detached from his work anyway, it was easy to be a part of it. We could both detach from the art and play a game. It was healthy for both of us. I never ran around saying, "I did Andy Warhol's art," because the art had a life of its own and we both just served it in some way.

How were the Shadow paintings received when they were exhibited at the Heiner Friedrich Gallery in 1979? Did you have to exhibit them in any specific manner?

Shadow, c. 1978. Synthetic polymer paint and silkscreen ink on canvas, 76 x 52 in.

Well, Heiner Friedrich, the dealer, bought the whole kit and caboodle of them: he loved them, felt that they were important. We did the show at his space on West Broadway. People were very curious, to say the least. The idea worked. It was in keeping with the mystery of Warhol, the paradox of Warhol, the shadowy life/death imagery of Warhol, the decorative quality of Warhol. They were large paintings, and they were installed butted up against each other, one after the other all around the space. I did the installation and Steven Mueller helped me. Steven Mueller is an abstract

I'm my own artist, but I would go to work for eight hours a day and think, "What color would I mix if I was Andy Warhol?"

painter and a very good one – it was interesting to do the installation with an abstract painter. We did it according to shape and color, like you'd do anything. It turned out to be a really strong show. The paintings were beautifully displayed right next to each other – boom, boom, boom, boom. We would think, Well, the aubergine is so dark and menacing, we could butt it up against yellow and make it look like Easter. Or we could keep it menacing. It was like being an abstract painter: You have eight zillion choices and you land on one or two by instinct, and somehow you create an installation that ends up working.

Were the Shadow paintings from the same period as the Skull paintings that also had shadows in them?

Shadows opened in January 1979, but the Skulls were earlier. The Skull paintings and the Hammer and Sickle images were done in 1976 to 1977, I believe. My chronology may be a little rusty. Andy came back from Paris in 1976 and handed me a skull. He said, "Shoot this, do pictures. I want to do this. Do you like the idea?" I said, "Yeah, it's like the classic still life; only there won't be anything else, there will just be this big skull – and it's everybody's portrait in the world."

So I shot the skull, and the photo that we landed on was Andy's favorite as well as mine. In the photo, the shadow that the skull throws looks loosely like a baby's face – a big bald cranium, little nose, and healthy cheeks. I didn't mean to do it – it was one of those art mistakes that happens when you're working and working and you come across something that you didn't know was there. I pointed it out to Andy. The baby's face didn't seem to matter much to him; he just said, "Oh, yeah, that's really wild." He didn't really have too much emotion about that. The Skulls had spongemopped backgrounds, which was new, as did the Hammer and Sickle paintings.

The hammer and sickle was such a strong image. How did Andy come to choose it?

Andy had just come back from Italy with Lucio Amelio, who was his and my Italian art dealer, and he had noticed that all of the Italian graffiti was from the Socialist Party. There were red hammers and sickles painted all over these spartan white Italian walls. And he thought, "God, that's a big icon." But it was also a very risky thing for an American artist to do. You could have been called a pinko. Well, McCarthyism was long since dead by then. But still, the idea of an American collector saying, "Gee, I want a giant hammer and sickle painting in my living room," was ludicrous.

Andy needed something to work from, so I took out the Yellow Pages, my favorite art tool, and found out where the communist bookstores were in New York. There was one by Union Square and several others in the twenties, I think. Every day, I went to communist bookstores and spent half the day looking for the hammer and sickle symbol. I bought some books and took them back to Andy. But the symbols were flat, stenciled. And I thought, Well, maybe I could find something that had more depth to it, like an etching or an engraving. But that wasn't too successful. Then eventually, one of us said, "Well, let's just buy the hammer and sickle and take photos of it." So I went down to Canal Street and got a sledgehammer-ish hammer, a short one. And I found a sickle that had the word, "Champion," engraved in it, which I thought was really cool because it Americanized the idea of communism and made it more banal, even more banal than the twelve thousand images plastered all over the walls in Italy.

I never ran around saying, "I did Andy Warhol's art," because the art had a life of its own and we both just served it in some way.

So I brought them back, cast large shadows on them with side lighting, and shot them. Then we did the paintings with a sponge mop – big, white, thickly painted backgrounds – and then we screened over them in red and black or just black. To me, those paintings were successful because they just weren't very communist; they weren't so dead-end. There was something architectural and almost semi-abstract about them.

You mean sculptural?

Actually sculptural *is* more the word. They looked like they could be an amusement park ride somewhere, in Disneyland even. The hammer and sickle.

Halston's boyfriend, Victor Hugo, had the original hammer and sickle. He had Andy sign them and then put them under Plexiglas. Just two objects crisscrossed under a Plexiglas box, but it looked fascinating.

It's the personal stuff about an artist that I love. The best Van Gogh show I've ever seen was at the Brooklyn Museum. The show had all Van Gogh's masterpieces and then one hall called "Sources," which was filled with his Japanese postcards and political cutouts. And it was brilliant to see how his mind leapt from Japanese postcards to his landscape paintings. At first, you thought, "Where is the connection?" And then you would get it, and you'd exclaim, "God, that's brilliant."

It's the same with Andy. The painted aprons, the signed real Campbell's soup cans, the stamps, the bananas, the silver pillows, the rain machines, the snow machines, the wind machines— all that stuff was the source of what are now known as the masterpieces.

Explain a little bit about the weather machines.

During that period, I didn't spend a lot of time at the Factory, but I would go up for screenings. Andy was very into movies already, but he was also making these machines. They were very technological and naive at the same time. They were essentially big aquariums that made rain, snow, or wind, and maybe some other element. They were weird: "Andy Warhol Does the Four Seasons." It was a very classical thing done in a totally weird way. They were early predecessors to something like Jeff Koons's basketball in an aquarium.

One of the things he did besides the rain and snow machines was the Invisible Sculpture *installation. Tell us about that.*

That was truly brilliant; Andy wanted to make the Invisible Sculpture. I don't know what the inspiration for that was. He may have watched *The Invisible Man* one night on television. So again, we got out the Yellow Pages and found burglar alarms, different systems. Some with sound, some with light beams. They were all different looking and sculptural because they had different shapes and different systems. We mounted these burglar alarms on brackets all around the perimeter of the big room in the middle of the Factory, which was by then referred to not as the Factory but as Andy Warhol Studios. And we aimed them all at the center of the room where nothing existed.

If you walked into the room and you hit this center point, all of these alarms would go off. You'd have every different kind of sound; chirping, booming, buzzing. It was funny. But it was also a kind of existential abstract question: If a tree falls in the forest and there is nobody there to hear it, does it make a sound? Is there

Still Life (Hammer and Sickle), 1976. Synthetic polymer paint and silkscreen ink on canvas.

something there if you can break this "space" and trigger off these alarms? It was a brilliant conceptual work but also very physical because we actually had the mechanical alarms. It was like a kinetic sculpture in some way: a sound sculpture, a light sculpture. But there was nothing there; it was totally invisible. We're again in the great Warhol scheme of things: it was something that *was* but *wasn't*.

The Invisible Sculpture stayed up for a long time, but it was experimental really. We only had it activated for maybe a month. It used to drive Fred crazy; it was almost like a practical joke. Andy and I would drag somebody in and say, "This is the new art; go stand in the middle of the room." And they would, and all the sirens would go off. Then Fred would come and say, "Andy, I'm *on the phone*." Or Brigid would yell. Everybody would yell because Andy and I were constantly having people walk into this imaginary space.

Did the Invisible Sculpture lead to other art works?

It was a successful experiment. And then eventually, all the alarms got unscrewed from their brackets and put into boxes in what were known as the Time Capsules, or the TCs.

Which reminds me, Andy always wanted to do a show at Leo Castelli's where he would just build shelves, wooden shelves all around – very uniform, beautiful wooden shelves. All the stuff he collected would go into eighteen-by-twenty two inch boxes. There would be rows and rows and rows of them. They would contain his mail, some of which he didn't read, some of which he read; letters from friends; junk mail; pieces of candy. Everything under the sun that came in would go into the TC box of the week or the month. Andy then wanted to blind auction them off. A collector would come in and say, "Give me number 32." And what you buy is what you get. I said, "Andy, that's going to be perceived as being a rip-off. What you should do if you're actually serious is a show with around 250 boxes. Then make 250 little line drawings, just simple line drawings, and we'll put one in each box. So when a collector buys it they're getting a tiny little line drawing, and then whatever crap you've collected." And he said, "Oh, that's such a great idea. We could really do that, couldn't we?" But I guess it never panned out, probably because Leo and Fred said, "Go home. It's not going to work." I thought it was a fun idea. The point was to get rid of the stuff – to be the shopkeeper and sell everything.

Andy couldn't let go of anything. It was probably some fear that could have been worked out in therapy, but thank God it wasn't because it made him who he was. Certain idiosyncrasies and neuroses I think one should hold on to because they make you who you are; the destructive ones you should probably let go of.

Ronnie, were you around when Andy did the sex paintings? I think they call them Torsos now. And the prints known as Sex Parts?

Guns, c. 1981–82. Synthetic polymer paint and silkscreen ink on canvas, 16 x 20 inches.

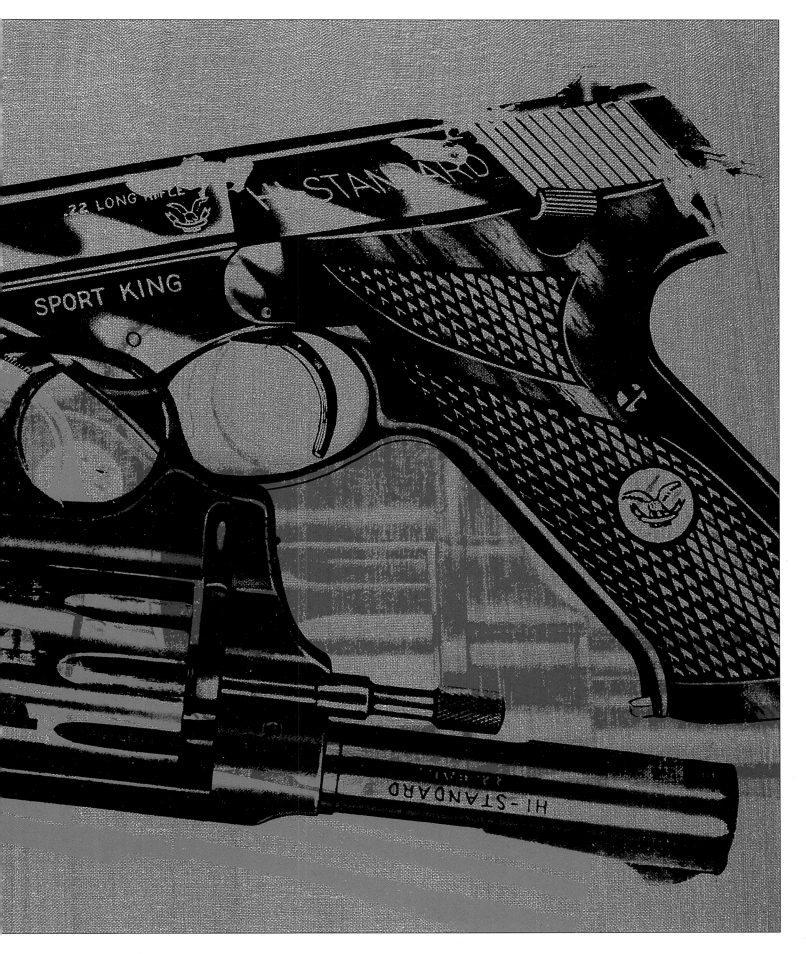

I brought in the drag queens for the drag queen portfolio, *Ladies and Gentlemen*, done in 1974 or 1975. I tried being a queen once; I did, I tried to be gay. A young straight guy could never get laid. I figured, "I've got to have sex," so I tried being gay. Half of my friends at that time were gay, so I thought, "Why not? This is great." And then I couldn't do it. I was such a miserable failure. I couldn't get it up, or I just wasn't doing it right, or I wasn't attracted. I was a failure. So I became a dyke and got all the girls. I'd hang out at Pam Pam, which was a restaurant on Sixth Avenue close to the Women's House of Detention. That was when girls were girls: Olga the Terrible and Sonnie and Butch, all these *real* lesbians. I hung

Andy couldn't let go of anything. It was probably some fear that could have been worked out in therapy, but thank God it wasn't because it made him who he was.

out with all of them for years. My ex-, ex-wife, Gigi, and I used to hang out at the Ramrod. She was the only woman on the whole waterfront let into the gay bars at that time. And the bartender would give us tons of free drinks. They all loved Gigi. So I had easy access to all the transvestites. At 3 in the morning, I would chase a transvestite down the street, yelling, "You're wonderful; we want you to pose for Warhol." And she'd be running away, looking at me, Was I going to bash her or cast her? And I'd say, "No, no, no, I'm serious." So I got models for the drag queen series.

But Sex Parts, as they were called, really took a guy who knew how to hang out at the baths. That just wasn't my scene, but Victor Hugo did that really well. He would recruit people from the baths in those days. I was there for all the shootings but not for the recruiting. The choreography was basically strip and make yourself comfortable. Andy was a very shy, coy voyeur. He was like, "Oh, oh, oh, that's so great. Oh, what can it do? Oh, what a big one. Boy, I wonder how it would look stuck in there?" That kind of manipulation. It was *so* weird and so innocent at the same time—just like all of Andy's sex. There was that period at the Factory when it was just boys and I would bring girls up to piss all over the Oxidation paintings. And there would be guys sucking and fucking, and Andy would be taking pictures. Later they euphemized the series and called it the Torsos. It used to drive Brigid Berlin nuts. Brigid could go from being the most insane person in the world to a conservative, homophobic, right-wing Reaganite in a matter of four seconds and then back to a total maniac.

Still, there were times when, even in my opinion, things would go a little overboard. I mean, Christopher Makos would come up with five wanna-bes, and it just got to interfere sometimes with

office work and some of the other painting. Very rarely did it bug me, but there were times when I thought, "Oh, my God, we have one of *those* shoots again. Here we go." We'd be right in the middle of a project, he'd give me five things to do, and then we had to "entertain" these guys.

But overall, I loved it. We would set up a giant canvas in the back room against the wall, and guys would come in with their combat boots. Gay men at that time had suddenly turned butch. They wore flannel shirts and cut their hair short and wore combat boots. Before that, scarves and stuff were in. That was the mid-1970s; there was a big war among the gay community about who was being effeminate and who was being macho. So they'd make their paintings with boot marks and urine stains. Then I would bring up a woman, who would piss a puddle and Andy would say, "Oh my God, she doesn't have a brushstroke, Ronnie." And Fred would repeat, "This is getting *out of hand*, Andy." Mind you, *Interview's* office was just the next room over.

Was Sex Parts exhibited as a show?

The prints were called Sex Parts, and the paintings that were exhibited were called the Torsos. Sex Parts was really Andy's personal portfolio. He did a series of about a hundred or so of each of those prints. But we always understood it was going to be one of those portfolios that would sit primarily in the back room; that it would take a certain type of collector to appreciate them, let us say. It was something that Andy needed to do. After years of voyeurism, he was garsh darn it going to make a print series out of it and make portfolios. I love an artist's sexuality when they get confident enough or stop worrying about it. But Andy was Catholic *and* a homosexual—that's a lot to carry. For years the joke was that Andy called homosexuality a "problem." So when he liked a new young boy coming up to the Factory, he would say, "Do you have a problem?" I think Sex Parts was a final announcement or affirmation of his homosexuality.

Andy and I would drag somebod in and say, "This is the new art; g stand in the middle of the room. And they would, and all the sirens would go off.

Were the Torsos a cleaned up version that would have mass appeal?

Yes, they were much more tame. But the Torsos were really the unspoken word. Of course, Andy Warhol was gay. Of course, the focus would have been on beautiful male forms or a hard dick.

Didn't those paintings end up appearing in American Gigolo, *the Richard Gere movie?*

Yes. They were hung in the drug dealer's living room, actually.

Let's talk about Andy's later period.

For me, his later art was like a lion without teeth. I think had he lived he probably would have made some great stuff again. But he

Brigid could go from being the most insane person in the world to a conservative, homophobic, right-wing Reaganite in a matter of four seconds and then back to a total maniac.

didn't, so we'll never know. He had some of the wrong people giving him advice or no people giving him advice. Maybe he was in love too during those years, and love makes you really weird. Maybe he just wanted not to offend people and just got pasty and quaint and loving.

I have a theory; I don't know whether it's really true or not, and I'm probably really going to get dissed for this. But my theory is that homosexual artists are much better than heterosexual artists in their youth. Then later on in life, they usually turn into these old grandmothers and make really delicate art. In contrast, heterosexual artists somehow get this power or something about them in older age. Maybe they don't care so much about pussy anymore or something, and they pull out the stops and make great art. For instance, Jasper Johns makes this old grandmother art now. Young Jasper Johns you cannot beat. Or young Tennessee Williams compared to old Tennessee Williams—the stories just get blander and blander. I'm not saying that art is either masculine or feminine. I think great art is neither. It always has both of those elements at once. But I think homosexual art gets very effeminate or grandmotherly when a homosexual man or woman gets older. And a young heterosexual man just doesn't have the connection with his masculine and feminine sides to make really great art early on.

It could also have something to do with the effects of fame.

No. I really think that later on, there was too much pampering going on. There's an image of Truman Capote in later life: he doesn't have shoes on, and you see these really horrendous baby fat little toes with no character to the feet. Inflated little feet. And that to me reflects the state of his mind: a doughy personality.

In his later period, Andy *was* love obsessive. When he would become obsessed with a new man, he would use holidays or any excuse to court him, make him lots of what I would call second-rate or even fourth-rate paintings—hearts on Valentine's Day or paintings of boxes of chocolates. And I seem to remember on February 14, he'd make you fourteen paintings of hearts or something like that. There were lots of them. You would spend days and days making somebody's Valentine present. I'm not as obsessive as Andy, but if I really like a girl, I'll make her a watercolor or something. What an artist can give is what he or she does. But Andy would just take it to the max. He would go overboard in obsessive fantasy and romantic love, which he claimed he didn't believe in.

How would that affect his art?

I believe it took him away from some of the main projects that he would be thinking of or working on.

But the Still Lifes were great. Andy wanted to update still lifes. He asked me to go out and buy things that would be good for Warholian still lifes. I thought of funny things like little fish bowls, toilet plungers, cheese graters—really mundane, almost silly objects. And then we would put his book, *The Philosophy of Andy Warhol (From A to B and Back Again)* in the middle of it. The book itself became part of the still life. So there would be his book with the still lifes. They were sort of philosophical in a sense, about things being mundane and almost comical and at the same time more important than maybe they really are. That's why I'd pick things like toilet plungers or yo-yos or whatever the silly item might be.

For me, his later art was like a lion without teeth. I think had he lived he probably would have made some great stuff again. But he didn't, so we'll never know.

If there was one thing that you think Andy should be remembered for in "The Big Book of Art History"—an idea, a painting—what do you think it should be?

I always say one thing, and it's the weirdest thing. What impressed me most about Andy was his belief in God. It's the one thing that really sticks in my mind. I think when an artist believes in God, he knows he's not God and that makes him a better artist and a much more humble person. I remember one time, Andy and I were doing an interview with a French journalist. I was just being his walking stick, sitting next to him during the interview. And she

said to him, "You were once quoted as saying you don't believe in anything. Is that true? Do you not believe in anything?" Andy was the coolest man on earth, at least during interviews; he would never, ever lose his temper. But he took this as a threat – maybe it was, maybe it wasn't. And he turned totally red in the face. I was shocked. Andy said, "I never said that." The journalist was taken aback because nobody expected Warhol to have such strong emotions. She said, "Well what do you mean?" And he said, "I never said I don't believe in anything. What I did say was look at the surface of my paintings and there you'll find what I'm saying. But I certainly do believe in things." And then she asked, "Well, what do you believe in?" He knew he was hemmed in. But he just straightforwardly said, "I believe in God." And then he realized what he had said, and it was almost like, "Man, he just shattered the whole image." So he added, "And I also believe in Ronnie." It was his second thought. On some level, I believe he said that because I was newly sober and making my way into the art world, and he was very supportive and loving and generous. So it was a half truth, but not appropriate for an interview.

It was a foil.

Exactly. He just out and out red-faced and furious told the woman that he believed in God above all else, and don't ever say that again about me because I'm sick of it. I'll never forget that day. It was the first time he ever in public just rolled out of his shell and took a stand.

The last major paintings during your time at the Factory were the Dollar Signs along with the Guns and Knives. Can you tell us about that installation?

It's my opinion that with those paintings, Andy was doing another variation on his love of money. By then Rupert Smith, his silkscreen printer, was well into the swing of things and could

What impressed me most about Andy was his belief in God. It's the one thing that really sticks in my mind.

rainbow roll his way into anybody's heart. So he rainbow rolled up these big old Dollar Signs, and they were interesting; I never thought that they were great works, unlike the earlier Dollar paintings, which I thought were brilliant and really well crafted. They were hand painted versions of the real bills not just the symbol.

At the same time, he also made big, beautiful paintings of butcher knives and guns. He sent everything down to Leo Castelli's

– the Dollar Signs, the Butcher Knives, and the Guns. And he said, "Ronnie, go down and install them." And I did. I made what I think was a beautiful installation: three or four Dollar Signs, two Butcher Knives, and a Gun. The paintings were sporadically arranged around the room, and Richard Serra walked in and commented, "Whoa, this is great. It's like being mugged. I love it." Leo said, "Oh yes, Ronnie, it looks really great." Fred Hughes walked in still drunk from the night before and said, "Oh, this will never do. It's too European." And I said, "What do you mean?" He said, "Well, let's just use the Dollar Signs." I said, "Fred, I think you're dead wrong. I've worked really hard. Before we do anything, let's call Andy." So I called up Andy. At this point, 1982 or so, Andy just didn't care anymore. Maybe he was obsessed about somebody romantically and just didn't care, or maybe he just didn't care. Maybe his spirit was a bit broken that year. Anyway, I had a little argument with him. I said, "Andy, don't you care? This is your art. Come down and look at it. Richard Serra and Leo love it. And Fred is still drunk and he's talking about changing the whole thing." Andy just said, "I don't want to fight anymore, Ronnie. Let's just let Fred do what he needs to do."

So the Dollar Sign show went up as the dollar sign show. All the critics panned it, it didn't sell one painting, and the paintings all came back to the Factory.

I remember one critic said something like, "Warhol's been accused of doing nothing before, but this is really *nothing."*

That was heartbreaking for me. I get no satisfaction out of being right. The show could have been great; he could have gotten some good reviews. And maybe somebody would have bought a block of them – two Dollar Signs and a Knife and a Gun or something – for their private collection. But we'll never know because it never happened.

Fairly soon after that, I began to give up, too. I thought, I really have to go off and make my own art and let Andy do what he needs to do. I respected him still. If he never made another piece of art, he had certainly done enough. But it was time for me to move on. Soon after that, I got a divorce. I told Vincent I was leaving. They threw me a going-away party with a stripper, a dial-a-stripper. Andy was really loving. He said, "You know Ronnie, I know it will work out for you." It was the strangest thing: I had told Vincent I was leaving, and Vincent had told Andy, and Andy and I had worked side by side for two weeks and had never said a word about it. It was like getting a divorce without talking about it. And I knew that was the way Andy would have to do it. It was too sad a parting. We didn't talk.

And on the last day, after the stripper left, he said, "You're always welcome back here if it doesn't work out for you, but I'm sure it will. You should have left here five years ago; you're a great artist." And that was the end of it.

Crosses, c. 1981–82. Synthetic polymer paint and silkscreen ink on canvas, 20 x 16 in.

Vincent Fremont

On Andy Warhol's Video Ventures

Vincent Fremont started working with Warhol in 1969. He became the studio manager and vice-president of Andy Warhol Enterprises in 1974. Vincent also acted as a contributing editor for *Interview* magazine in the early '70s. He worked on video ideas throughout the '70s, and went on to produce *Andy Warhol's TV* and *Andy Warhol's Fifteen Minutes*. He became executive manager of Andy Warhol's Studio in the early '80s. Vincent was a founding director of the Andy Warhol Foundation for the Visual Arts, Inc., and for the past five years, he has been the Foundation's exclusive sales agent. Vincent also works with various other artists as a dealer and art advisor.

You began working at the Factory in the fall of 1969. What was your first position?

I was a freelance writer for Andy. I was in a group called The Babies with two of my friends. We looked like an L.A. rock-and-roll group, but we didn't play any instruments. We had ideas, we were conceptual. My friends had met Andy six months earlier when they had first come to New York. In the first three days of being in New York, we went up to visit Andy. I wanted to learn about film from Andy. I started by reading scripts for him and writing and then I later began to work with video.

Can you tell us about some projects that were being videotaped in the early '70s?

Well, I was working on some ideas. All we did in those days was develop ideas. Andy was not interested in getting on cable television; he was more interested in pursuing ideas. I worked on some early videos with Ronnie Cutrone in the early '70s. Then I

started developing what became known as the *Soap Opera* project, using Halston models like Nancy North and Karen Bjornson. It was modeled after the film *Stage Door* and Andy's *Chelsea Girls*. As we added more people to the cast – Candy Darling, Maxime de la Falaise, John Richardson, and Brigid Berlin – Andy decided to call it *Phoney* (1973), a play on words – phonies and people who are always on the phone. Andy also wanted to develop a TV show about a couple continuously fighting. Andy and I cast Brigid Berlin and Charles Rydell in the tape that was titled *Fight* (1975). This tape and parts of *Phoney* were eventually shown at the Whitney in *Andy Warhol's Video & Television Retrospective* (1991).

> Andy also wanted to develop a TV show about a couple continuously fighting. We cast Brigid Berlin and Charles Rydell in the tape that was titled *Fight*.

Didn't you film a big dinner party attended by Halston, Bianca Jagger, Victor Hugo, and others?

No. We taped a dinner party at Maxime de la Falaise's apartment as a test for a TV show about people at dinner parties. Where you would have various guests talking over dinner. Unfortunately, everybody stepped on each other's conversations as you would in normal conversation, and you couldn't understand very much. It was a disaster. Later, when Andy, Bob Colacello, and I were pitching ideas to Metromedia, they took our idea and suddenly it

Andy Warhol with Brigid Berlin's dog, Fortune, c. 1986.

became a short-lived program in which the first one starred Bianca, Victor, Halston, and others. It was boring too.

Was this before or after the idea for the show that was called Nothing Special?

That was another idea that Andy had for the name of another TV series. There wasn't really a complete idea of what this TV series would be about, but we did various tests including monologues by different people, the best done by Brigid Berlin. Her monologue about money is one of the highlights. We also practiced with Brigid doing newscasts. I taped Paloma Picasso and Nicky Weymouth for a talk-show format, Angelica Huston and Joan-Juliet Buck as well.

Didn't you and Andy meet with Lorne Michaels from Saturday Night Live *about a project. Can you tell that story?*

I was working on a TV version of Andy's *Chelsea Girls* with Victor Bockris. We took the idea to John Head who was working with Lorne Michaels at *SNL*. At that time, they had one Saturday a month available for other programming and were looking for other people to fill the slot. Lorne Michaels came to the Factory to meet

Though the size of each of these studios differed, there really wasn't much of a difference – we just got older. Some came and went but a lot of us were "lifers."

with me, Andy, and others. Andy did not accept the proposal because he felt we were not ready to do a one-hour special. I was disappointed, but I realized Andy was right. If the show had been a disaster, Andy would have taken the blame since his name would have been used, and he had little control over the show. He was right not to get involved in the deal. Instead, Andy asked me to put together a video crew and learn about producing a TV show from the ground up. The art director for *Interview* magazine, Marc Balet, suggested I speak to a director, Don Munroe, who I hired to be the director for our TV shows and we built a team around him. Andy bought a broadcast quality Ikegami camera, and we started creating shows. We started on Manhattan Cable, Channel 10, and then Madison Square Garden network, and by the time Andy died, we had a series on MTV called *Andy Warhol's Fifteen Minutes*.

Was Andy angry about losing money in bad film distribution deals – Frankenstein *and* Dracula *and all the rest?*

Yes, of course he was, especially since we had a big lawsuit over royalties with Carlo Ponti over those films. I think the first personal financial beating he took was when he made *Bad*. After that film he stayed away from making films for a long time. He was just getting back into filmmaking at the time of his death. His interest in TV was a different matter.

Looking at television today, you can see Andy's influence. The interviews, the short clips. Andy Warhol's TV *seemed so innovative. It was active almost with the different cuts and takes – bits of a fashion show, bits of an interview, sound bites. How did Andy react to the finished product? Which things did he like the most?*

It depends on which of the three series we're talking about. Andy was very supportive of all of our TV projects. He had a very good eye for television, he loved it. The format and style of our show evolved from one subject for a half-hour to many segments, starting with our show entitled, *Fashion* to *Andy Warhol's TV* until our final TV series, *Andy Warhol's Fifteen Minutes*. The pace of the show changed, the segments moved faster and faster. As we created these shows we realized that the cable TV audience had a very short attention span. We started experimenting with the editing making some segments longer and some shorter. Sometimes it worked, other times it didn't. We burned out a few editors in the process.

What was it like working with the MTV people? Did they understand what you were trying to do better than the people at the other networks?

MTV was much better suited to our way of working. Unlike other cable networks who would use our ideas and ignore us, MTV listened. John Sykes introduced Andy, me, and Don to Bob Pittman, then the head of MTV and one of the founders. They liked our idea' of a show called *Andy Warhol's Fifteen Minutes*. Originally, it was going to be fifteen minutes long but because of advertising considerations, we made it a half-hour long. I don't know how the show was doing in terms of ratings, but we were getting a lot of fan letters. Andy really enjoyed being on MTV. He had gotten better and more comfortable in front of the camera by this time. We would script segment intros for him but usually his ad-lib versions were much better. We had some regular guests like Debbie Harry and Jerry Hall. Andy loved his blondes.

Tell us about the TV column that you wrote as a contributing editor at Interview?

I used to review TV programs from that period. I also did interviews with different movie stars of the day like Ron O'Neal from *Super Fly* and Tamara Dobson who was the star of *Cleopatra Jones*.

Andy as bartender on the set of the "Hello Again" music video for The Cars, c. 1984.

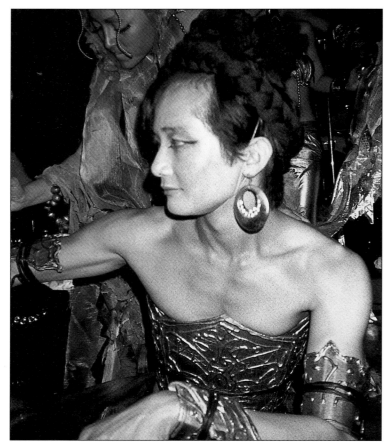

Ming Vauze (Benjamin Liu) prepared for a Warhol music video, c. 1984.

Brigid Berlin dressed for photo stills for Tama Janowitz's *Cannibal in Manhattan*, c. 1986.

I also did a series of video interviews with movie stars and personalities as ongoing TV ideas for Andy.

Pat Hackett wrote in her introduction to The Andy Warhol Diaries *that* Interview *magazine kept Andy from falling into '60s obscurity. Do you think that's true?*

That's one point of view. But I don't think Andy ever would have fallen into obscurity. He was always propelling himself forward. He never really looked back. He hated talking about the '50s unless you happened to be walking down the street with him and he bumped into a friend from that period. But he never talked about his artwork from that period. In fact, I've learned more about his artwork in the '50s since he died. Those pieces are absolutely fantastic.

Tell us about how the Andy Warhol Studio first started producing music videos.

Andy wanted us to be producing not only the TV show, but camera-for-hire projects, like fashion-promo videos and music videos. Our first big music video job was with the band The Cars. Andy co-directed the video with Don Munroe with me as the producer. Don directed Ric Ocasek's solo song, called "True to You." We did other music videos for Miguel Bose, Laura Donna Berte, Walter Steding, and Curiosity Killed the Cat.

I always think of Andy as never throwing anything away. Did you ever see him throw anything away?

Rarely. Maybe just food containers when we had box lunches from Brownies or candy wrappers and other things like that.

You mean they didn't go into the Time Capsules?

No. When we were getting things ready for The Andy Warhol Museum, I went through about sixty Time Capsules, that Andy and I and others put together in those boxes. A lot from the '60s, some from the '70s – it brought back memories. We found a lot of sealed letters that were usually bills. When I first started working for Andy, I'd spend Saturdays at the 33 Union Square West Factory trying to get Andy to pay the bills. There would be stacks of bills. I would spread them out on the floor and try to put them in some sort of order. Then Andy would start begrudgingly writing checks. Later (around 1973) I was made vice-president of the corporation, and the accountants decided it would be a good idea if I had check-writing responsibilities. Andy started a special checking account to be used by the both of us, and it was called Andy Warhol No. 3. Finally, I could write checks so the bills could get paid.

How would you describe the difference in mood or feeling between the three different spaces you worked in—33 Union Square West, 860 Broadway, and 22 East 33rd Street?

The 33 Union Square West studio (Factory No. 2) was where I first met Andy. This is where we started calling Andy's place "Andy Warhol Studio" instead of the Factory. By the early '70s, Andy's studio was more businesslike to the outside world, though it was still far from a normal office. 860 Broadway (Factory No. 3), was a larger version of the last place, and 22 East 33rd Street was the biggest of all. In it was Andy's art studios, his magazine, *Interview,* and his video studio all under one roof—actually three roofs (the building was in the shape of a "T"). All three studios were centers of a great deal of creative energy, with Andy in the midst of it all. Though the size of each of these studios differed, there really wasn't much of a difference—we just got older. Some came and went but a lot of us were "lifers."

Which is your favorite period?

All of it. It wasn't exciting every day, but it was always creative. I was always working on the next idea. You could be depressed or angry. But you always had something to do. Andy always wanted you working. There was always somebody interesting or famous coming through the front door. There was always somebody new. Andy attracted people; they came to see him.

What were Andy's work habits like?

He was a true workaholic. His life was art and he was always working. Before I got married I was working six days a week. After, I reduced it to five, with longer hours because of our TV show and other projects. I remember during the last big NYC blackout in the late 1970s, with phones out the next morning, no one in the city really knew what to do. Do you go to work or don't you? I wandered around with my wife, Shelly, the first part of the day. To see if the phones were working, I called the office (860 Broadway) in the early afternoon. Andy was there! Andy had bought a flashlight, climbed the stairs to the studio, something he would normally never do. He knew no one would be there, but he could make the point he was there, WORKING! Where was everybody else?! Of course I ended up joining him for the rest of the afternoon. How much work we actually did get done I don't remember.

What did you observe about Andy's friendship with Brigid Berlin?

Brigid's life by the mid-1970s was at the front desk at the Factory. She'd just sit there typing for Andy and doing needlepoint. If a tank had rolled by and you'd asked her, "Did a tank come by?" she'd look up completely unaware. She and Andy were like a

On location filming The Cars' music video "Hello Again," c. 1984.

Pat Hackett, editor of *The Andy Warhol Diaries*, c. 1987.

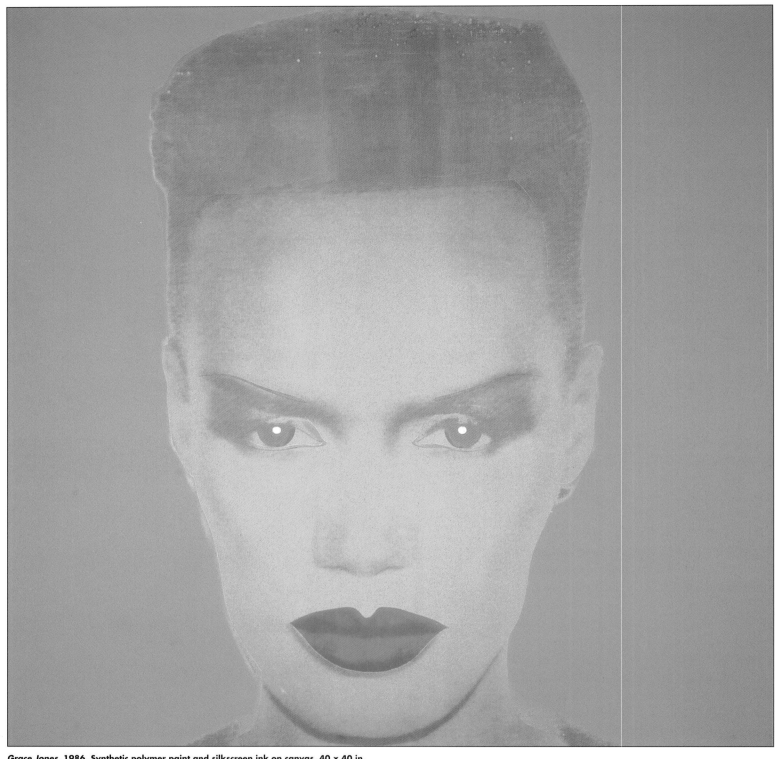

Grace Jones, 1986. Synthetic polymer paint and silkscreen ink on canvas, 40 x 40 in.

married couple. Brigid was the only one who could fight with him that way. He would offer her a painting as a present, and she would say no, and ask for a washing machine instead. Andy and Brigid had a great relationship; they spoke on the telephone every morning. Brigid was Andy's "B" in the *Philosophy of Andy Warhol (From A to B and Back Again).* In many ways Brigid was a muse to Andy all the years that they knew each other.

One day I was being nosy, and I looked into Andy's armoire, and the first thing I came across was an old-fashioned black and white Polaroid picture of Brigid nude. Andy had taken it. The picture had probably been sitting in that armoire for fifteen years.

In the '60s and the beginning of the '70s Brigid routinely took her clothes off at Andy's Factory. Andy took a lot of pictures of her

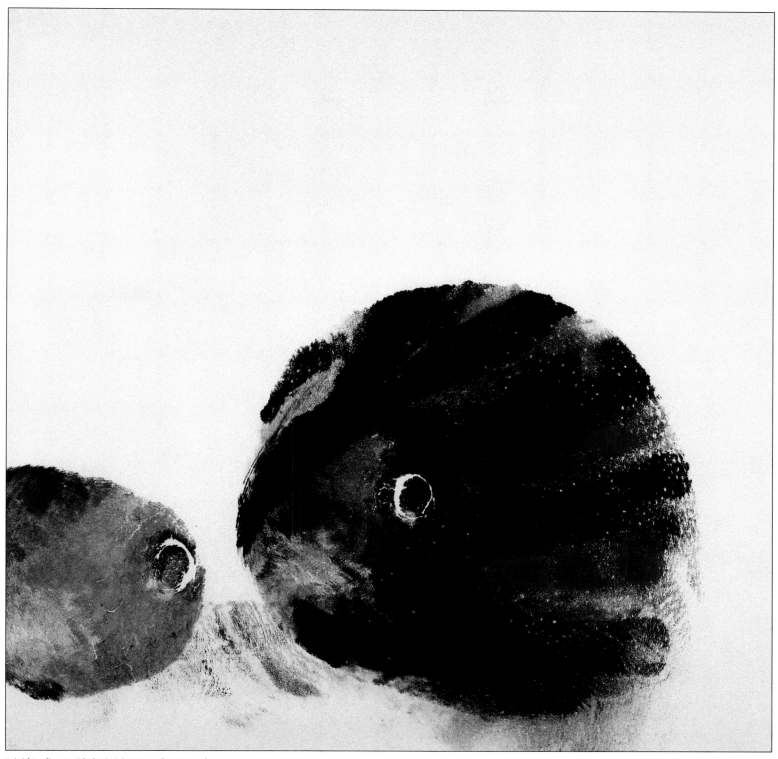

Brigid Berlin, *Untitled (Tit Print)* (Detail) 1995. Ink on paper, 8¾ x 11½ in.

nude, especially Polaroids. Brigid was photographed by Cecil Beaton exposing her breasts at the Factory. Andy photographed her doing tit prints. Andy took photographs of Brigid with a sheet of Plexiglas pressed against her body, with her on the floor below it. Brigid was her own art.

How did things change after Andy died?

A void. I remember coming back in the limousine from the airport after Andy's funeral in Pittsburgh where I saw him lying in the casket. It was so surreal. I had just wanted to say, "It's time to go. Let's get out of here." And not see him in that casket at all. When I got back to Manhattan, it just hit me. A big emptiness. I think a lot of people had that feeling. There was just something missing. Because he was *always* there.

Bob Colacello

Interview's Editor Remembers the "Boss"

After spending over ten years as editor and executive editor at *Interview*, Bob Colacello went on to become senior editor at *Vanity Fair* in 1985. He is the author of *Holy Terror: Andy Warhol Close Up* (Harper Collins, 1990) and is now special correspondent at *Vanity Fair*.

How did you end up in Manhattan working for Interview?

I was born in Brooklyn, and I grew up on Long Island; Manhattan was as far away for me as if I had come from Kansas. Manhattan was golden – this place you only went to with your mother holding your hand, taking you to Radio City Music Hall, to Schrafft's for lunch. I finally ended up in Manhattan when I went to graduate school at Columbia's School of the Arts. I was studying film criticism, and I wrote a review for homework for Andrew Sarris's class. He was the *Village Voice* film critic, and he had so many pages to fill in the back of the book that he would print a few student reviews every week. He printed my review of the Warhol film *Trash*. I wrote that it was a great Roman Catholic masterpiece in the tradition of Mary Magdalene – you know, everybody can be redeemed, we Catholics believe, including prostitutes and hustlers and junkies. And that's what I thought *Trash* was about – redemption.

My introduction to Andy was the result of that review. I got a call from Paul Morrissey, who said, "I work for Andy Warhol. We loved your review. No one ever got that Catholic thing before." And he asked me if I wanted to come and meet with them and write for *Interview*.

What made you think you'd fit in with Andy's group?

Well, I was aware of who Andy was. When the film *Chelsea Girls* came to Washington, my group of friends and I went to see it about four or five times. You see, in 1970, I was at the Georgetown School of Foreign Service, and I was part of a small group of kind of "rebels without causes." We were against the Vietnam war and things like that, but really we were just typical spoiled kids from the suburbs. We were the only group that took drugs. I think I was maybe the second pot smoker at Georgetown and the first pot dealer there. I used to keep the pot in a jar buried under a tree in a park about a half a mile away from campus. Anyway, this little coterie of four or five friends had a band called the Brave Maggots. Since I can't carry a tune to save my life, I was their "manager." They didn't have any gigs, so there was nothing I could manage. I was their groupie, really. They were all handsome rich kids. So I started being a groupie to handsome rich kids even *before* I met Andy. That's why I fit right in. You know, Catholic, groupie, involved with beauties and anyone who had money. I just fit right in naturally.

I think Andy really popularized art. Culture was not big in America before Andy. It was not the middle-class thing to do yet.

So, Andy was already the rage then.

Well, it was really just a very small group that was interested in him at Georgetown. Don't forget, in the '60s, not that many college kids were interested in art. It was very much a fringe thing still. Not that many people went to museums. You would go to the Metropolitan Museum, and it would be empty. I think Andy really popularized art. Culture was not big in America before Andy. It was not the middle-class thing to do yet.

Warhol in the Boardroom at the 860 Broadway Factory, April 1983.

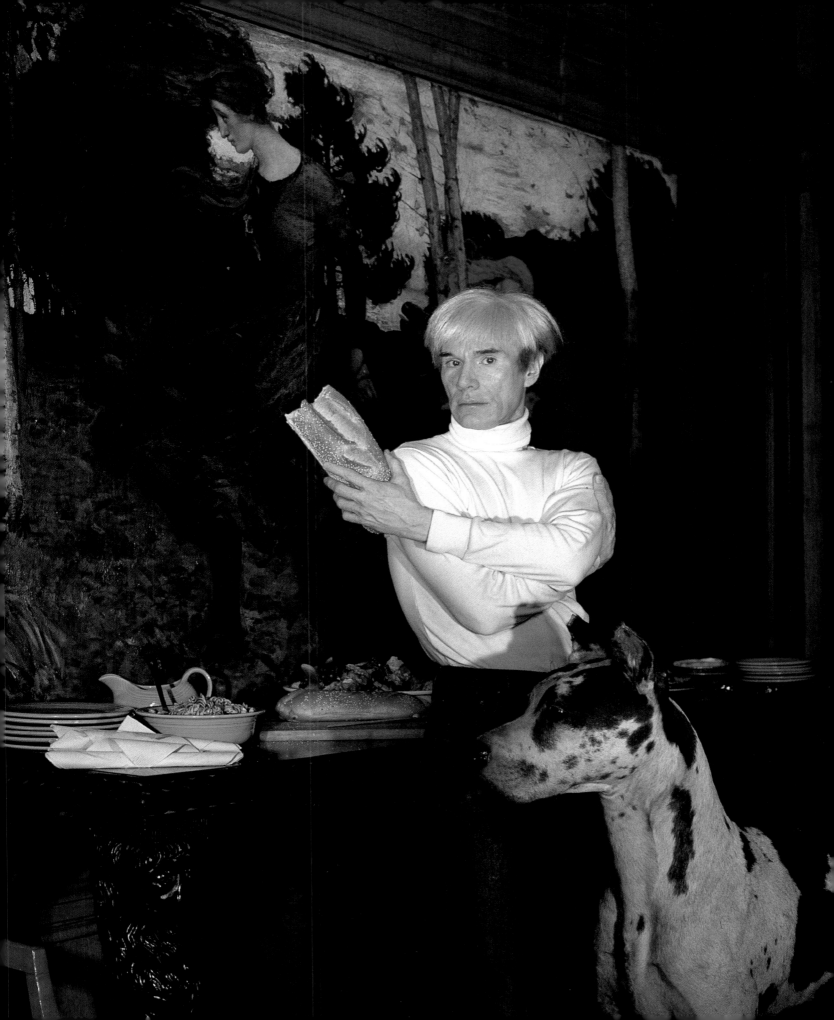

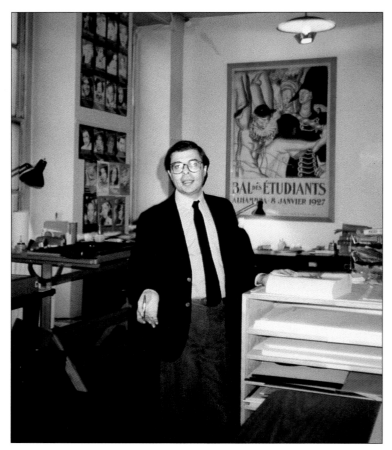

Bob Colacello at the *Interview* offices at Warhol's 860 Broadway Factory.

It took a personality to spread culture to middle-class America.

As always. It always takes personalities to get anything anywhere in America.

Originally, it was strictly about movies. For my first issue, Paul Morrissey handed me a stack of Rita Hayworth photos and told me to put one on every page.

What was Interview *like when you first started working there?*

At the time, it was a little rag, literally. You could barely touch it, it had so much ink on it. It was printed in Chinatown, and the editor was a guy named Soren Angenoux. The name Soren was an homage to the philosopher Soren Kierkegaard. He was a speed freak with a half-inch pony tail. He had a little office on the tenth floor of 33 Union Square West. The Factory was on the sixth floor. And there was a bulletproof door with a little window in it, and when you looked in the window you saw what was supposedly

Cecil B. DeMille's stuffed dalmatian. DeMille's sister wrote me a letter, after I mentioned the dalmatian in *Vanity Fair*, saying that her brother would never stuff a dog.

Another lie.

Well, DeMille's dog or not, *that* was Andy's idea of a security system, a stuffed dalmatian. The people he was afraid of were all high on drugs anyway, so they'd see the dog and think it was real and jump back and run away.

Who was the audience for Interview *at that point in time?*

The audience was Paul Morrissey, Fred Hughes, and Andy; and I don't think Andy even read it himself. I wrote a few things, got paid twenty-five dollars per movie review or interview. I wrote more movie reviews than interviews, actually. And then one day Andy said that they needed a new editor. Soren, they alleged, had been taking the twenty-five-dollar checks that Andy had been signing and had been turning them into two-hundred-and-fifty-dollar checks. He allegedly would cash them and give the writers twenty-five dollars in cash. So Andy asked me if I wanted to be editor. I was reluctant because I was still at Columbia working on my masters. Andy suggested that I talk to Andrew Sarris about giving me credits for my work at *Interview*. So I went and talked to Sarris and the head of the School of the Arts, and they gave me nine credits for two semesters of being the editor of *Interview*.

I asked if Glenn O'Brien could be my assistant, and Andy agreed. I was paid fifty dollars a week, and Glenn was paid forty dollars a week. Glenn's wife, Jude Jade—a name she made up the minute she met Andy because she wanted to be a superstar—worked for free. We each had a little office on the tenth floor where some kid taught us how to size photographs. The type for the magazine would have to be glued by hand onto the layout. And when you wanted to correct a typo, you had to cut it out with a razor blade. Glenn would always lose the corrections, and he would make Jude turn the whole garbage pail upside down looking for the one little razor-bladed piece with the word "Bertolucci" on it spelled correctly.

How did Interview *change its scope over the years?*

Well, the magazine evolved gradually. Originally, it was strictly about movies. For my first issue, Paul Morrissey handed me a stack of Rita Hayworth photos and told me to put one on every page. And I said, "There are all these reviews of European movies. What does Rita Hayworth have to do with this?" He told me that it didn't matter—just put one on every page. Jonas Mekas, the guru of underground film who ran Anthology Film Archives, proclaimed that issue a revolution in magazines, and it was, to see Rita

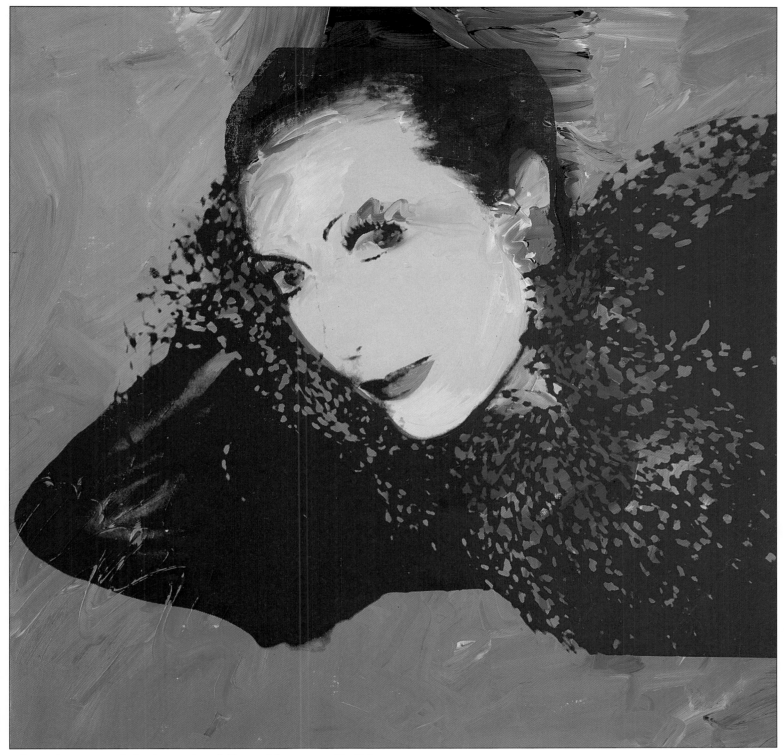

Helene Rochas, 1975. Synthetic polymer paint and silkscreen ink on canvas, 40 x 40 in.

Hayworth on every page. Nostalgia wasn't big then, you see. In the '60s, everybody was looking forward to the future. And suddenly Andy Warhol, who's supposed to be the forefront of the *future* in 1970, has a magazine that does a Rita Hayworth issue followed by an Elvis Presley issue. And then we came up with art deco type. No one had ever heard of art deco at that time. No one was interested in it.

The next phase really began in 1972 when Fred Hughes started becoming very friendly with Halston and Joe Eula. We came up with the idea of having Pat Ast interview Halston. Halston designs clothes for movie people, so an interview like that could be a part of a magazine on movies, too. In that way, little by little, *Interview* became more and more about fashion and society as well as movies. We kept expanding the notion of what movies were. We

started interviewing people if they ever had been in a movie for one minute, or if they had designed something for a movie, or if they had ever met a movie star.

Or if they had ever seen a movie.

Exactly, it grew. And then the magazine gradually became more and more about Andy's social life which was all encompassing.

The funny thing was that even though we'd have these little fights about whether we should use Rita Hayworth or Kim Novak,

> # We started interviewing people if they ever had been in a movie for one minute, or if they had designed something for a movie, or if they had ever met a movie star.

the fact of the matter was that Andy, Fred, Paul, Glenn, and I were all into the same thing. We were all into old Hollywood glamour. We all loved Italy and *Death in Venice*, and we all wanted to do a *Death in Venice* issue, which we did when the Visconti revival

came out. What was interesting about Andy and pop art in general was this mixture of high and low. I always felt the Factory was so much more European than any other place in New York. Europeans, because they grow up with high culture, are not afraid of popular culture. They don't let popular culture rule their lives either—they're more balanced in general. I think that at the Factory, we had a pretty balanced approach to things. We weren't super intellectuals, we didn't worship at any intellectual altars, but at the same time, we didn't take popular culture seriously the way so many people do. Andy wasn't as pop as he pretended to be.

You came from a more intellectual background than all the participants you just mentioned. Did you find that unusual?

Well, Andy would say, "Oh, Bob's an intellectual." But I wasn't really an intellectual. Andy led us into the world of fashion. Once we started going to parties at Halston's on 68th Street, everything was so glamorous and all these models were so beautiful—Pat Cleveland, Donna Jordan, Jane Forth, Jay Johnson, and Corey Tippin—we didn't really care about intellectuals anymore.

But at the same time you were putting interviews with Truman Capote in the magazine, pieces that would attract a different audience, a more literary-minded one.

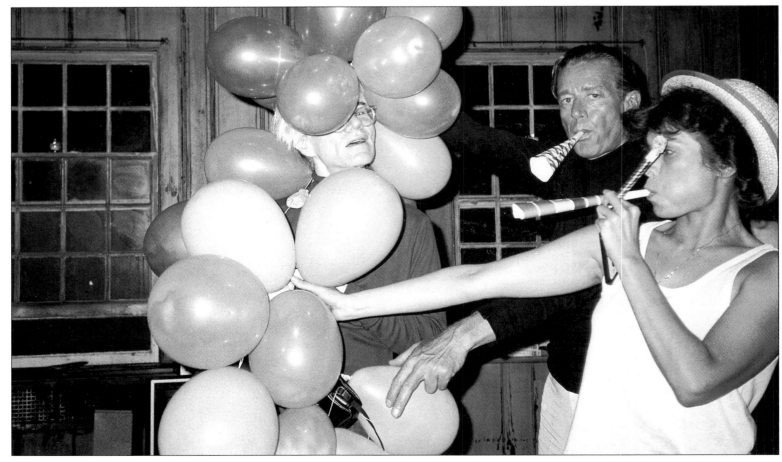

Halston and Bianca Jagger at a private birthday celebration for Warhol, Montauk, NY, 1981.

That's true. But I wouldn't call that intellectual. When I hear the word "intellectual," I guess I think of the *New York Review of Books*. I definitely read more than almost anyone there, with the exception of Paul. Andy read—he said he didn't, but he did. Still, he never read the kind of books that I read. For instance, I just read the new biography of Francis Joseph, the last Hapsburg. Andy would have no tolerance for reading that kind of book. He thought it was a waste of time. Michael Gross's book about models or something like that—that was another story.

How did the idea for your column "Out" come about?

It all goes back to how the diaries started. I was always keeping a diary, and Andy saw me writing in it when were on a trip. He said, "If you're going to keep a diary, you should keep it for me." And I said, "No, it's *my* diary." Well, I left *Interview* for a while and went to Mexico because I wanted to write a book about Andy's films. Actually, I wanted to get away from Andy. And when I came back, I really had nothing to do because Glenn was editor. Andy wanted to put me on payroll so he came up with the idea of having me do a fantasy diary. That's how Andy trapped me. He would make me sit and write every day. He would tell me what he did, and I would just fantasize about it and write. For instance, he would say he had lunch with Philip Johnson, and then they went down to Wall Street to look at some new building. I would write, "I had lunch with Philip Johnson, and then we went down to Wall Street, and we threw chocolate-covered cherries out the windows of our limousine at the cute boys."

I used to make things up. After we went on trips, Andy would sit there and say one sentence and I would turn it into three paragraphs because I would remember every place we went, what the people wore, what they said, what the house looked like. The early diaries are interesting because the narrative "I" would change from being Andy to being me. I would slip in and out of writing in his first person.

So that was the first step. Then one day I said, "You know, your diaries are so interesting, Andy. It would really help sell the magazine if we could take these diaries and make them into a kind of gossip column." So he told me to write one up. I did and handed it to him. Andy handed it back to me, and where I had written "Diary of Andy Warhol," he had crossed out "Andy Warhol" and had written "Bob Colacello." He felt it was too embarrassing for him to do his diary as a column. So I started writing my diary as one instead. The name of it, "Out," was Fred's idea. *Women's Wear Daily* was really big on "in" and "out," and we were out. I thought it was the most perfect word—that old tradition of the outsider. The gay connotation never occurred to us at that time. You never spoke of people being in or out of the closet then. What's hard for young people to understand today is that we never thought of *Interview* or Studio 54 or Andy as being committed to anything gay. We didn't want to be straight, but we didn't want to be gay. We just wanted to be what we were. Things weren't so classified.

Did the idea behind the "Out" column in Interview *culminate with the book* Exposures?

In a way—both books, *Exposures* and *The Philosophy of Andy Warhol (From A to B and Back Again)*. Fran Leibowitz once told me that I was making a big mistake in helping Andy with his philosophy book. She thought I was giving Andy my sense of humor and, once given, I'd never be able to get it back. To a certain extent, I think what's known as Andy's voice in literature was my voice. It's very mixed up.

The philosophy book, although Pat Hackett wrote a lot of the chapters and Brigid Berlin gave quite a bit of input, started with me writing the first chapter. I set the tone, I came up with that voice of "I get up every morning and I look in the mirror." I remember Adriana Jackson saying, "This is great. You've turned Andy into a character in a novel. That's what *you* should write; forget writing this for Andy." But of course I never listened to any of this advice because I always thought I needed Andy and I needed the money. I didn't have the courage to go out and be a starving artist. I was too bourgeois, too Republican.

Andy loved the idea of doing philosophy because it meant he didn't have to talk about people in a specific way. He could

I always felt the Factory was much more European than any other place in New York. Europeans, because they grow up with high culture, are not afraid of popular culture.

be more abstract. And I think that actually brought out the best in Andy.

The whole process of doing the book was very, very funny. We would have all this extra time on trips to Europe, and Andy would say, "Oh, come on, let's do the sex chapter today." We had already *done* the sex chapter, but we would do it again. That's why there are three sex chapters. We would just sit there going back and forth, and that was the A and B thing that eventually became the title of the book. And then the cleaning chapter was Brigid's work. And then Pat would take these chapters and she'd expand upon them. She'd ask more philosophical Christian Scientist-type questions. That gave it another dimension. The collaboration really worked.

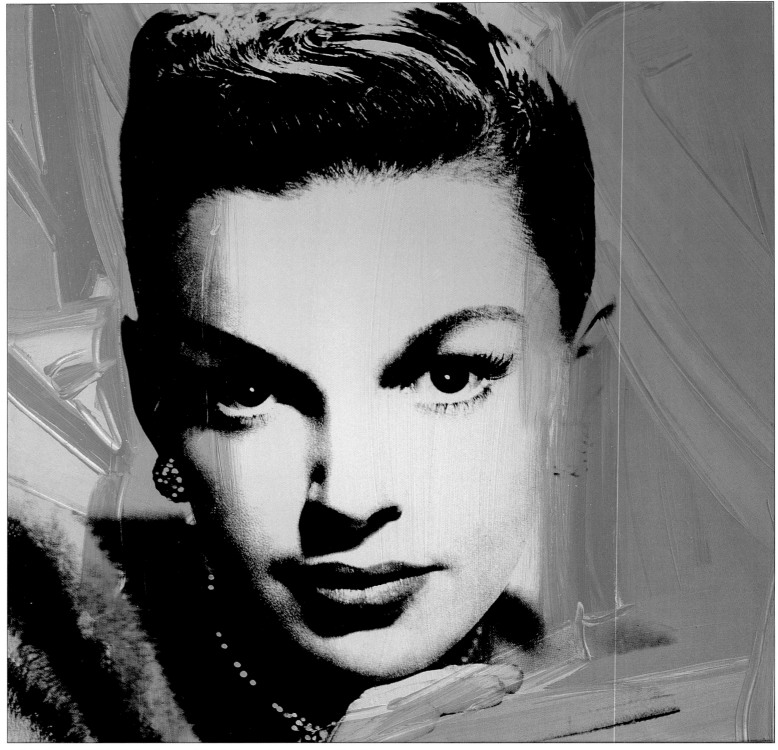

Judy Garland, c. 1979. Synthetic polymer paint and silkscreen ink on canvas, 40 x 40 in.

My favorite chapter is the last one on shopping for underwear at Macy's. When Andy told me about the idea, I said, "What does that have to do with philosophy? No, we're not going to do it." Finally, he got Vincent to agree to do it with him; and he called me and said, "Vincent and I are on our way to Macy's to shop for underwear; it's going to be the last chapter in the philosophy book. Do you want to come?" I figured I better go to get it right. And, as usual, Andy was right. It was one of the funniest chapters in the book; there is something about shopping for underwear that is so funny. Especially since we learned that we were the only men who bought men's underwear. Only women were in the men's department, buying for their husbands.

What about the creation of Exposures?

The way we did *Exposures* was that I would go over to Brigid's place after work every day and smoke five or six joints and start talking like Andy. I would impersonate him—an exaggerated version because Andy would never talk as much as I did, and he would never describe people in words as much as we had to in order to make those descriptions into a book. Brigid would type and edit as we'd go.

Chris Makos was the art director of the book. What a disaster that was. I am a terrible businessman, and I made the deal of paying Chris by the hour. The book took about fourteen years and two days to complete. We also were paying him around ten or twenty dollars a print, and he found an Italian immigrant who he paid one dollar a print. And then when all the layouts were finally done, they were all a quarter inch off. So, the publisher had to have them all redone and we got billed for the redos by the publisher. Andy and I didn't make a cent on that book.

When we spoke to Christopher Makos about the book, he mentioned that there was a lot of retouching of the photographs.

Andy's photographs were always so overexposed. Fred would retouch them. He would take a magic marker and just get rid of the chins, starting with his own and mine.

Speaking of magic markers, I've got to tell you a one-minute story. There was an ad for a restaurant that ran in Interview *for years. The owner was pictured in the ad. I had taken over that account, and Andy said that I had to get more than sixty-two dollars a month for that ad from her, and when I called her she got all pissed off and screamed at me. I went back and told Doria Reagan, who was your secretary then. She had an idea. We got the mechanicals and a black magic marker, and we blacked out all of her teeth. So, in one issue, the owner had no teeth.*

That's a side of Doria Reagan that I didn't know existed.

Speaking of raising money, people have suggested that the luncheons for celebrities and advertisers that were given almost daily at 860 Broadway were only for raising cash and were sort of dry and boring.

No, they were not dry and boring, but their main purpose *was* to raise cash. We also helped people network. I'd say, "I saw the Eberstadts last night and I invited them to lunch." And Fred would say, "I saw Leo Castelli and I invited him." And Andy would say, "Oh, and I invited the Dupont twins." And we'd say, "No, no, *disinvite* them." Some days eight people would come, and some days over twenty people would come.

It really was sort of a salon.

Yes, and selling definitely was one of the major motivations for doing it. Andy was deducting every last tuna salad, so it had to have a business basis. Fred would always say, "You know, you sell the most when you never ask anybody to buy anything. Andy, they know what we're selling. They know you do portraits, they know we have a magazine." There'd be the latest portraits of Marella Agnelli leaning up against the wall, conveniently, as the guests walked out of the dining room. "Oh, is that Marella Agnelli?" they would ask. "Oh, yeah, would you like to see them?" we would answer. We

The way we did *Exposures* was that I would go over to Brigid's place after work every day and smoke five or six joints and start talking like Andy.

worked, but it was always selling without really selling, creating the illusion that it was all accidental and sort of dipsy—they don't really know what they're doing down there but isn't it so much fun, we should take out some ads. And it worked.

Doria Reagan, editorial assistant to Bob Colacello, among some of Warhol's purchases.

Interview magazine cover with portrait of Nancy Reagan, December 1981.

But the one purpose that Andy always kept in the forefront of his mind at those luncheons was what kids could he help, who he could introduce them to. If Grace Mirabella was coming, Andy would automatically think of three girls who wanted to be models and he would call them up. Or if an art dealer was coming from Paris or Germany, Andy would get on the phone to two or three young artists. He really liked helping young people; he really liked making those connections for them, maybe because he struggled as a young person starting out as a fashion illustrator and he was helped by a lot of people. I think he knew how important that networking is when you're starting out. I think that Andy, Diana Vreeland, Leo Lerman, and Jerry Zipkin were the great, great patrons of young people in the city. And there are not that many. In order to be in *Interview*, you didn't have to have done ten things already. You could have written one scene of one play that was put on one night at a disco. The idea of *Interview* was to discover talent, to discover people. And the mainstream press today is about covering people who are already famous. It's not about discovering people.

Don't you think that magazines today are trying to be cutting edge?

They're trying to be cutting edge, but they're not really about discovering people. I just don't think there are that many editors that work that way. They want the scoop, but they want the same story everybody else wants before everybody else gets it. That's obviously a very valid approach, and it's what I myself tend to do now. But it's still exciting to see somebody who's never been in the press before. We would run a photograph and an interview, and the next thing you know they'd be in fashion shows or they'd be in *People* magazine or they'd have a part on a TV series or their book would be getting published. It wasn't a feeling of power. It was a feeling that, amidst all this silliness, you actually could help another person.

What kind of other collaborative projects did you do with Andy?

Well, I signed all the posters for the Green Party. Hans Meyer and Lucio Amelio worked out this deal for Andy and the artist Joseph Beuys to trade portraits, but Joseph Beuys's condition was that Andy had to do a poster for the Green Party, which he was very involved with in Germany. Andy did it, of course. Princess Ingeborg of Schleswig-Holstein was working for us at that point; she was our sort of honorary foreign receptionist for that month. She got wind of these posters and started making a big scene, saying that the Green Party was an East German front and that Andy had no respect for her country, West Germany. She actually started crying and screaming and shouting and saying that she was going to call up all her friends in West Germany and tell them Andy was doing a communist poster. Andy didn't know what to do because he didn't want to lose the deal with Beuys, but he also didn't want to upset anyone. So he came up with the perfect solution. "Bob," he said, "you will sign these posters, that way people won't

I think that Andy, Diana Vreeland, Leo Lerman, and Jerry Zipkin were the great, great patrons of young people in the city. And there are not that many.

be mad at me because I didn't sign them, and the Germans will never know that you signed them because you know how to write my name." So I forged the whole series of Warhol posters for the Green Party.

Were there any other notable collaborations?

In the early days, Andy asked me to write a screenplay. I wrote one based on Eva Peron. It was for a musical comedy that was to star Candy Darling as Eva Peron and Joe Dallesandro as her brother, Juan Duarte. I did a lot of research on Eva Peron because I had always been fascinated by her. I had gone to school for one year in Madrid, and Peron had lived in Madrid. I didn't think the Perons were great for Argentina, but I thought it was all very funny and good material for a musical comedy.

I got great material from Diana Vreeland, who had known Eva Peron. She told me that Eva Peron used to do these incredible things like have the entire Dior collection flown to Buenos Aires. I interviewed Diana a lot, and she found other people who had known her. And I wrote songs with titles like "There's a Charming Dictator Living South of the Equator." I showed what I had written so far to Andy and Fred – about thirty pages – and Andy said, "Oh, God, Bob, no one even knows who Eva Peron *is* except you and Diana Vreeland. This is ridiculous; this is so campy." Paul loved it, but Andy kept saying no.

So I chose another route. There was a boy named Paul Palmero who was Marina Schiano's assistant at the Yves St. Laurent men's boutique. He was going out with someone who worked for Robert Stigwood. I showed the treatment to Paul, and he gave it to the Stigwood boy, and the Stigwood boy gave it to Stigwood, and

Stigwood was a partner of Andrew Lloyd Webber. A couple of years later there was a Broadway show called *Evita* starring Patti LuPone. Andy said we had to put Patti on the cover of *Interview*, and I said, "No way, this was my idea and I know they stole it." Andy usually won those arguments. The only thing I was able to stop was Andy's decision to put a black person on the cover every month for a year. I thought it would be better to put one black person a year on the cover. I had made the mistake of saying the Diana Ross issue sold well. And Andy's mind was always multiplying. I

The idea of *Interview* was to discover talent, to discover people. And the mainstream press today is about covering people who are already famous.

was into the idea of alternating a man, a woman, a man, a woman, because I thought it was very important that *Interview* didn't become just a men's magazine or a women's magazine. From selling advertising, I knew that our unique position was that we were the only magazine that had a little bit of everything. We weren't male or female; we were young and we were affluent, but we had a great

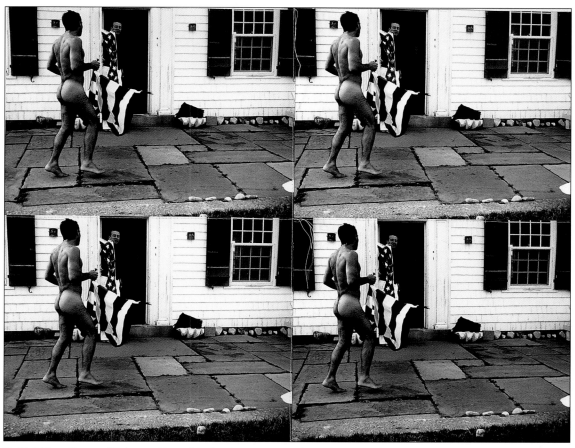

Untitled (Victor Hugo and Halston at Montauk), 1976–86. Four sewn gelatin silver prints, from a portfolio of ten, 22 x 28 in.

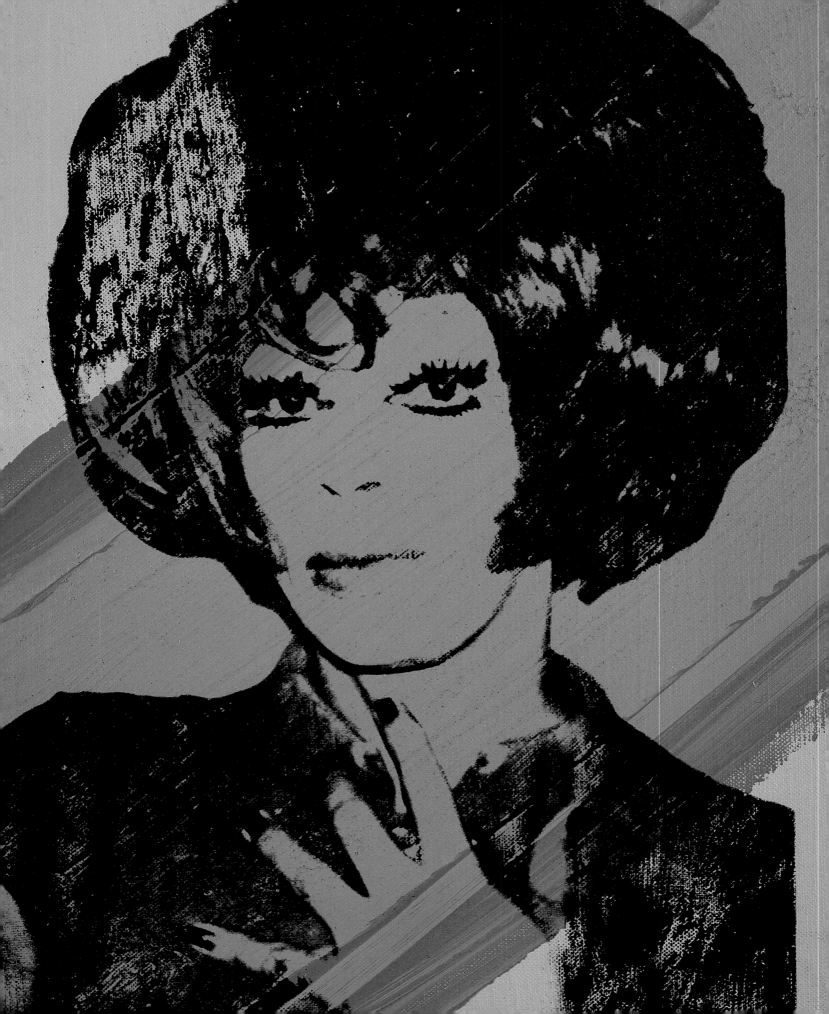

cross section of men, women, gays, straights. The common denominator was hipness more than any racial or religious or sexual identification, and I thought that was better. If you put a black person on the cover every month, you're going to have a black magazine. Nothing wrong with that, but it probably wouldn't have worked for the advertisers.

When did Andy think Interview *started doing well?*

When we started making money. I would say 1980 was the first year we made a profit to put back into the magazine. Only a little bit, around five percent, I remember. But five percent is not bad in the publishing business. Andy loved it when we had a lot of ads. He loved it when we had Nancy Reagan on the cover, even though he hated Nancy Reagan and she hated him. He still liked the idea that we were able to get the First Lady.

How many times did you and Andy visit the White House together?

We went first to do an interview with Gerald Ford. We went to a couple of Carter receptions. I remember they served beer and horrible wine from Georgia, no hard liquor. And then we went to the Reagan White House for a state dinner for President and Imelda Marcos. I think Andy was seated at Vice President Bush's table. When we went to the White House to do the interview with Mrs. Reagan, we went with Doria, Ron Jr.'s wife. It was very odd because they didn't invite us upstairs. We sat downstairs, and they never offered us so much as a glass of water. Mrs. Reagan was very nervous, very stiff. She's very cautious, she thinks about every word. And then, of course, Andy started her off. One of the first things he said to her was, "Oh, gee, Hollywood people are so *strange*, they always talk behind your back, they don't even wait for you to leave the room." And she said, "Well, you know, Andy, I'm sort of a Hollywood person." It went downhill from there.

I think Andy felt that the interview was all about me, not about him. Andy was very jealous of the fact that suddenly I was getting a

We had finally figured out that the way to get press…is to do things that keep surprising people. The Nancy Reagan cover got us a tremendous amount of publicity.

lot of attention not only because the magazine was starting to do well and naturally enough the editor-in-chief would get some attention, but also because of this very strong connection I had with Jerry Zipkin and Betsy Bloomingdale and Alfred Bloomingdale

and other people in the Reagan crowd. It was very grating to Andy that the White House called every so often asking for me. Mrs. Reagan would call mainly because she wanted to discuss something about Doria and Ron. For instance, they wanted to get rid of their Secret Service protection, and she thought they looked up to me and wanted me to convince them that they should keep it.

Everybody who was visiting from Europe, whether it was Karl Lagerfeld or Mick Jagger, wanted to have lunch at the Factory and then go to Studio 54.

Originally there were rumors that you were trying to get Ronald Reagan for that cover.

No, it was always Nancy Reagan. I just thought that Nancy Reagan was getting very negative publicity being portrayed as a very stiff, ultra-conservative, Southern California *Hausfrau*. She could get rid of that image quickly by being on the cover of *Interview*. I knew it would cause a lot of controversy and talk, but that's what we were trying to do. We had finally figured out that the way to get press if you're a small magazine is to do things that keep surprising people. And the Nancy Reagan cover got us a tremendous amount of publicity.

At what point do you think the Factory was at its most exciting and glamorous?

Probably around the time Studio 54 started in 1977 or 1978. Things started to build in the '70s as Andy came back from being shot. When I started there in 1970, the scene was moribund in a way. Andy wanted to function almost in secret because he was so afraid of being shot again. Everything started loosening up by the late 70s. Everything just seemed to come together. It seemed for a while that we were at the center of everything. The phones never stopped ringing. Everybody who was visiting from Europe, whether it was Karl Lagerfeld or Mick Jagger, wanted to have lunch at the Factory and then go to Studio 54. The magazine was really clicking. Andy was enjoying himself. He was doing great paintings—the skulls, the drag queens, the hammers and sickles. We were traveling a lot. We would go to Washington and have dinners with Senator Javits and Senator Heinz and Senator Pell. We'd go to L.A., and Andy would have big shows at Doug Christmas's gallery, and all these Hollywood stars would come to the openings.

The book tours also were great fun. On the 1975 *Philosophy* tour, we went to about twenty cities, and all these kids poured out

Ladies and Gentlemen (Detail), 1975. Synthetic polymer paint and silkscreen ink on canvas, 14 x 11 in.

Ambassador Francis Kellogg and his wife Mercedes, c. 1980.

to see Andy. That tour was the beginning of the great period for me because it was so fascinating and at the same time affirming to see thousands of kids show up in Baltimore and Boston and Ann Arbor and San Francisco and Dallas and Houston and wherever Andy went. They weren't freaks, just kids — eccentric art students, preppie kids, all kinds of people. And they'd ask Andy to sign everything. They'd come with Velvet Underground albums, with Campbell's soup shopping bags, with their breasts, their penises, their dogs. A signing that was scheduled for an hour would go on for three hours. The bookstore people would want Andy to stop, but he just wouldn't. It was really wonderful.

Can you tell us how the drag queen series, Ladies and Gentlemen, *came about?*

Actually, there's a funny story about it. Like so many of Andy's painting series in the '70s and '80s, it started with an art dealer

giving Andy the idea. He had this gallery dealer in Torino called Luciano Anselmino. We used to call him Anselmino of Torino because he looked like a hairdresser. He had this big bouffant hairdo, and he was really funny. We were sitting in this coffee shop in Torino, and he suggested that Andy do drag queens. We had taken him to the Gilded Grape when he was in New York, and he was fascinated by all these black and Puerto Rican drag queens. Anselmino said that drag queens should look like men, they should have heavy beards. It should be obvious that they're men in wigs and makeup. Andy thought that I would make a perfect model for the paintings because I have a heavy beard.

So Andy agreed to the idea, and Anselmino thought it was wonderful that I was going to be the model. Andy and I got in the car — we had to go to Monte Carlo from Torino — and all the way there we fought. I said, "Andy, I am not going to be the model. I am not going to be a drag queen for you." And Andy kept saying, "I'll give you paintings." Well, I thought, sure, two inches by two inches. To

make a long story short, when we got back to New York, Andy finally convinced me that I should do it, and there are Polaroids that Andy's assistant, Ronnie Cutrone, did with Andy. Ronnie's first wife, Gigi, did the makeup and got a wig, and I put on a bikini top or something, and my chest hairs were sort of pouring out of this bra, and Andy took these horrifying Polaroids. That's when we realized that it was not going to work. Thank God.

Instead, Vincent and I started going to the Gilded Grape on a regular basis and asking these Puerto Rican and black drag queens if they would pose for a friend of ours. They thought it was a trick, a job. I'd say, "Come to 860 Broadway tomorrow at twelve o'clock." They would come, Andy would take a few pictures, and then Vincent would make them sign a release and would give them a check for a hundred dollars. They would always say to me when I'd see them two nights later at the Gilded Grape, "Tell your friend, I'll do a lot more for a hundred dollars."

The paintings were shown in the beautiful Palazzo Diamante in Ferrara, Italy. They looked fantastic in this Renaissance palace that was made out of diamond-shaped stones. One room after another, *en filade*, of these big drag queens and little drag queens. As usual, Andy made me sit next to him at the press conference for the show, and the first question came from the communist newspaper, which was one of the biggest newspapers in Italy. The reporter asked, "Isn't it true that the reason you painted drag queens is that American capitalism doesn't give black and Puerto Rican boys any choice but to become drag queens?" And Andy didn't know what to say. I said, "Just say yes Andy. It'll sell more in Italy because the country is very communist."

Andy decided to do hammer and sickle paintings after that press conference.

Were there any other projects that you did with Andy?

Well, there was a big project that Fred killed after Andy died. Lewis Allen, who was the producer of *Annie* and of *Tru*, the Truman Capote one-man show, had taken an option on the *Philosophy of Andy Warhol* and *Exposures* and had this wonderful idea to make the two books into something called *Andy Warhol: A No Man Show*. It was going to be a robot of Andy sitting on stage just gossiping and philosophizing based on the text of those two books. Peter Sellars was going to direct it. But the technology kept moving so quickly that every time Lew thought he had a robot, they'd find they could make an even more advanced robot, which would have eleven hand movements instead of three hand movements. And so he'd actually invest more money to get a better robot and then that would put the whole project back a year or two.

Andy loved this idea; he loved the fact that there was going to be this Andy Warhol robot that he could send on lecture tours. It could do talk shows for him. The idea was that the show, if it was successful in New York, could then also simultaneously be running in London, Los Angeles, Tokyo with cloned robots. And people would actually be able to ask questions of the robot, which would be programmed with a variety of answers. The whole thing was so Warholian and so perfect.

Andy loved this idea; he loved the fact that there was going to be this Andy Warhol robot that he could send on lecture tours. It could do talk shows for him.

But when Andy died, Fred refused to renew the option. I owned fifty percent of *Philosophy* and *Exposures*, and Andy owned fifty percent. So the Foundation got Andy's fifty percent after he died. In any case, the deal was killed. I think that Fred didn't want this Warhol robot haunting his existence. It's a shame. It really would have been the greatest thing that could have happened for Andy. It would have almost been like coming back from the dead. And he really loved the project. He sat for hours at some high-tech place in the San Fernando Valley where they made a mold of his face and his hands.

We remember seeing an image of him with little straws poking through the wet plaster on his face so he could breathe.

Yes, there's a whole photo session of it.

If you had to pick out a painting that you would say is the most representative of Andy and what he was about, which one would you choose?

Well, I'd be torn between *Marilyn* and the original thirty-two Campbell's Soup paintings that were shown at Irving Blum's gallery in L.A. in 1962. The Campbell's Soup series really declared the beginning of the age of media, advertising, and pop art. It was a great philosophical statement.

Marilyn was a more religious work. It was an icon and very, very important. Andy's work has a lot to do with icons. Andy's religious and cultural upbringing was part of the Greek and Russian Orthodox tradition. The Eastern Rite Catholic church in Pittsburgh where Andy went three or four times a week when he was growing up had the iconostasis, all the saints in a grid and gold leafed, very two dimensional, very flat. With *Marilyn*, Andy hit upon an icon of our *secular* religion. I think Andy identified with Marilyn. They were both these poor kids, who made it to the top and who were victims in a way – very lonely, very confused, very inarticulate.

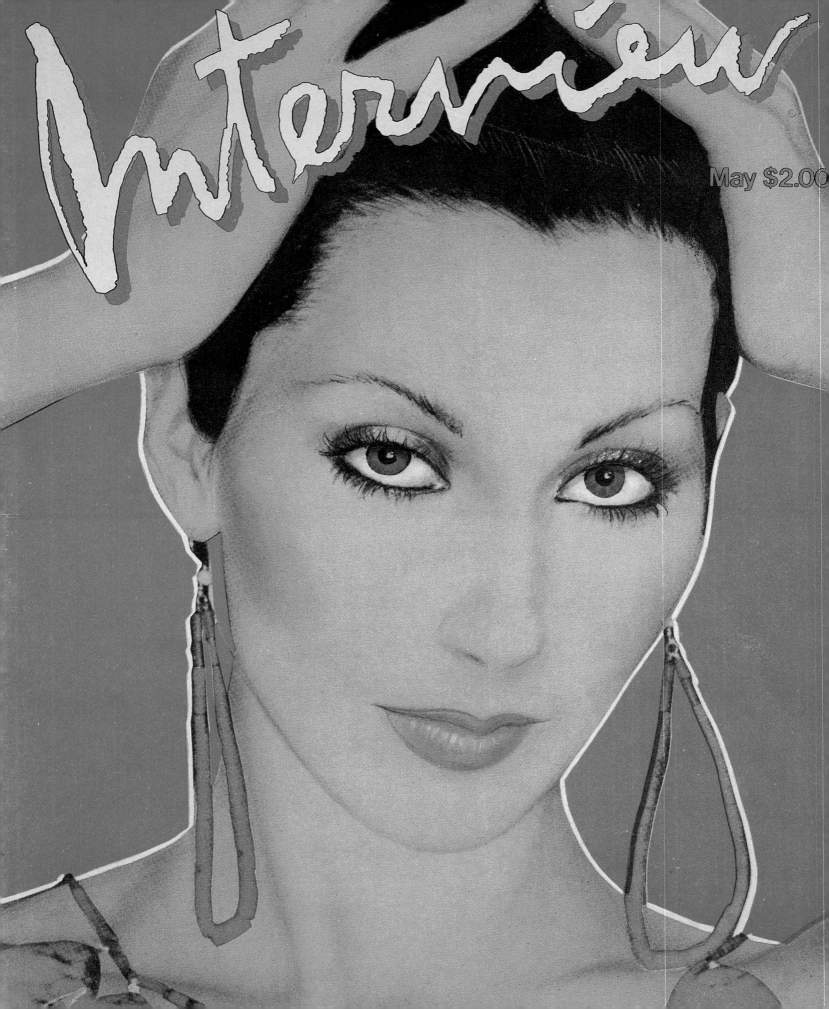

Interview

May $2.00

Marc Balet

RISD to the Factory: An Art Director's Story

Born in 1948, Marc Balet received his undergraduate degree in architecture from the Rhode Island School of Design in 1972 and was awarded a Prix de Rome the following year. In 1973 he presented his work in a one-man show entitled *Dreamhousing* at the Whitney Museum of American Art in New York. After spending twelve years as art director of *Interview*, Balet went on to design advertising for clients such as Anne Klein, Karl Lagerfeld, and Giorgio Armani. Balet is currently creative director and partner in the advertising agency Balet & Albert in New York.

Marc, What was your first contact with Andy?

I'll give you the very abridged edition. I went to the University of Connecticut for a year and then transferred out of there to RISD, the Rhode Island School of Design. I had the worst year of my life at the University of Connecticut. It was just the worst school; I almost had a nervous breakdown.

And so I transferred. Someone had told me about this school in Rhode Island; I ended up applying, and I got in – luckily. It changed my life. That's where I first saw Andy. He had come to school on a bus to the museum, and he had done something called "Andy Raids the Icebox." I remember sitting in a little pocket park across the street from the museum, and all of these glamorous Warhol people were there. Everyone was all atwitter; all of the kids just couldn't believe it. We couldn't believe that Andy Warhol was there at school. My friend Day Gleason, who is now a department head at the Pratt Institute said to me, "Oh my God, aren't you going to run across and meet Andy Warhol? Don't you want to see him?" And I said, "You know, I just think I'm going to meet Andy Warhol when I'm supposed to meet Andy Warhol." I just didn't feel that I was supposed to meet him that day.

Then I started going to Max's Kansas City in New York when I was still at RISD. I think this was in around 1969. I had braces on my teeth at that point. My parents thought college would be a perfect time to put braces on my teeth. There I was getting into Max's Kansas City with little braces on my teeth. That's where I met Glenn O'Brien, his wife at that time, Jude Jade, Larissa, and Ronnie Cutrone. Debbie Harry was a waitress there, but I didn't know her then. I remember sitting down at a booth one night quite high actually on a little bit of acid, talking to somebody. And some woman sat down and started screaming and talking to me. I was so wrecked. She had feathers on or something, and the feathers went over me. And she put down a bottle of her own liquor on the table, and I thought, "Who the fuck is this?" And I turned, and it was Janis Joplin sitting next to me. I almost lost my hair. It was so great. I just couldn't believe that I was this kid from art school, sitting in Max's Kansas City with Janis Joplin talking about old times.

For me, that was it. That was what life was about. At RISD, you had the choice of either going to Boston or going to New York. To me, Boston was always like sitting at the children's table at a bar mitzvah. If you were cool enough, you could sit with the adults, who had more things to say and better things to say than the kids. New York was the big people's table. All I knew was that I wanted to be in New York, and Max's seemed like the logical place to be. It was the centerpiece of what was going on there as far as I could figure out.

So when did you two finally meet?

Well, it's a long, roundabout story, really. I believe it was the summer of 1973 when I was awarded a show, a one-man show at the Whitney Museum called *Dreamhousing*. I had won the Prix de Rome by that point, and I had been in Rome for a year finishing

school. I came back to New York to do this show, and I rented a loft on the corner of Spring and Wooster, the top floor. I shared it with a gal I knew from RISD named Fran Heaney. We paid $125 a month for the floor.

You must have been pioneers in that part of town.

Yeah, there was nothing there. Literally. It was the wasteland. Anyway, the Architectural League of New York had sponsored my

I was living in an apartment on Gramercy Park with Tina Bossidy for about four cents a month and typing Fran's *Interview* column for her – that was my job.

show, and I asked them whether we were doing any press for it. They told me I could do one ad. And I said, "I only want to do it in *Interview.*" That would be my one ad. I took out a quarter page ad, in the September 1973 issue and I think it must have cost around $150 or $100.

Contributing editor Fran Lebowitz at *Interview* offices, 1982.

I did my show at the Whitney, and then I went back to Rome for two years. I had these friends in Rome – Joan Buck, she was a correspondent for *Women's Wear Daily* in Rome and her boyfriend, who was this German/Austrian body builder, slash fabric designer. He called me up – I can't remember his name – and said, "Marc, a friend of Joan's is in town with nothing to do. Could she come up to your studio?" I had a studio on the top of the Janiculum overlooking Rome at the American Academy. And I said, "Sure, what's her name?" He said, "Fran Lebowitz. She works for Warhol; she has a column." I said, "Yeah, have her come up."

Fran came up, and we instantly became friends. And I told her I was coming back to New York. I had kind of had it with Europe. And she told me to call her when I got back.

So I did. We met at the Russian Tea Room for a little snack. She said, "What are you going to do?" And I said, "I don't know, I'm going to find a job I guess." I only lived on grants and my parents, so I really didn't know what I was going to do. So in any case she said, "Well, let's see what happens." I was looking around to be an art director, and I tried to be an art director at ad agencies. But I was an architect with this conceptual kind of crazy dream house stuff. No one was taking an interest at all.

Then this unfortunate thing happened. The art director of *Interview*, Joan Stashko, died suddenly of an embolism. We had all been hanging out together as a matter of fact – Fran and Joan and I. I was living in an apartment on Gramercy Park with Tina Bossidy for about four cents a month. And at that time I was typing Fran's *Interview* column for her for nothing – that was my job. Then I started illustrating her column with my montages. We'd talk late, late, late into the night about the column and other things. I had done that for a few months when Joan died suddenly. Fran called me up and said, "You know, Joan died." I said, "Oh my God." She said, "You know, you should be the art director." I said, "Oh, God Fran." She said, "Yes, you've got to call up. You've got to assert yourself and call up." And I said, "All right."

So I went over there, and I sat down with Fred Hughes and Bob Colacello and Andy. I said, "Well, I'd kind of like to be the art director of the magazine." And they said, "All right, I guess so."

You didn't have to show them anything?

I didn't have anything. All I had were Fran's pictures that I'd done for five months. I didn't know anything about a magazine at all. Andy stood there, and said, "Oh God, I guess, yeah, all right." Bob said, "OK. All right, you're the art director." And I said, "Oh great."

I must have been paid around $100 a week. No expenses were covered, nothing. It sounded fabulous, but I had less money than I did before I got to New York. It cost *me* money to be the art director of *Interview*. I didn't know anything. I didn't know what a layout was. I didn't know about the type. I had always just handed my

Interview cover artist Richard Bernstein with singer Grace Jones, 1985.

photograph in and left. So I never knew how you put the type down on a page or anything else.

Bob started yelling right away. He started yelling, "You're the art director, how could you not know how to do a layout?" And I said, "Well Bob, calm down. I'll learn. It can't be that hard." So I started making phone calls finding out about layouts, and I just started doing it: on-the-job training, basically.

It was hilarious. I don't know if that could happen now, a story like that. That to me was the magic of New York. And I think, I hope that it's still here somewhere, that on the big game board of Manhattan anything is still possible.

Little dreams do come true, and I did meet Andy when I was supposed to meet Andy. I ended up working for him for twelve years. Those were kind of madcap times, with Richard Bernstein painting the covers of the magazine and Peter Lester editing.

In what way were they madcap times?

Well, in the mid '70s, there were lots of drugs and parties. *Interview* to me was a safe haven. When I went to the Factory, when I went through those doors, I felt protected. I'd sit on that window ledge in the late afternoon sun, and I remember how good it felt to sit there and look out over Union Square, watching people getting mugged and running for their lives and screaming and yelling.

And you felt so fabulous that you were here. You felt that if New York was the big spaceship, then you were at the command module. You were not actually at the helm because Andy was always at the helm, but you were still near to the person who was making the decisions. You felt very cocoon-like in the Factory. You felt it was the best little club you could be in. And not ever having been a

Well, in the mid '70s, there were lots of drugs and parties. *Interview* to me was a safe haven. When I went to the Factory… I felt protected.

joiner in my life, this was the only club I had ever really joined. As Brigid Berlin said, "You're a lifer."

She always talked about being a "lifer."

One thing I did realize though, and I warned Donald Munroe about it. I had brought Donald to the Factory because we had gone to school together and Vincent Fremont was looking for someone

to run the video department. So I told Donald, "Don't get caught up in the whole Factory thing because it's not what it seems to be. And although it's really fun, it's really great, it's really easy – diversify. Don't put your whole 'portfolio' into this business. You've got to keep diversified."

As you know, a lot of people didn't do that, and it got very difficult there. We used to call *Interview* "Invitation" because you were invited to everything, you could go wherever you wanted. I remember when *Cocaine Cowboys* came out, we all got cocaine invita-

We used to call *Interview* "Invitation" because you were invited to everything, you could go wherever you wanted.

tions, little bits of coke. You'd walk into the office and there would be anyone from Arnold Schwarzenegger on the phone in a little bathing suit, to Georgia O'Keeffe sitting quietly in a corner by herself. It was an anything goes sort of thing.

But Interview *itself was more or less run like a business. People had to keep certain hours…*

It wasn't like that in the beginning. A lot of people would come in at any particular hour. Let's see, Catherine Guinness – certainly there was no time frame for Catherine. She came and went. But I

Interview art director Marc Balet kisses managing editor Robert Hayes, 1982.

always felt that Andy liked me because I was a worker. I went out a lot – no two ways about it – but I really got the job done.

I remember when I decided to quit *Interview* after six months because I had gotten a real job that was paying me a lot of money. I worked at *Vogue Patterns*; Larissa actually got the job for me. It was going to pay me $20,000 a year, which I couldn't believe. It was a lot of money. I remember Andy was away. I told Peter Lester, "Peter, I'm quitting. I've got to really, my parents have just had it. I've got to get a job, and I've got to get some money in here." And he said, "I totally understand."

So I tendered my resignation, as it were. Andy called from Iran. I think it was the only time Andy ever called me. He called me up and said, "Freelance the magazine." I said, "What are you talking about?" He said, "Why don't you just freelance the magazine?"

And I remember I actually had tears in my eyes. I put the phone down, and I said, "Andy said I could still stay on, do the magazine freelance." And so for three and a half years I did *Interview* during the late afternoon and evening, and I did *Vogue Patterns* during the day. I went on trips all around the world for *Vogue Patterns*. And I always made it back. I went to Tahiti and to Bali and to Hong Kong, and I always made it back on time to get *Interview* done with the incredible support of the managing and later editor Robert Hayes and the staff. I would come in and sit at the big table at the Factory and they would just feed me stuff. I stayed on doing the magazine like that for twelve years.

For a while, I didn't tell the *Vogue Patterns* people that I was still working at *Interview*.

They wouldn't have been happy if they knew?

No. They wouldn't have been happy. I'd take long lunches and run and do *Interview* at my lunch hour.

Vogue Patterns was on Spring Street and the Warhol Factory was on 17th Street and I had my bicycle, my little Schwinn. So I was on that bicycle up and back and up and back all day long. I weighed about four pounds at that point. I had amazing legs. I would go up there, I would do *Interview*, I'd come back, and Robert Hayes would be on the phone screaming hysterically that I had to come back, I had to come back. So I'd have to leave the *Vogue Patterns* office. I lied and lied and lied. Until one day I was on a photo shoot and the editor of *Vogue Patterns* came up to me and said, "Marc, I just got a message from Arthur Elgort's studio that the shoot is on for this evening." She said, "What shoot is on for this evening?"

That blew my cover. And I told the editor, who was fantastic actually, that I had been doing both jobs for almost a year. And she said "All right, I don't care. It's fun. Keep doing it."

Did you know of anybody at that time who was in a similar job situation?

Brooke Shields photographed for *Interview* by Albert Watson, August 1983.

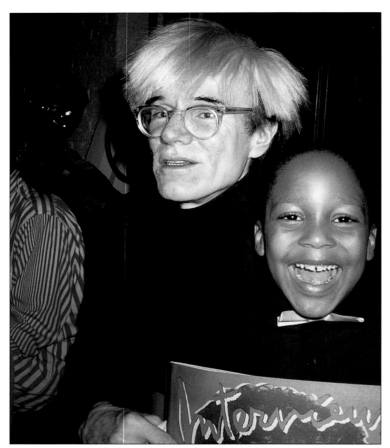

Andy Warhol with young *Interview* reader, October 1982.

I certainly don't think that anyone was doing two magazines at the same time. After about three and a half years, though, I decided that was about as much I could do at *Vogue Patterns*. And I left there to open up a little advertising shop, which is how I started doing work for Armani and Yves Saint Laurent and Lagerfeld.

I think Andy got upset when I did a lot of advertising. He thought I wasn't paying enough attention to the magazine. But for the most part, he really enjoyed the fact that I would just work. In the beginning, I balked at the ads I had to design for *Interview* advertisers. I said, "Listen, why am I designing someone's ads? I should be paid for this." Whatever anyone asked me to do, I did. Especially in the early days, if ads had to fit, I *made* them fit. In those days, no one was doing ads 17¼ inches high. They were doing the 8½ by 11 ads. If things had to be reconfigured, they brought them to me and I would redesign them free to get the ad in the magazine. It was very important to Andy. I realized that, and I did it.

What was Andy's involvement in the magazine like?

In the beginning, when we were at 860 Broadway, Andy once told me, "Make the magazine look like a phone book." He wanted it to look like a phone book with pictures.

Andy was very involved in the advertising part of it in the beginning, much more than later on, it seemed to me. When I would go out with him, he would always bring copies of *Interview* with him, giving them out, selling the idea of the magazine.

Also, he was always involved with selecting who would appear in the magazine. In the beginning, I used to sit there and Andy would bring in whoever it was we were supposed to put in the magazine—usually a cute little guy, but sometimes a cute little girl. And Robert Hayes and I would look at each other knowingly. You couldn't balk at it because Andy did have an unerring eye for beauty and for really cute guys and cute girls. And so he would bring these people in and say, "Gee, wouldn't it be really great to do a picture of this guy?" In his own way, he was saying, "Get the picture done, I want this guy in the next magazine."

There was a section in the magazine for that, wasn't there?

It was called Inter-man and View-girl originally, and it became the whole up-front section basically. At that time, nobody else was doing it. Now of course *My Weekly Reader* is doing it; everybody is doing it. Of course the studios and the PR people in Hollywood loved us because with these pictures we promoted the next rising cast of characters coming out of L.A. To pay us back, the PR people gave us the major celebrities, also. We got everybody.

It's interesting, though, in the beginning I always had to spell out *Interview*. I remember when I'd call people up, and I'd say, "Hi, it's Marc Balet from *Interview* magazine." And I'd wait, and I'd say, "I-n-t-e-r-v-i-e-w." And I knew that times were changing when I could stop spelling the magazine to everybody.

Who was the readership of Interview?

Interview was like smoke signals out to the hinterlands for the very hip and the very gay, "Look," *Interview* said in a kind of code, "We know you—come on down!"

Did you see the magazine change over the years?

Absolutely. Things got more commercial. The magazine became a magazine to be reckoned with out there in the marketplace. People really took it very seriously. There were some pivotal issues. I think that the Bruce Weber issue on the 1984 Olympics was amazing. Bruce had originally started it for *Rolling Stone*, but there was some disagreement between *Rolling Stone* and Bruce. And I remember Robert Hayes was on the phone with Bruce and he said, "Bruce wants to know if we want to do the Olympic issue with him." I think that probably there was that homoerotic flavor to the pictures Bruce was doing that *Rolling Stone* objected to.

But also it was the first time athletes were being stylized and groomed and made glamorous.

That really put us on the map. There were other issues that put us on the map, too. Having Mrs. Reagan on the cover, for instance.

We did a lot of special issues. There was the Las Vegas/Miami Beach issue, which was fantastic. There was the health issue. There was the Hollywood issue. *Interview* was always that horrible term "cutting edge." Really it was pre-cutting edge. Today everybody is cutting edge. Now the *Christian Science Monitor* is cutting edge. Everyone is always desperate for "the next new thing." But at that point *Interview* was the only one covering that beat.

Did you ever go to Europe with Andy?

We went to Italy together. Andy did a series of interviews at the Grand Hotel in Milan. He sat in this one room, and each crew was allowed to spend fifteen minutes with him. The crews came from Monte Carlo and from Paris and they came from Rome and they came from all of these other bizarre countries. And they came in to

Interview's Olympics special with photos by Bruce Weber, January/February 1984.

have their little fifteen minutes with Andy. The interviews were in Italian so I had to translate every one for Andy from dawn until dusk.

At one point, the Walter Cronkite of Italian news television was introduced to me as he came in to do his interview. He set up his crew and, speaking in Italian, said, "We're with Andy Warhol, the most famous blah, blah, blah." He talked about how he knew Andy personally, and Andy had no idea. And I thought to myself, Gee, it doesn't seem to me that Andy knows him.

Then he started to ask Andy questions. I translated them and Andy gave his little monosyllabic answers. At one point, the guy asked Andy, "How does Andy Warhol see the world?" And I said, "Oh, Andy, this guy just asked you how do you see the world?" Andy mumbled, "Oh, well, I don't know, I see…" And I turned to the guy and I said, "Andy sees the world through contact lenses."

So the guy stopped the interview, and he explained the answer to the crew. He said, "Now do you understand that only Andy Warhol could come up with that answer?" He then told the crew what a genius Andy was for coming up with that line. And I turned to Andy and said, "Oh, Andy, they really liked that one. That was a really good one." Not a clue. And he said, "Oh, gee. Thanks. That's really great." And then we finished up.

My understanding is American pop art gained its fame in Europe first. American acceptance came later.

Probably. He was a real celebrity there. It was a bit of an eye-opener for me.

What do you think Andy's major contribution is as an artist?

He was the center of things, that kind of star that shone so brightly and attracted everyone. But there was a little bit of a black hole about it. The star imploded. And all of the energy just got sucked in around him. So what had seemed to be a bright, shining star in the beginning became a void, a kind of crushed galaxy.

If you had to single out a painting, which would you choose as his most important?

That's very hard. There is a painting I always loved, and I always used to go and stare at it. It was the painting of an inside of a refrigerator. It's an old painting. I think it was black and white. To me, it was like Monet's *Water Lilies*. I absolutely loved the composition.

It was laying propped up against a wall at the Factory, and it was probably worth a half a million dollars. And I'd go back there to his workspace – it was really calm and dark back there – and I'd look at that painting. It was such a small workspace. Andy probably felt safer in a small space. I think he needed that sense of security. Even though his paintings are kind of remote and cold, there is something intimate about them even in their grotesqueness.

MADONNA ON NUDE PIX: SO WHAT!

STAYING COOL

AILS: BACK PA

"Andy Warhol and Keith Haring used to come to all my dinner parties and try to steal my boyfriends. They were particularly fond of the young, impressionable, gorgeous ones."

Madonna

Andy Warhol and Keith Haring, *Madonna/Sean Penn Wedding Gift*, 1985. Mixed media, 14 x 11 in.

"Andy Warhol, all about Buddha."

Michael Chow
Buddah. Glazed porcelain with black marker, approx. 12 x 10 x 5 in.

"Jean-Michel brought the portrait Andy had painted of him to my house. I said, 'What are all those strange, green dots?' He then told me the story about Andy having people piss on the wet copper paint to get that effect. We laughed about that."

Gerard Basquiat

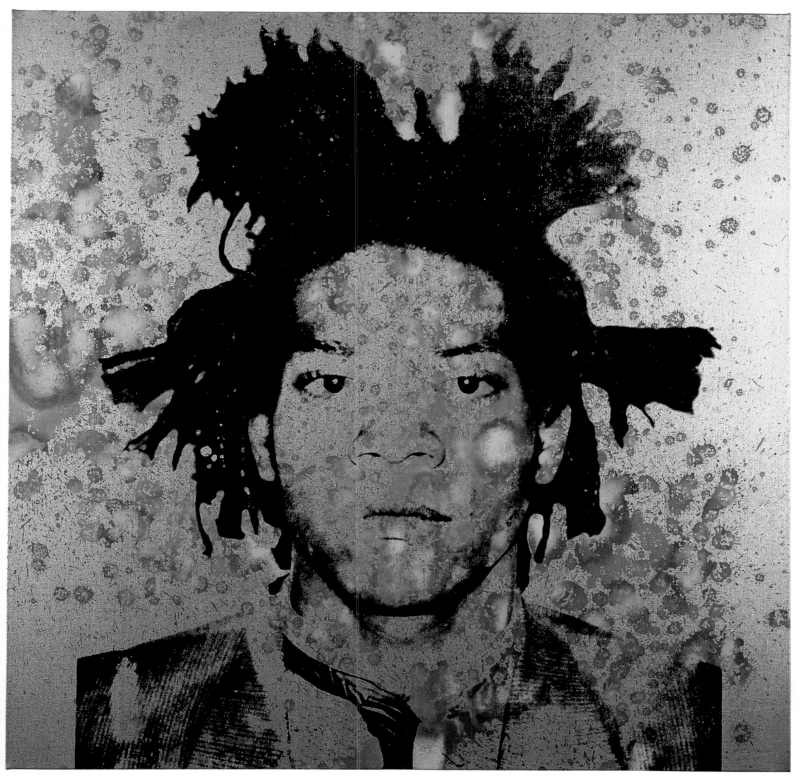

Jean-Michel Basquiat, c. 1982. Mixed media on canvas, 40 x 40 in.

"Abstraction is in the eye of the beholder. What man sees as chaos is in reality, order. Order in not straight lines and mathematics. When you fly over New York City at night, the lights of the city are as random as the leaves in the forest… There is no way to defeat the patterns of nature."

Chris Stein

Yarn. 1983, Synthetic polymer paint and silkscreen ink on canvas, 40 x 40 in.

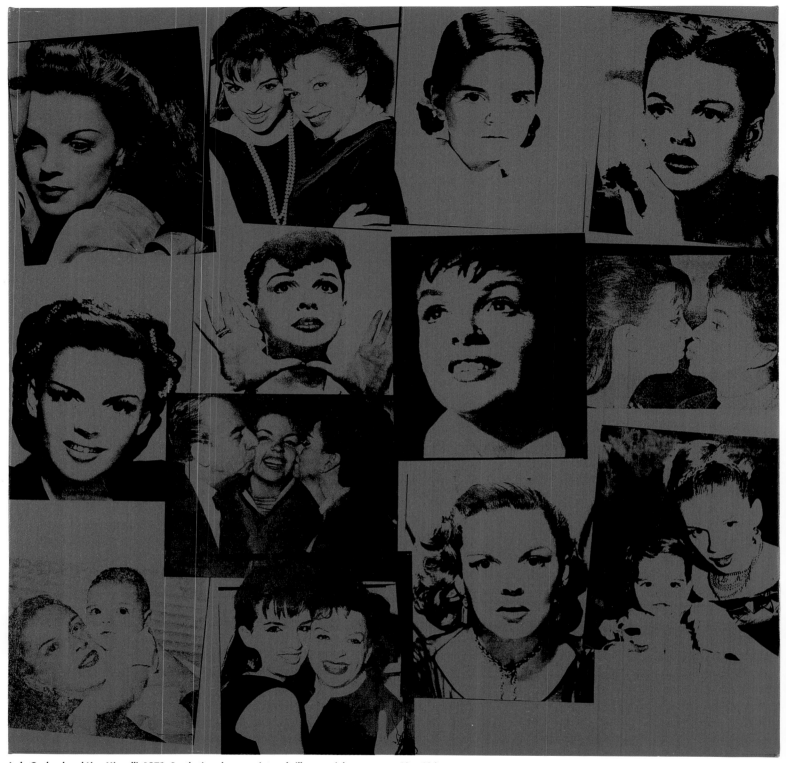

Judy Garland and Liza Minnelli, 1978. Synthetic polymer paint and silkscreen ink on canvas, 40 x 40 in.

"Andy so loved the famous, that he made anyone he met – like me – feel famous just to talk with him."

Philip Johnson

Christopher Makos

Andy Warhol's Photographic Mentor

Christopher Makos came to the Warhol Factory by way of Paris, where he worked as an apprentice to photographer Man Ray. Working in the '70s and '80s with Warhol on his photography as printer and photographic advisor, Makos collaborated on such projects as the book *Andy Warhol's Exposures* (Grosset & Dunlap, 1979), which he art directed. His most recent book is *Warhol: A Photographic Memoir* (New American Library, 1989).

You want the short and tall of it. Is that what the story is here? I met Andy through Dotson Rader, who had brought me to this big show at the Whitney, the one with all the *Cow* wallpaper on the walls. Dotson Rader was sort of that lonesome cowboy type that Andy loved. He was a writer. He graduated from Columbia University. He was involved in all of that political stuff. Dave Dellinger. The Chicago Seven. All of that. He lived with Ruth Ford, who was married to Zachary Scott, the famous actor from that period.

Didn't Dotson Rader write a book about Tennessee Williams? I heard there were a lot of questions about it.

Well, the book takes a lot of license. The thing that I find about books like that one is that the people who write them take this amazing amount of license and remember it the way they see it. And usually the way people see it is much bigger than the way it actually was. I find it unbelievable the way that people think that Chris Makos was one of these people who went to all of these parties. I used to go to the openings and the closings of these places, and I'd be seen by the press or people, and they'd think, "Oh my God, he goes to *everything*."

And the fact is that I didn't. It's the same with all of those stars. Andy didn't go every night. Neither did Liza Minnelli. You went to *selected* events. And the general public thought you went to everything. People like me who weren't at the same level as a Warhol got the label of being a hanger-on. What was Bob Colacello's name for those kids, the Millionettes? Debutantes of the decade.

In the '80s, they called people like that Celebutantes.

Well in the '60s, it was the Superstars. That's how people would refer to me. There was always that question, Well, what's *he* doing there? And I had become a friend of Andy's by then.

Through Dotson Rader.

Well, actually at that time, I barely knew who Andy Warhol was. I thought, "My God, who is this guy?" He was interesting and peculiar. And then I had my first photography show down in SoHo in the early '70s. I think it was probably 1972. It was called *Step On It*. All my photographs were on the floor covered in Plexiglas—that's why it was called *Step On It*. I invited Warhol and the *Interview* people, hoping they'd come. Of course, Andy didn't come, but I met Bob Colacello there. Bob then gave me some of my first pictures to do in *Interview*. Portraits. Peter Firth, the actor, was one of the first ones.

From Equus.

That's right darling, you've got those facts down. And another was Nicky Weymouth.

Didn't Andy tell Bob Colacello at that time, "You should give Christopher Makos two pages in Interview *to do whatever he wants with?"*

That came later. I did the two pages for *Interview* after Bob left. When Bob was there I remember so much of everything was based on sexual undertones. You have to remember I was twenty years younger. I was a lot cuter than I am now. I call it the Marilyn complex. If you're blond, somewhat attractive, and you come to New York City, no matter how much talent you have, no one sees the talent. They just see your blondness.

And in a city that is full of dark-haired people, blondes really stick out. I frankly wish that I had slept around more. I *should* have slept with Jann Wenner. I *should* have slept with Andy. I *should* have slept with Bob Colacello. I *should* have slept with Charlie Cowles. But I'm friends with all of these people now. The thing is, as a young photographer or a young artist on the scene, you couldn't do anything. It would get around, and no one would respect you.

So at that point, you were contributing to Interview.

Yes, it was great. Of course, when you're in the middle of something that's very cool, you don't really realize it. People have a lot of respect for me now because of that period I went through. But when you're right there, you don't really realize what it is.

A lot of the stuff started happening in 1977 when I published my own compilation of photographs called *White Trash*. That was the year that I spent photographing Debbie Harry, David

Johansen, and the New York Dolls. They weren't exactly punk, they were glamrock. They were that transitional stuff. Tom Verlaine. The rock group Television. Princess Diane de Beauvau-Craon and all of those kind of princesses. Tennessee Williams, Marilyn Chambers, Divine—they were all in the book. I did it in a really raw, matter-of-fact style. The book was more of an artifact of that time than a document. I wasn't trying to tell a story. I was just showing what I saw. Andy loved the book. He really responded to it. He said, "Chris, why don't you come do *my* book just like you

> ## Andy loved the book. He really responded to it. He said, "Chris, why don't you come do *my* book just like you did your book?"

did your book?" And I remember that caused a lot of animosity between Marc Balet and me. Marc was the art director that Robert Hayes had at *Interview*. Of course, I ended up getting the job to design Andy's book, *Exposures*. Because I was prettier I guess—this is *good*. Let's get this stuff out in the air and make controversy. I'm ready to say *anything*. The more trouble you can get into, the more it boosts your career. So any kind of trouble you can get me into, I'm up for it.

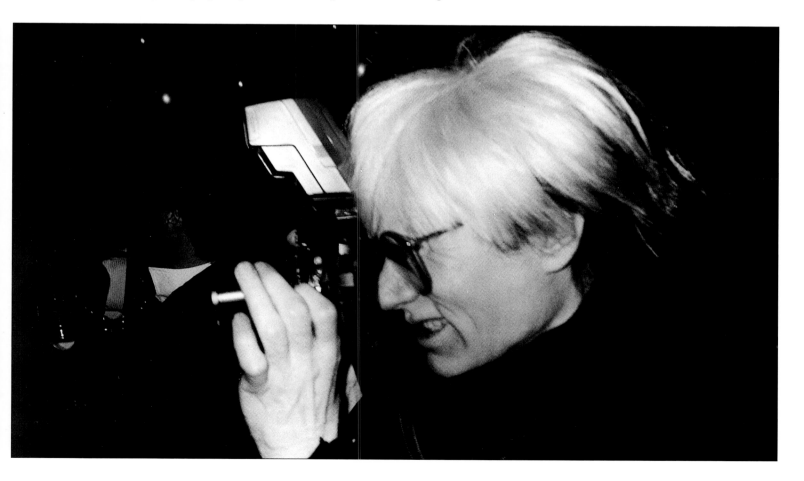

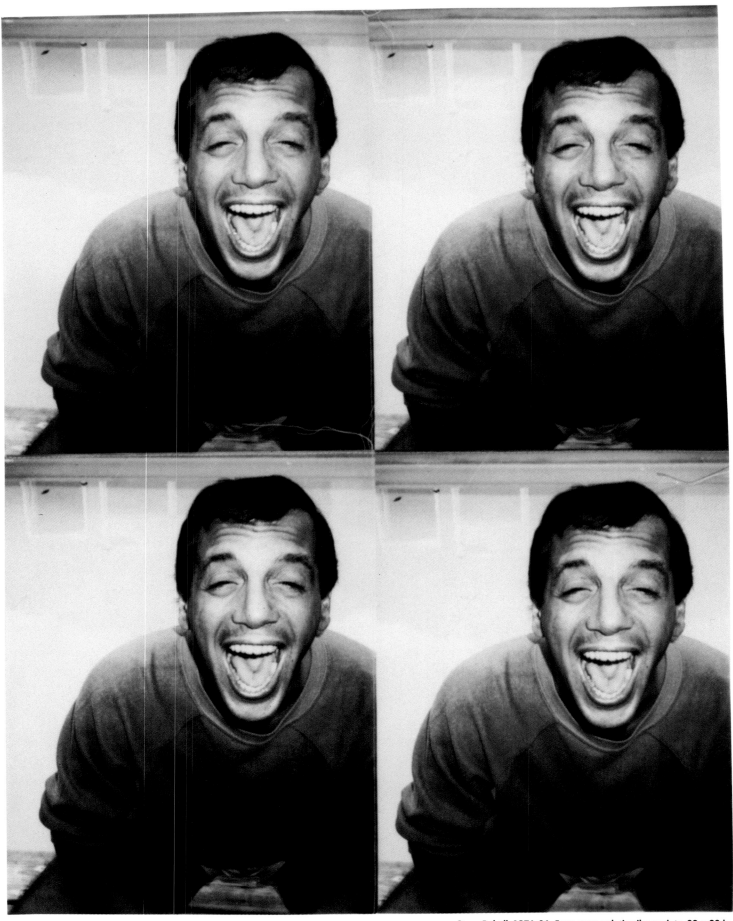

Steve Rubell, 1976–86. Four sewn gelatin silver prints, 22 x 28 in.

Pickle Jar with Alarm, c. 1983. Mixed media, 6 x 4 x 4 in.

Warhol and Makos at the Ronald Feldman Gallery, c. 1981.

So tell us more about Exposures.

Andy was responding to my eye, to what I saw and how I saw it. But I didn't know anything about cropping photos or wheels or proportions or anything. And Andy never knew what he wanted, and Bob didn't know what he wanted, and I didn't know what to do. So the project went on for years at around $10 an hour. It was a good project, I remember, but it was driving Andy crazy because I would say, "Blow it up. Blow it up. Blow it up." And I didn't know how to use those proportion wheels and stuff. So I'd just make stats and then stick the stats down into a dummy book. But then Andy

It has, of course, a major effect on you personally. All of my years with Andy Warhol were like going to the University of Andy Warhol.

wouldn't like it or Bob wouldn't like it so we'd have to go back and reblow them up and take the glue off and so that was a pain.

Still, that book was very successful for Andy. So with the book, I thought things were really going to happen for me. But it only happened for me after Andy died. It's the truth. I kept thinking about

all these big projects. But when you're in the shadow of such a big, tall building, you remain in that shadow until that building falls down. This thing about celebrity rubbing off – it really doesn't rub off on you. It has, of course, a major effect on you personally. All of my years with Andy Warhol were like going to the University of Andy Warhol. One learns an enormous amount from a person like that. And now anybody that works for me learns an enormous amount from me. You pass it on. In the end we even had a similar drawing style – we had the same line. I think we had that all along though. Probably because we both went to Catholic school.

Was there any image that got cut from the book because it was too much?

I do remember that they air-brushed a pot cigarette out of Philip Niarchos's mouth. It was a picture of Catherine Guinness and Ralph Richardson and Niarchos's son all in leather jackets getting ready to go to one of those late-night leather bars. And Philip had a joint that he had rolled in his mouth. And they air-brushed that out.

Were you there when Andy was commissioned to paint a BMW?

I was there when Andy painted the fake BMW, the little baby one. The mock-up when he used the rollers – it was so ugly. The whole experience was so ugly.

Why did they ask him to do it in the first place?

I think it was because Andy's boyfriend, Jed Johnson, wanted to have the free BMW to drive around in. They got a free BMW, didn't they? They got a late-model BMW for three years to drive around in. I don't think money was exchanged.

You helped Andy with a lot of his photography efforts, suggesting different kinds of cameras for him.

I was sort of his photographic guru. So many people ask me about me being inspired by Andy. It was really quite the opposite. Andy was inspired by me and by all of us.

Andy used to take photographs from the newspapers; he never really understood photography, though he always said to me that he wished he had been a photographer. My take on photography was always quick, fast, and facile. And he liked that because he himself was into producing as much work as quickly as possible. But painting was slow. The silkscreen process was slow. He loved the idea of the quickness of photography. He liked how I didn't labor over my photography. I did snapshots or Polaroids. He liked that aspect. For the longest time, I printed all of his photos.

One of his last big photography shows, and his most successful one, was based on this idea that I had given him – take four of his

Singer Debbie Harry, c. 1985.

photographs and then sew them together. Similar to his painted multiples. We hired Michelle Loud as the original seamstress. Michelle sewed all those photos. She did it all. And they were so slow to give her credit; she couldn't even get a *catalogue.*

That show of sewn photos was very well attended. Did you go to the opening?

There I was at the Robert Miller Gallery. And there was Andy. And everybody was standing around. I had picked all the photos for that show, and Michelle sewed them. All those pictures were taken on little baby cameras that I had told Andy to either get or buy. And on a lot of trips I had said, "Oh, shoot this. Shoot that." I essentially curated and art directed that show. And there was Andy glowing. It was wonderful, and I was happy. I went up to him

Warhol with Fred Hughes at the Robert Miller Gallery for the sewn photos exhibition, January 1987.

at the opening and joked, "Oh, can I have your autograph?" And he said, "Oh, sure." And I said, "I love the work." And he said, "Thank you very much." And then of course I left. When I got home, there was a message on my machine. Andy had called to say thank you so much for giving me this idea and helping with it, which was really sweet. Andy was like that. If you ever thought

If you ever thought that he was ignoring you or didn't work, he always proved in the end somehow that he did care for you.

that he was ignoring you or didn't work, he always proved in the end somehow that he did care for you. He always would thank you in some unexpected way.

That was one opening that I didn't attend. Andy knew that I wasn't there, and he called me up. He was hurt actually. I didn't have an excuse. I just didn't go that day.

Oh, he got hurt easily. If you forgot something about him, a sweet moment or something, he would notice it, and he'd punish

you. I remember I had done something that he didn't like to a boyfriend of mine at the time. And he punished me for a long time because he thought you shouldn't do that in relationships. He acted very paternal. I remember he didn't let me print pictures for a week. He knew that the way to *my* heart would be through my pocketbook, so he didn't give me a job for a *week*.

What were the different kinds of cameras that Andy used?

The first camera Andy had was one of those Minox cameras. They frustrated me. I hated the Minox system. Three to five. Five to eight. Ten to infinity. A lot of the pictures in *Exposures* were taken with the Minox camera. And then Konica came out. Konica was one of the first cameras with an autofocus system. And then Chinon. And then all these different Japanese manufacturers came out with these little baby cameras. I started experimenting with them. I was so happy. Andy had always wanted more precise focusing. So every time a new camera came out, there'd be all this excitement—like there is with computers today. A new camera would come out every six months. Better autofocus. Better auto-flash. Better auto-*everything*. Andy would buy new cameras. We'd go to Olden Camera, where I knew a guy who would give him the best deal, and Andy would always buy two cameras. It was strange. He'd always buy things in twos. I think that he was afraid

of losing them. He'd always keep one in that backpack and then one somewhere else.

When did you receive the Warhol "sculpture?" Can you describe it?

The Warhol sculpture—I think it's from 1982—was a Christmas present. Andy would use big holidays as reasons to purge his creativity. Andy was always asking me and his other friends, "What can I do for sculptures? What's unusual?" Those were hard questions for Andy because he thought in very linear terms. He didn't think in three-dimensional terms at all. Photographic terms, canvas terms, flat terms. He couldn't figure out what you do to do something sculptural.

So he thought in abstract terms instead. The thing that started off his sculptures was the idea of making big cardboard boxes and filling them up with cement. He had hired a friend of mine, Mark Burkett, who was in the group called the Pedantics. Mark was one of these musicians looking for freelance work, and I said, "Here's a job, Mark. We've got this idea of filling up these boxes with cement." Well, if you take a box that's three feet by four feet and maybe four feet tall, it's a nice strong box. But you fill it up with cement, it gets wet and expands and finally explodes.

The first couple of tries were disasters. And then they got the idea of lining the box with plastic. Line it in plastic and then fill it up. Of course these projects made an enormous mess. It drove everybody crazy—this white powder flying everywhere. And they mixed it with something that stunk. And so it stank up the whole area. It was wet. It was messy. In those days, the Factory was at 860 Broadway. It was smaller—all that shit was being done in the back not far from the *Interview* offices. So people were always whining, whether it was the piss paintings stinking up the back or the naked boys being photographed. Everybody whined all the time about Warhol's other stuff.

Anyway, they'd let the cement harden and dry. And then they *couldn't move* these boxes. They didn't know what the hell to do with them. Now *my* gift is a tiny little version that's four inches by about three inches by about two inches tall. And it's a Whitman's box of chocolates that's been emptied of its chocolate and filled with cement. The punch line is that, even though it's filled with cement, it is very, very lightweight. It fulfills the original idea of cement. It's very nihilistic. It doesn't mean anything. I think he signed it on the inside. Sealed the box up. Resealed it in the cellophane wrap. And that's it. No one knows what's in the box. I know it's a little bit heavy.

I also have a sculpture in a similar vein. It's a pickle jar filled with pennies with an alarm on the top.

And the teeth sculptures—like an iron jaw. More experimentation. Andy took molds and casts that dentists have for false teeth and just signed them. He just found them at dental shops. It was so Dali. Warhol was so impressed with Dali. Andy loved the idea of pontificating about something and saying it is art. And as Andy got older he got lazier and tired. And the idea of saying "this is art" really fascinated him.

I felt kind of empty when I got that box. But maybe that was the point of that kind of artwork.

When you received the cement candy box, what did you think of it?

Oh my God. I just wanted something *else*. You always want something that the artist is famous for. Like on a record album, you only listen to the hits. You don't listen to all the filler, the songs in between. And those kinds of things were filler.

But perhaps that piece of art, that piece of sculpture, so nihilistic and so nothing, has an important place in his work. It may not be a Marilyn Monroe and worth $250,000, but maybe it's important to his idea of the abstract.

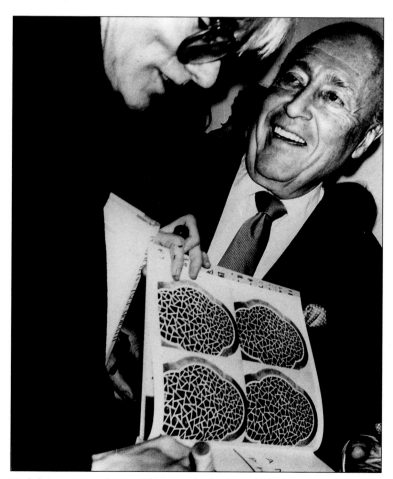

Warhol signs a sewn photos exhibition catalog for Jerry Zipkin, 1987.

You're In, 1967. Perfume bottle, cap and label, silver paint on glass, collection of Joan Kron.

Whitman's Sampler, c. 1984. Cement-filled candy box with cellophane wrapper, 7 x 10 in.

I felt kind of empty when I got that box. But maybe that was the point of that kind of artwork. To feel empty. Not like the flowers or the Hammer and Sickle paintings or the Skull paintings or the Gun paintings. I could identify with some of those things. That's cool or that's tough or that's strong. Instead, I felt empty.

Do you remember another "sculpture" that was printed on mylar?

That was another series of experiments in sculpture. I think some of them are more effective than others. I have the version that's the front page of the *New York Daily News*. The one about the Beirut blast when three hundred Marines were killed. A silkscreen of that on mylar. And that works. Because it means something. The newspaper was all crumpled up. It came in a box with tissues but I put mine in an acrylic box.

Then the Brillo Boxes were exciting. They were red! They were interesting! They were sort of silly because they were kitchen elements, but they were much happier than a box of brown chocolates filled with cement. There's something about cement that's not very uplifting. I mean, you make highways out of cement.

A person on the street who didn't know what Andy was about would say he was full of shit. Look what he did. He just copied a picture out of a magazine and printed it, and that's art? That's not art. Andy liked that. What makes something art? The minute it's sold does it become art? Before it's sold, is it non-art? Or is it just an experiment? In other words, the minute you write a check for something, is it art?

Did anyone at the Factory try to push him to do a certain type of art?

Well, I think Fred Hughes would try to push him into some areas, and Bob Colacello was always trying to get him to do portraits. Bob would go to all of those society lunches and dinners.

Andy himself would push those portraits as well. He would say to me, "So-and-so lives on Park Avenue. She has got to have her portrait done."

Those portraits paid the rent—the day-to-day business at the Factory and *Interview*. I'm sure Andy thought those cement sculptures, though, were failures; he probably didn't think they were art in the end. Towards the end when he did the Last Supper paintings, I know that he was at the end of his rope still doing the same kind of work that had made him famous. It's hard. You have to keep reproducing yourself; the art market does not allow you to go far off the highway on a lot of tangents, because if you do, you destroy the whole financial framework that the art dealers have created for you.

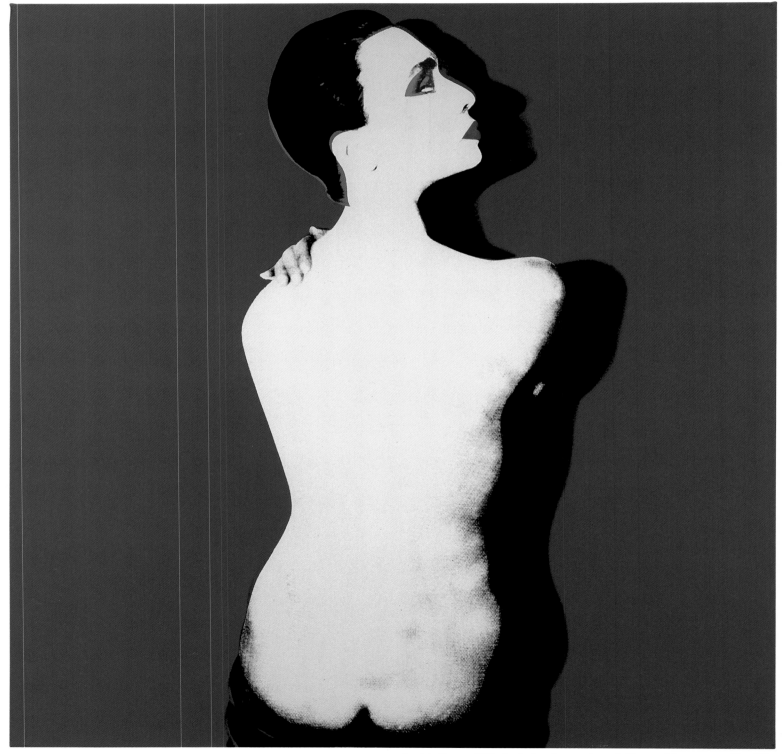

Daniela Morera, 1985. Synthetic polymer paint and silkscreen ink on canvas, 40 x 40 in.

Daniela Morera

The European Editor on Andy's Persona

Born in Rodi Garganico on the Italian coast and raised in Rome, Daniela Morera was a model before she became the Italian correspondent and later the European editor of *Interview* **in the mid-1970s. During that time she was the New York correspondent for** *L'Uomo Vogue* **and later also for** *Italian Vogue.* **She has worked as a fashion art director for projects worldwide. At present, in addition to contributing to** *L'Uomo Vogue* **and** *Italian Vogue,* **she is working with the Lama Gangchen's World Peace Foundation for the creation of a spiritual forum at the United Nations.**

We're going to just let you talk; no questions.

I have Andy's portraits, you know my portraits and I have the nude one; You were there for the nude, Benjamin, you remember? Andy had never done anything like that painting, never. It's completely different. I already had his portraits, and he wanted to do another one of me. And I said, "Andy, I already have enough portraits." Many women are really very vain, which I'm not. They love to put their portraits all over their apartments. I already had a lot of portraits because I knew a lot of artists. I don't hang all of them on my walls, so I don't know what to do with these portraits that I have. But of course with Andy it was different, so I said, "Andy, let's come up with another idea. Don't do my portrait. Why don't you do a classic inspired by Goya or Matisse? And you can do my back because I have very tiny tits, so you're not interested in doing my nude from the front." So first he said, "No, no, I cannot do anything like that." After we spoke again, finally he said, "You know, Daniela, it's a good idea, I'm going to do it." And that's when he told you, Benjamin, to buy the white powder from Chinatown, all white. And he did it. He put the white powder all over my body with his own hands. And I

think it's a great painting. Mine is yellow and lavender – the background is yellow, and the body is very light lavender. With big red lips and a black line all around the figure so it looks very three-dimensional.

So I have that portrait in Milano, and I have the plates signed by Jean-Michel Basquiat and Andy.

Tell us that story.

Jean-Michel and Andy came to Milano together. Andy had an exhibition, a very badly organized exhibition. The exhibition was only some portraits of second-class fashion people. Some people commissioned some work from Andy. It was all business. I think that Fred should have avoided it because it was really a little, tiny gallery.

Why don't you do a classic inspired by Goya or Matisse? And you can do my back because I have very tiny tits, so you're not interested in doing my nude from the front.

After the opening, there was a dinner at this famous restaurant called El Toula. There were many invited guests. There was many boring Italian press. And thank God I was there at the table with Andy and Jean-Michel because, the two of them, they were so bored with those kind of people. They didn't know anyone! We had

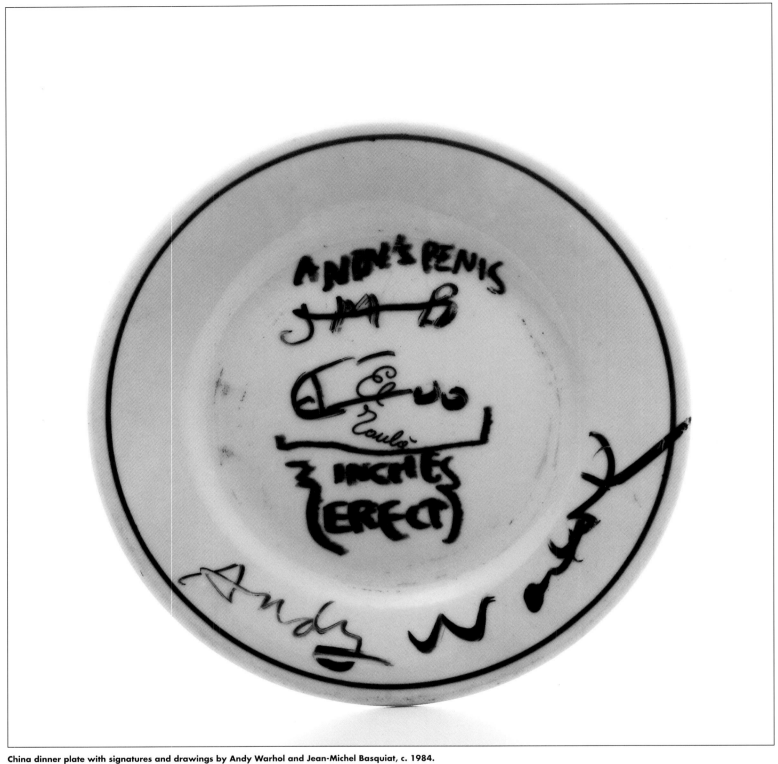

China dinner plate with signatures and drawings by Andy Warhol and Jean-Michel Basquiat, c. 1984.

a lot of fun. The three of us sat in the corner, and we didn't give a damn about the other people.

People were asking for autographs, and Andy and Jean-Michel didn't know where to sign, so I told them to use the plates. And of course the entire room, there were two hundred people I guess—everybody wanted to have a signed plate. The El Toula restaurant owners were desperate because they had no more plates. But I knew the owner, the director, the manager, the maitre d', everybody. So I told them, "Give me a plate, and I'll have Andy sign it for you."

Of course, *then* they pulled out all the dishes. Finally, a great stack of dishes came out. And Jean-Michel started drawing on the plates with Andy, one after the other. Jean-Michel did his crown drawings and some other little things.

That night, Jean-Michel asked me for money. He said, "I need $4,000 cash tomorrow. And I'll give you two paintings of mine. When you come to New York, I'll give you two big paintings." I said, "Jean-Michel, I *want* to buy your paintings, but I cannot give you cash in dollars. Tomorrow is Sunday. I can't go to the bank." And in those days, we couldn't really ask for American dollars from the bank very easily. It wasn't very easy to get $4,000 in a minute. So I said, "OK, if you insist, if you insist. I will do my best and try. But sign this paper because you have to give me the paintings."

You could never talk to Andy in those days; Andy was not talking. Andy was like this lamp – a part of the decoration of the space.

You know, I still don't have a painting by Jean-Michel Basquiat. I wrote a story on him when he just started painting, and I went to his studio in the basement of Annina Nosei Gallery in SoHo. I wanted to buy the paintings for the longest time. He was so crazy. He'd say, "No, tomorrow, today I don't think so." After that, I went to his studio again. I said, "Listen, Jean-Michel, I've asked you so many times. I want to buy a painting. When you feel like giving them to me, you tell me because I can't do this anymore." Every time I came to New York I didn't want to have to say, "Can I come to your studio and finally see what you have to sell me?" Like begging! I really wanted a painting because I thought he was a great artist. And I don't have anything.

We'd like to know how you met Andy in the beginning.

You know, I don't remember how I met him the first time. I don't have strong memories sometimes. But I remember the beginning was at Max's Kansas City. I think it was 1970 perhaps or 1969. Andy had been shot a couple of years before, so he was still very shy and filled with fear. I saw him there, he was in a corner. All the kids from the Factory were around him, making a protective cage. I tried to talk to him, to make conversation. You could never talk to Andy in those days; Andy was *not* talking. Andy was like this lamp – a part of the decoration of the space.

A year later, after I had seen him many, many times, I finally understood something about him. I understood that he was completely afraid. And much, much later I understood that he was afraid because he had been shot. Initially, I didn't understand why this guy was going out every night, never talking to anybody, always with this group of people forming a human cage, a human shield around him. I thought, Is he having fun? I came from Rome, from Italy; I'd never seen people like that before. Andy was a very

unusual creature to me. He didn't talk, he didn't drink, he didn't do anything. He didn't even move from the corner.

I started to go out with Andy every night. Kids from the Factory would call and say, "Daniela, let's go out tonight with Andy." That's how it all started. But even though I went out with him, I never spoke to him. I think it took at least twelve months before I heard the sound of his voice.

What was the first conversation you had when he finally spoke?

I can't remember, you know. For ten years I only rarely heard his voice – a very limited edition of words, darling. A few years before Bob Colacello came on the scene, Andy started to go to Rome. I used to live in Rome, and I used to write about the Roman scene for *Interview*. I came to New York as a model during that period, so Andy asked me to write a column for *Interview* from Rome. And I said, "Andy," (at that time we were talking evidently), "Andy, I can't do it. I don't know how to write. I've never written." He said, "Don't worry. Write exactly the way you talk; tell me what's happening there." Of course, he wanted only glamour, the fabulous people. He wanted to know about the Prince and Princesses Barberini, Colonna, Orsini, what they were doing, what the young people were doing. Who was fucking whom. How the parties were.

Andy adored Rome; he adored the scene; he thought that the parties were divine, that there were the most good-looking young people. When it was summertime we would go to the beach together. Andy would be all dressed in white, completely covered head to toe with a hat. There were all of these gorgeous young Roman kids playing volleyball, football, or soccer on the sand. Andy was ecstatic. Once, he asked me very precisely, "Do you have to

Andy adored Rome; he adored the scene; he thought that the parties were divine, that there were the most good-looking young people.

open your legs for all these boys?" I had never heard him be so specific before. I thought that was vulgar. I said, "Of course, I don't have to. What are you talking about? Andy, what do you mean? You think because these are gorgeous…" I mean, I wasn't even *looking* at those guys, but *he* was looking. "You think that because they look gorgeous to you that I'm in love? I don't even look at them." He said, "No, that's not possible. What are you saying?"

I remember great people coming to Andy's parties in Rome. People like Paulette Goddard and Giorgio Sant'Angelo, who gave parties at his villa. There was a big scandal one night. Andy's villa

was old, not very well kept; the maintenance was a disaster. The pipes exploded in the bathroom shower upstairs one night when the party was supposed to start. Nobody was organizing the party. Imagine Paulette Goddard with big diamonds and rubies everywhere arriving with Anita Loos amidst all this chaos with the water running down the stairs in the living room. It was at the Appia An-

> # I think that Andy was too generous. I always thought to myself, You know, he is a big artist. He should be a little bit more selective.

tica next door, where Sophia Loren and Gina Lollobrigida had their villas and Andy felt that to be next to the stars — it was marvelous. Andy said, "This is real Hollywood." Every day, he met a prince, a princess, a count, a baroness, and so on.

Can you tell us more of what it was like when you first started to write for Interview? *What was Andy's involvement in the magazine?*

I think it was 1974 or 1975 when I became the European editor for *Interview.* By that time we became a little more professional. Andy always had the last word, especially in the beginning. Later, Fred Hughes had the last word on the cover. Not everything was Andy's idea, but Andy *was* the magazine. The magazine would have never looked like it did if Andy hadn't been there. Like with the films — he didn't do anything, but he did *everything.* It's very difficult to explain. The man had the ideas, the courage first, even if everybody else was helping. Andy was Andy, Andy was the genius.

During that period, we were really friends. Andy had changed. He was not afraid anymore. He began to speak with different people, and we started to go out every night to Studio 54 and all of that. I have to say that during the last days of Studio 54, I saw Andy talking to young kids and touching them, even kissing freely. From Max's Kansas City to those days was a total evolution. A complete personality change. He behaved just like everybody else at Studio 54, while before at Max's Kansas City, he behaved like no one else. I was totally shocked when I saw him sticking his tongue in the mouth of young boy at Studio 54!

I think that Andy was too generous — making himself available to a lot of people. I always thought to myself, "You know, he is a big artist. He should be a little bit more selective." Because if you are

Daniela Morera sunbathing in Atlanta, Georgia, c. 1981.

too obvious, you're open for anything, people don't take you seriously. You diminish your own value if you are too available. I was always very respectful of what Andy wanted to do and about how he wanted to do it. Perhaps it was a new style of being and living. But sometimes I tried to give him a little good advice, of course.

Did you ever see the Studio 54 drink ticket painting that Andy did during those years?

Yes, I've seen it. I was with Andy so much at that time, and when you are in the middle of it, you don't think to collect all of those things. Unfortunately, there are many things that I didn't keep. I didn't keep a diary of the dates and those things. In those days, who had the time? And, you know, I had another life. I had a husband, my life in Italy, my other work that had nothing to do with *Interview*.

I still remember when you'd come in to the Interview *offices on 860 Broadway, and you'd be wearing long leggings. And I thought, Who's that? She's so elegant. You'd just whoosh in, and then you'd whoosh back out and fly back to Europe.*

Exactly. I wasn't really dedicating all of my time to Andy Warhol the guru.

Andy changed again after that glamorous period of Studio 54. He had become more and more international and extremely wealthy. I started to see that Bob Colacello had no more respect for him; Fred Hughes, in particular, had no more respect for him. The way Fred treated Andy – I could not believe it. As I told you, I always respected Andy very much. He was so delicate, he was so fragile. Perhaps he was a bitch and he wasn't so fragile. But that's the way I saw it. And the way Fred was disrespectful – that really

Daniela Morera and Andy Warhol, c. 1981.

> I always respected Andy very much. He was so delicate, he was so fragile. Perhaps he was a bitch and he wasn't so fragile. But that's the way I saw it.

was very painful. It was like an old marriage. They couldn't stand each other. Still, the whole time I was there, I never heard Andy treat Fred badly. I don't want to say that Andy was an angel because we know that he wasn't an angel. But at least he was Andy Warhol. Why did people working for him, why did his friends, have to treat him so badly? Believe me, I was shocked.

But it was all a sign of what was really happening in his life. Not everybody was paying attention to Andy anymore. He didn't have all of those big parties to go to every night, all of those incredible people giving dinners for him anymore. The times were different. Even me. If Andy called and said, "Daniela, what do we do tonight?" I might have had another group of friends that was more fun for me to go out with because, with Andy, it became a little repetitious. He had sold himself so freely that suddenly it was just the same scene.

I remember that Andy wasn't invited to Madonna and Sean Penn's wedding, and he did *want to go.*

He asked Keith Haring to help him to be invited. In those days, he had to push a little bit to make big things happen for himself.

Tell us about The Last Supper *exhibition. Wasn't it in Milan across from the original masterpiece?*

It was exactly across the street from the church, Santa Maria delle Grazie, in Milano. It was the last show of his life. It was a major show, wonderful work. People finally have started now to

recognize how incredible *The Last Supper* collection is. And when you see it, in the museum in Pittsburgh, in that space it's divine, divine!!

Andy came to Milano for the show, bringing his friend, photographer Chris Makos, with him. I was constantly on the phone with Fred Hughes before Andy arrived. They had asked me to check how the people in Milano were handling the show. So I was their inside curator and press office more or less. The gallery people had their own curator, of course.

When Andy arrived, he was tired. He was in pain, the gallbladder pain. He wanted to stay for only two days. He wanted to go back to New York immediately. We had the press conference in the morning before the opening of the show. And of course, Andy didn't want to hold it. I said, "Andy, I don't know how to say no to every press request. One press conference, only. Because you don't want to give interviews directly to the journalists, do one press conference." Of course you have to do some publicity and Andy was the king of advertisement!

When we went to the press conference, Andy was wearing dark glasses. I remember this very funny question that one journalist asked, "What is your connection with Italian history and culture?" Because, you know, there we were near this Leonardo da Vinci masterpiece. And Andy said, "Spaghetti." I thought it was so funny. I said, "This is so Andy. I hope that the people understand." Pizza and spaghetti—it is so banal. I thought it was the most clever answer. And I said to Andy, "This is the most Warholesque line that I've heard in a long time."

What was the actual opening for the exhibit like?

The opening was the biggest success ever. And I was so happy because in New York at that time, Andy didn't have this incredible audience. In Milano, darling, kids from the South of Italy came by train. They traveled all night. People in the art business, graphic

Last Supper, 1985–86. Synthetic polymer paint and silkscreen ink on canvas.

I think the pre-pop drawings, for instance, are so sublime. The soft lines are very unique. The drawings of the shoes are masterpieces.

designers, fashion people from everywhere. We were expecting five hundred; around five thousand came. The whole street was blocked; it was the most incredible scene. I couldn't believe it was real. Andy was so exhausted; he was in so much pain. I found a little table in a corner. I asked two of the guards to push it in front of Andy, Chris Makos, and me because the crowd was suffocating us

and we didn't have any defense, nothing. Then Andy, after signing the posters, *Interview* magazines, invitations, and any other piece of paper available, started to sign glasses, ties, bags, bras, scarves. Everybody was giving him something to sign. They were craving for the guru's signature. Finally, I said, "Andy, you're tired, let's go." "No, no, I'll finish it," he answered. He was so sweet, so sweet, really, very generous with everybody till exhaustion—a real pro-star!

Anyway, the opening went very well; it was fantastic. Andy went back to the hotel, and he didn't feel well at all. He said he didn't want to take medicine. Instead, he ate some chocolate and felt worse. Two days later, he left for New York. That was exactly one month before he died, the exhibition in Milano, exactly one month before.

A couple of weeks later, I arrived in New York myself. Andy wasn't feeling well. I called him a few days before the night he died, and he told me that he was in pain and that he had to go to the doctor. He was scared, and he didn't want to go to doctors in general. I asked Andy what he was doing for the weekend. He said, "I'm staying home." I said, "O.K., so I'll call you during the weekend to see how you are, and perhaps I'll see you or, if you want, we can take a walk together or something."

I called him on Sunday. I woke up, it was around 11. On Sunday, I don't wake up very early. I woke up, and thank God I was in bed. I called, and I said, "Andy?" And the voice on the phone

said, "No, this is Fred." I thought, My God, what is Fred doing on Sunday morning at Andy's house? I said, "This is Daniela. I told Andy I was going to call today to see how he was doing." Fred said, "Talk to Vincent (Fremont)." He was very tense. So he gave me Vincent, and Vincent said, "Oh, Daniela, I'm sorry to tell you, but Andy passed away a few hours ago."

I collapsed. Thank God I was sitting on my bed because I collapsed. It was absolutely shocking, absolutely shocking. I started to cry like a maniac. I said, "Vincent, let me come. I want to see him. I'll come immediately." He said, "No, no, no, it's impossible. No, no, no, nobody can come. Listen, you can't even come later." They were business-like, Vincent and Fred. They were rude and very distant – more than business-like. I said, "But this is impossible, I can't believe it. What do you mean he's dead? Which hospital is he in? I want to go see him." "The man is dead," Vincent said, "No, no, it's impossible Daniela – don't ask. We are in the middle, we have so many problems, don't give me problems. We have to deal with the lawyers!" I said, "OK, Listen, can I call you later?" "OK, yeah, don't worry, I call you, you call me." But that was it. Of course, they didn't invite me to the funeral in Pittsburgh. Later, they did invite me to the memorial service at St. Patrick's Cathedral.

What would you say is one of your favorite Warhol works that you feel encapsulates his career?

Many. I think the pre-pop drawings, for instance, are so sublime. The soft lines are very unique. The drawings of the shoes are masterpieces. Of course, the *Marilyn*, the golden canvas with the little Marilyn in the center of the painting. That's the beginning of his really strong pop statement. It's a masterpiece. But there are many. There are so many. The *Car Crash* – incredible. The *Elvis Presley*. The *Jackie Kennedy*. The *Coca-Cola Bottles*. The man did incredible, incredible work.

Have you been to the museum in Pittsburgh?

Yes, I was there for the opening. Many people criticize that museum. Every museum, the way it is organized, the way it's designed, of course can be criticized. It's so easy to criticize. I know that Andy wanted a museum in New York, and perhaps he didn't want one in Pittsburgh. But he was born there and I think that the museum – for that city – is an important statement.

When I went to the opening, I thought the layout of the exhibition in certain rooms was fantastic. Certain others were a little less. Everybody follows his own idea of how he would want to exhibit a certain artist. I thought it was a great idea to open the museum for the whole night, for forty-eight hours. I thought it was very Warholian. I adore the room with the Shadow paintings displayed on all the walls. To see all those paintings, all the shadows

abstracted in those beautiful colors. I thought that was fabulous, fabulous.

I think that Andy was a great, great artist. He still has an incredible influence on our future. It will take another twenty years to understand his real values. I have to say that after he died, I was completely sad. My husband teased me. He said, "Daniela, please, don't play the widow. Come on." I didn't go out for four or five months. I could not attend social events. Then I started to realize that every layout I looked at in a magazine, every style of ex-

I think that Andy was a great, great artist. He still has an incredible influence on our future. It will take another 20 years to understand his real value.

hibition I saw — everything reminded me of Andy. Everything we wanted to do — Andy did it before. I'd say, "Nothing is original in this world anymore." Now a few years have elapsed, so I'm more detached. But the first year after Andy's death, there was nothing that I could find exciting. Everything for me was a copy of his actions or at least inspired by him.

Someone at Andy's memorial service said something that we thought was very true. They said that when they found out that Andy had died, they expected the physical landscape of New York to change somehow. And I had that same feeling. The skyscrapers should be gone. Or something should look different because it sure felt different.

Yes. His influence is enormous. People don't realize it. Somehow Andy thought prophetically in so many directions. Like his idea of having the automat restaurant with the TVs for each individual. People now, what do they do? They fuck through TV, right? The Internet has turned into communication. And Andy was like that. Andy was the first person to say, "I want to be like a machine." What's happening today? We are becoming machines. Look at the famous line, "Everybody will be famous for fifteen minutes." Didn't that come true? Today it's three minutes, actually. You see these talk shows on television with these people who don't have any support from family, society, friends. So they go tell the TV audience on these stupid talk shows; a couple says that the husband fucked with his sister, and they are raising the baby. People used to go to priests with their problems. Then they went to shrinks. Now they go on TV. It's everything. TV is saint, devil, companion, friend, lover, supporter. Andy somehow foresaw that: "I want to be like a machine." Unfortunately, we are.

I *don't* want to be like a machine. I remember a funny story. I look a little bit like Diane von Furstenberg. And when I came to New York, some people would call me Diane or they would call her Daniela. So Andy said to me, "Daniela, why does Diane have such awful taste. You have better taste, why don't you do something like her in fashion.? You could do it much better with your style!" I said, "Andy, I can't because I don't want to dedicate my life to money." I didn't want to sacrifice myself, my life, my privacy to become rich, to become famous. But for so many years, Andy said, "Daniela, you know, I don't understand you. You don't like money, and I don't understand why you don't." And I said, "It's not that I don't like it." He didn't understand why. He saw that I had the potential to become very rich, to take advantage of the moment. But my ambitions were different. My ambition is freedom and growing my consciousness, my ambition is not money and becoming famous.

Did he ever give up trying to convince you?

No, he never understood. I said, "Andy, I want to live with beautiful things. I travel very luxuriously, I go to beautiful hotels, I want to take divine trips. That's what interests me in my life — traveling and discovering. I don't want to become a slave of my own business." Even Andy, as you both know, was a slave of his Factory.

Andy had the type of personality that never knew when to stop.

Who needs all that money to leave to your foundation when you die? Look what happened at the Andy Warhol Foundation: they spent most of the money in litigation. So why do I have to struggle all my life to make all the money, for what? You can't take it with you when you die.

To me, though, Andy was Andy. I never was treated badly when he was alive. When Andy died, they started to treat me very badly. They tortured me. I loved Andy, I respected him, and the rest of the people I don't give a shit about them — that's the bottom line. Other people say that Andy manipulated them. I don't know, darling. If somebody manipulates you, it means that you want to be manipulated somehow, don't you think? Don't blame it on Andy. People say he was tight with the money. But all those people were worse. Everybody has their own point of view, of course. But I was not a poor girl from the Midwest or a little junkie from New York or a gay guy who wanted to be around Andy for fame, for fun. I had my identity, I had my job, I had my husband, I had my beautiful international life.

I didn't go there looking for anything. I didn't want anything from him. It just happened that I met Andy. So my point of view could be closest to reality. He was much more famous than me, much richer than me, and I ended up helping him.

Paloma Picasso photographed by Andy Warhol at the Council of Fashion Designers of America awards dinner, January 1985.

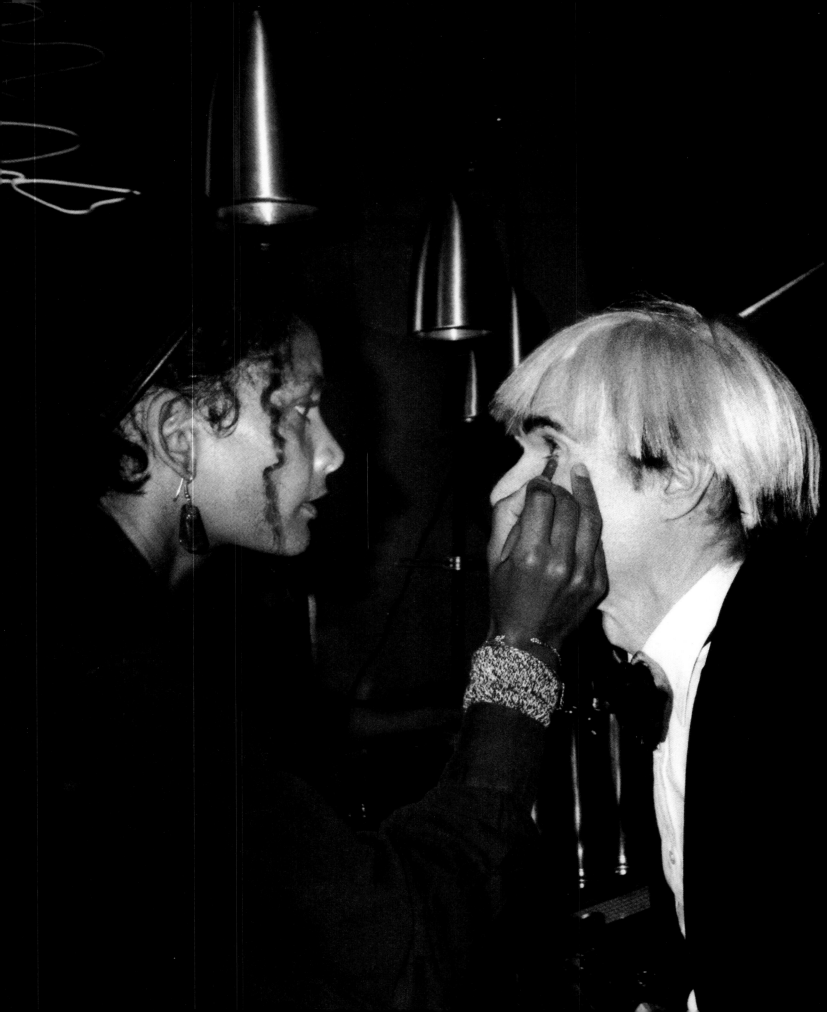

Don Munroe

From Film, to Video, to *Andy Warhol's TV*

After ten years with Warhol, Don Munroe continues to make fashion and music videos for MTV and commercials for fashion designer Cynthia Rowley, Jordache, and many others. He often works with longtime friend Marc Balet at Balet & Albert Advertising and for Vincent Fremont at the Andy Warhol Foundation. He is also developing a television series based on the club and dance music scene in New York City.

Marc Balet told us that you went to college together at RISD. He also mentioned an exhibition Andy put together there. Did you see it?

The first time I ever met Andy was at the Rhode Island School of Design Museum where he had curated a show called *Raid the Icebox*. The show was perfect for Andy, who was fond of rummaging through flea markets and collecting off-beat objects like cookie jars. He rummaged the museum's basement and mounted an exhibit of obscure antiques. Everyone was pretty excited about his visit and he arrived by charter bus with a little entourage that included film director Paul Morrissey and a very exotic tall black model. This being the '60s, a lot of the students were involved in various protest movements, and to some of us Andy stood for *New York*, the very center of the art world and *Freedom* – social, political, artistic, and sexual freedom.

A few of us, including our own campus radical, Jinx Rubin, hatched a plan to interrupt Andy's news conference with the local papers and TV stations. We would make a statement – a loud protest to end the war in Vietnam. We thought Andy would love this. Andy would be with us.

As the TV cameras rolled, the local anchor man, Providence's answer to Ted Baxter, was becoming very frustrated with Andy's non-response to his questions. Andy's interview technique at that point was to have anyone but him answer the questions. The black model who was speaking for Andy was giving the newsguy what we now call "attitude" and he was becoming angry. He started yelling at Andy, "Why don't *you* answer my questions? Did you come all the way here to say nothing? Don't you care?"

All of a sudden Jinx jumped up and screamed, "Well we've got something to say – Out of Vietnam Now! Strike, Strike, Strike!" Andy was so startled, he almost fell over backwards. You could see his whole entourage's hair stand on end. They fled that scene faster than you could say "Power to the People."

But, you know, thinking about that first encounter now, I believe that's when I first saw the real Andy Warhol, a shy guy, a loner not a joiner, someone who never instigated controversy around him. It just happened to Andy. He was an event magnet – one who attracted society's more extreme cases. However Andy felt about the politics of the times, he kept it private. He made his own protests in his work, letting his art and others speak for him. He was the original poser: he remained the center of things all his life by keeping quiet and letting it happen around him.

When did you get involved in video at the Warhol Studio?

I was directing a video studio for Bloomingdale's department store in the mid-'70s. We were doing a lot of fashion, and at the time Bloomingdale's was the hippest and trendiest thing going. Can you imagine a department store throwing these parties with the cachet of an exclusive club? Well they were doing it. They also employed quite a few very talented, very creative people. They had Candy Pratts doing outrageous windows – now she's a fashion director at *Vogue*. They had Carrie Donovan in advertising and fashion photographer Helmut Newton did a very sexy lingerie catalogue. They knew how to get a lot of attention.

Make-up artist Sandra Bocas prepares Andy Warhol for the filming of The Cars video "Hello Again," c. 1984.

We were shooting a Bloomingdale's cable TV show about a big store promotion at the time. My friend Marc Balet had introduced me to Vincent Fremont, who had been shooting a lot of video around the Factory. Vincent was developing a TV show for Andy, and brought me in as the director. Marc and I collaborated on the first shows, which were called *Andy Warhol's Fashion* — a series of ten shows about the New York fashion world.

Andy then agreed to do a cameo in the Bloomingdale's show and we shot Andy's fashion show intros in the Bloomingdale's video studio.

Our first show was titled "Models and Photographers," and Marc came up with the idea to get three models and three photographers — one just starting out, one who would probably never

> *Fifteen Minutes* had a *Brady Bunch* opening. We used a quad screen in other words. The idea was to have Andy up in one of the corners almost like *Hollywood Squares.*

really make it but would be influential, and one seasoned master. The models were Phoebe Cates, Amina Warsuma, and Lena Kansbod, who at that time was one of the biggest models around. Her face was everywhere, but she had a really thick accent, so she never really made the transition into acting. She was very Swedish. We got great, great quotes out of her. We got everybody. The models would just begin speaking and go on and on — this was before the era of the pro-handler.

We took what they were saying and juxtaposed it against everything else. For instance, we had Phoebe Cates saying, "Oh, going on a trip is so much fun. I just love it, love it, love it. I just went to Morocco with Bruce Weber and it was just so great. The girls were so great and everything. We had such a great time." And then Lena said, "Well, going on a trip is a problem because you never know who you're going to have to sleep with and you never know if you're going end up with an ice cold shower and some bitch who just nags and nags and nags." She got into it on a diva level. And then I asked, "Does that happen a lot?" And you heard Lena say, "It doesn't happen anymore." It was one of the all-time greatest lines. Amina also had some great lines. We used Amina to point out the reality of it. She was just no-holds-barred. If she saw another model, she just wanted to take a gun and kill. *Kill, kill, kill!* When the show aired, it produced such a scandal. Johnny Casablancas called up Andy and said, "How could you do that? My God! She's ruined, she's ruined. The show's ruined. Oh, my God."

Later, we started expanding the show into a slicker version based more on the ideas behind *Interview* magazine than on the idea of fashion.

Where did you film the show?

We did the first three shows in the Bloomingdale's video studio. And then Andy purchased a lot of video equipment. Broadcast-style equipment, so we could run around. That changed the show because we weren't stuck in the studio anymore. We did a lot more location shoots, went to clubs, started covering the new clubs opening downtown and shooting the art community as well. At that time, there were a lot of really small clubs. They came at the end of the Studio 54 era. Clubs like the Mud Club and the ones that would open just for the weekend and then you'd never hear about them again.

When did you first start doing shows for the Madison Square Garden Network?

There was a guy who was a sports-star agent whom Andy knew well, and he got us involved with Madison Square Garden. We did shows for them that were more formatted and interview based. We had a real deadline schedule, so it was less experimental. But we still did some great shows for them. The Diana Vreeland show with the interview by Henry Geldzahler was one of those shows.

And by this time the show was known as?

Andy Warhol's TV. First there was *Andy Warhol's Fashion* on Manhattan Cable, then *Andy Warhol's TV,* and then *Andy Warhol's Fifteen Minutes* on MTV. *Fifteen Minutes* had a *Brady Bunch* opening. We used a quad screen in other words. The idea was to have Andy up in one of the corners almost like *Hollywood Squares.* And, as in the *Brady Bunch* opening, everyone's sort of looking at each other and smiling and doing crazy things. Whoever was in the show would be in the opening. Like Diane Brill, Grace Jones, and Paulina. The premise behind the show was to have Andy sitting watching TV and changing channels — channel surfing.

Do you connect today's way of constructing a show, like VH1's Fashion TV, with what you guys were doing nine or ten years ago?

Oh, yes. But that's always the way it is.

How did you decide to change the pacing on the show from a longer format to the shorter one of the MTV show?

Everyone gets fifteen minutes of fame — that was what it was about. Except our tag line was that today, you only get fifteen

A frame from the opening of *Andy Warhol's TV*, c. 1983.

seconds. So make it good. And that created the pace of the show – next, next, next, next. When we first started doing the Madison Square show – well, you know Andy was the guy who had the stationery camera focused on the Empire State Building for twenty-four hours. He was *very* unsure about fast cutting. And we said, "Well, you know, this is the way the world is going. Things are going to get faster and faster." And it just got quicker and quicker. In the first show, we'd do one subject throughout. By the end of the series, it was ten or twenty.

No critic ever understood the meaning behind the pace, with the exception of Caryn James in a piece she wrote for the *New York Times*. She understood part of it, but she connected the fast-paced click with MTV instead of with Andy changing channels. All MTV wanted was Andy's name. We could have had him sitting on a toilet for half an hour. They would have been really happy. I think today's equivalent of *Andy Warhol's Fifteen Minutes* is *House of Style*. "Let's get a superstar model and have her be the spokesperson." So basically, Andy Warhol turned into Cindy Crawford.

I think he would have been happy to know that. Did Andy ever ad lib his lines or did he always read them?

He got better and better at being on camera, a lot more relaxed. Really, the whole peak of the TV show started happening when Andy left this planet. In the beginning we used to have to almost trick him into being on camera or to come down and say hello to people. He really was very shy and sort of independent. One time I was going to interview this guy from Brazil, absolutely beautiful. And I said, "Andy, I want you to meet this guy. He does TV in Brazil." And he said, "Oh, I've got to meet this guy? I don't *want* to meet him, I don't *want* to meet him." I had to drag him over.

What kind of input did Andy give on the shows?

Well, one of the best things he ever said after the first "Models and Photographers" show was that the colors just didn't look real. We used really bright colors. These big pink and blue and orange

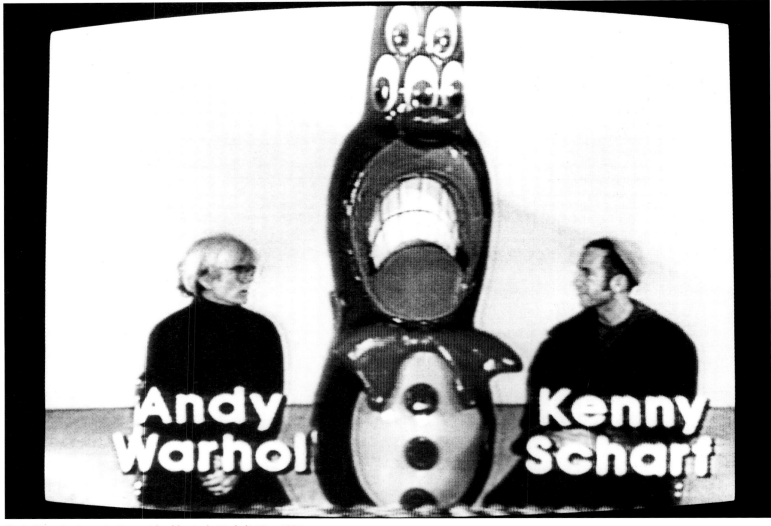

Warhol interviewing artist Kenny Scharf for *Andy Warhol's TV*, c. 1985.

backgrounds. It was an interesting thing for Andy to say since he was such a colorist himself.

The only time I ever saw him get mad at me was when we had this deal with a new personal computer company, whose product wasn't quite ready for the marketplace yet. The idea was to take the video and put it through the computer and have the computer do all these great things, fancy Jurassic Park-type things. But the model was a pre-release one, and it just wasn't working. One time, the computer operator picked up the mouse and threw it against the wall, smashing it. There were so many problems with it, but finally we got one short piece from it.

When Andy saw the piece, he came down and said, "That looked *terrible*." It didn't really look terrible, it was the machine that was inadequate. It never went anywhere, and Andy never did get the ad. He was pissed.

Evidently, as soon as a show would come out, Andy would be very complimentary about it. And then three days later, he would start saying, "Well, why don't you do this differently or that differently?"

Right. He would see it again. When you see something once, you're just amazed that it ever got put together. And when you see it a couple of times, then you can start getting critical about it.

Do you know what kind of TV shows Andy watched?

He watched reruns of news. He was very interested in what was going on. Part of Andy was about the very next thing and the newest thing and the latest thing and a curiosity about the entire world—what's happening there, what's happening here, who's got the most money, who's got the most talent. It was the curiosity of a newshound. I know a lot of people today who watch news twenty-four hours a day. *CNN, Headline News, News One, News Two, ESPN2.*

Tell us about the music videos that you did. Andy appeared in The Cars video, "Hello Again," didn't he?

The video began with a car crashing through an MTV studio and with people talking about sex and violence on MTV, which at

136

that point had just become a real issue. A lot of tongue action going on between shots of people kissing, making conscious references to Andy's other films like *Kiss.* Andy was the bartender and sang the chorus. Looking back on it, it was interesting because it was shot in all different kinds of formats, which was unusual for the time. We used a Super 8, which was also unusual. We were doing something a little rougher instead of trying to be really slick. Super 8 film is grainy, the shaky camera, which became very much a cliché of the '80s, and the sort of *I Spy* quality of it. We also used a lot of props. We had the word "hello" on Diane Brill's breasts. We had it on a guy's tongue. And we had specially created earrings that spelled out "Hello Again."

Who had the idea behind the video made for the group Curiosity Killed the Cat? Wasn't it a remake of the Bob Dylan film?

The original Bob Dylan clip was from *Don't Look Back.* The song was "Subterranean Homesick Blues." We used the mylar mirrors to distort the lead singer. These guys were very cute, and the lead singer liked dancing a lot, very into himself, a model. We

had the idea of getting a mirror and letting him dance in front of it a lot. So we got these huge mylar mirrors, and I got very interested in what was happening in the mirror. All these wonderful distortions, which were actually used three years before in a fashion show for Stephen Sprouse, who was one of our fashion victims in the original *Fashion* show. We wanted to get Andy in it. And so I thought, Let's go back to that great scene from that movie *Don't Look Back,* where they had Allen Ginsberg in the alley holding up the cue cards with the words to "Subterranean Homesick Blues." We did that, but on Andy's cards, nothing was written.

Did you use black and white?

Yes. Woody Allen hadn't done *Manhattan* yet, which got everybody interested in black and white. How beautiful. On television, black and white was a dirty word. "It doesn't sell, it doesn't sell." How many times have I heard that. Before we went to MTV, Vincent and Andy and I would go to the meetings. And this one guy was the funniest. We showed him what we were doing, and he said, "Oh, God. This is all wrong for TV. This is what you've got to do.

A scene from "Hello Again" music video, c. 1984.

Vincent Fremont, Marc Balet, and Don Munroe on the set, c. 1984.

We've got to get a studio. We'll get an audience. Andy the host. He's in front. He'll introduce everybody and get the show going. And then we'll have the guest come from the audience."

When MTV came along, they were totally into Andy, Jack Nicholson, Duran-Duran. MTV was all about being hip and cool and packaging what were basically little three-minute ads.

How would you determine what would go into a show or a video?

Well, we started with the general theme. The first show we did for MTV was sex, vegetables, and drag queens. It was the gayest thing. And it was 1985 when people were starting to hear about AIDS. So for MTV to go ahead and put on this crazy, very gay show was pretty good. MTV is certainly not afraid of controversy and never has been.

Drag queens were also becoming very glamorous then. We positioned them as a form of performance art. Lady Bunny, John Kelly, who's now like a huge performance arts superstar. Hapi Phace, The Jackie 60 crew, all those kids. They were all in it. We also got this baby, baby drag queen whose name was Jelly Joplin. We filmed him having a shit fit in the dressing room and getting onto his bicycle and leaving. Then we followed him and went to all these different clubs that he went to. So the show was based on him running around.

With wild pumped-up Love and Rockets music in the background, it was so fast paced it sounded like background tracks to Sylvester's music.

We loved finding really great music. Ben Hollander chose a lot of it. And a lot of it was from London. Some of it never made it here, at least in terms of the Top 40. A lot of it was what we were hearing in the clubs. The music was always a very integral part of the show.

What were the vegetables about?

Everyone we interviewed was so into being vegetarian—it was sort of a joke. Vegetables were supposed to increase your sex drive.

The last show that aired right after Andy died was the most "out there" show of all. It was about these boots, based on Eleanor Anton who was sort of a sensation in the 1960s, a performance artist who would take these boots and put them in museums or put them in SoHo or put them in galleries. They went around the world, these boots. So we had her boots walking around Manhattan. Andy was no longer there. Who was going to fill his boots? Nobody. That was the subtext of that final show. We were all in such a state of shock.

If there's one thing I learned from Andy about interviewing people it is that you don't have to do the traditional thing of asking a question and letting the whole thing be about two personalities talking to each other, like the talk show host and the guest. What we did was into the camera; there wasn't a host really. There was Andy, but he was always off someplace else.

On the phone.

On the phone or sitting down or talking to somebody else. We certainly had a knack for getting very verbose people. Sometimes we would throw two people together and see what happened. That was the wonderful thing about Andy—he'd really let you do what

Ric Ocasek of The Cars on the set, c. 1984.

you did. And the only criticism he would ever have of it was when you did something that wasn't good.

Did Andy ever appear on any TV talk shows as a guest?

People were always trying to get Andy to be a guest on their shows. But he would never do it. It all went back to the *Merv Griffin Show*. His one and only talk show. Merv Griffin tells the story. I never heard it from Andy or Vincent or anyone else. It must have been the late '70s. He went on the show and just froze up. He didn't say anything. And of course, Merv Griffin thought that it was arrogance, and it was very awkward. "I couldn't get anything out of him. I said, 'Well, just shake your

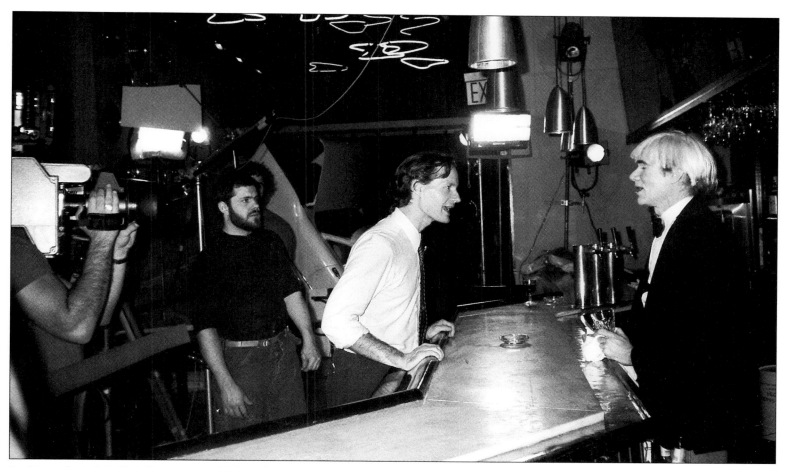

Don Munroe directs Andy Warhol in a scene from "Hello Again," c. 1984.

head up and down.' Yep." So I guess, that's what Andy did. He was very shy.

And he didn't come on the show with a beautiful, black woman?

Oh, no. They wouldn't allow it. Just himself.

He also had trouble on the Love Boat *trying to remember his lines.*

Right. They changed the lines for him. That was a funny little piece. To see the entourage that they picked out for him. Their version of the Andy Warhol entourage. But people always felt that it was some sort of personal slight when he wouldn't come on a show. They didn't realize that it was because he was shy.

When Andy died, what were you working on? What was in process that maybe didn't get realized?

Oh, certainly a lot of things. I can't remember specifically what direction the show was taking at that time. But I remember one shot that I have of Andy walking down the runway. It was right before he went into the hospital and he was groaning, "Oooooh, oooh, ooh."

On tape. He was faking it. Well, maybe he wasn't faking it. He was playing off of what was really happening. He always had that off sense of humor. At one show, a famous rock star didn't show up and Andy said, "Offer cocaine – he'll be here in two seconds."

Were there special qualities to Warhol most people didn't get to see?

The thing that people don't realize about Andy is that he really helped so many people get their start. You can make a major list of people that he helped out from Keith Haring to Jean-Michel Basquiat to fashion designers like Stephen Sprouse. And then bringing in a group of talented people like Fran Lebowitz, Marc Balet. He was a patron to a very large family of people. What Andy did on a day-to-day basis I think is very interesting – the way he helped people out and brought them in. He was a very positive influence. I think that when people think of Andy Warhol, they have a negative opinion of him. And he was much more than that. He was prophetic when he said, "Everybody will be famous for fifteen minutes." Everybody's going to turn to tribes. Now there's gay this and lobby group that. Today we're a nation of tribes. Artists get together. Everybody bands together under their own little flags. And I think that Andy saw what was really happening. That's what his whole stable of superstars was about – the tribal nation.

John Reinhold

A Personal Take on a Personal Friend

Born in New York City, John Reinhold has his own diamond and jewelry business. When not working, he continues to build and refine an impressive collection of contemporary art. John appeared extensively in *The Andy Warhol Diaries* (Warner Books, 1989) and was a source for Bob Colacello's book *Holy Terror: Andy Warhol Close Up* (Harper Collins, 1990).

The way in which I was introduced to Andy was actually a funny moment. It was around 1979. My cousin, Henry Geldzahler, who was Commissioner of the Arts in New York City, said to me, "It's now time for you to meet Andy." He waited all those years and then said, "Now it's time for you to meet him." So I met him; he came over to my office.

Henry didn't think you were ready to meet Andy earlier? Was he preparing you?

I guess he had felt it wasn't "time" before, and suddenly he felt it *was* "time." That's exactly how he put it. So Andy came over to the office and asked, "Do you want to have dinner tonight?" And I said, "Oh, OK. That would be great." Then a few hours later he rang me up and started naming ten or twelve other people who would be coming, too. And I said, "I'm sorry Andy, but you asked me earlier today if I wanted to have dinner, and I said yes. And I thought that meant having dinner with you, not with ten or twelve other people."

I think he was very taken aback. In those days, he didn't go out to dinners one on one. But he did that night. I didn't realize I was doing something…

Naughty?

Well, no, not naughty. Unusual is more like it. But I thought, How do you have dinner with someone if there are ten other people? It just didn't make any sense to me. I think that Andy was afraid to go out one on one. Conversation sometimes seemed difficult for him.

And what was the dinner like? What did you talk about?

Jewelry, mostly. He loved jewelry. He really knew jewelry; he knew diamonds especially well.

Did he know jewelry from buying it?

No, from shopping. Shopping doesn't necessarily mean buying; it means learning. If you go and look at stuff over and over and over, even stuff that's alien to you, you'll start to understand what it's about; it's not that complicated. Nothing is that complicated.

> And I said, "I'm sorry Andy, but you asked me earlier today if I wanted to have dinner…I thought that meant dinner with you, not with ten or twelve other people."

For instance, if you know nothing about art and you want to learn about it, about the process of art, once you look at six, seven, or eight paintings of the same thing, you'll begin to understand it.

Andy would often bring me things and ask my opinion on them. But what he really wanted me to say was just buy it. We once took a

trip to Pennsylvania. I'll never forget it. It was the funniest little trip. New Hope has a lot of antique shops, and he had an enormous wad of money in his pocket. When we got there, everything was so awful, but he was just dying to buy something. You know how it is when you have cash in your pocket and you want to spend it? He was so upset because he wanted to spend that money. He said, "It's Rupert's fault." He was referring to Rupert Smith, of course, his silkscreen printer who had bought a house in New Hope.

I'm sure Rupert built it up and said New Hope was the place to buy antiques.

Maybe it is, but it certainly wasn't on that particular day. That day there was nothing good. And he knew there was nothing good, but he wanted me to say, "Yeah, this is really great. Buy it." He didn't buy a thing; he was so unhappy going home. He said, "This money is burning a hole in my pocket."

He probably thought the way we do: If there is something you really like to collect, you have it in your head as you sleep. You dream that you have uncovered rolls of antique Fortuny fabric for a dollar at a yard sale and you get all excited.

Exactly.

Well, that's interesting. So then you and Andy became fast friends?

Immediately. I think somehow I was a little bit mysterious to him; I don't really know. It wasn't just because I was in the diamond business. I think I was one of the few people that he was really able to talk to about things that he wouldn't say to most people. We would have these dinners night after night after night.

What was Andy busy doing at that time?

Worrying. He worried a lot. About paying the bills, paying the IRS, paying the kids at the office.

Did you and Andy go out to nightclubs together, for instance, to Studio 54?

Oh God, yes. A typical night was to meet for dinner, and from dinner go to Studio—three or four nights a week. You'd feel like you had been at Studio for five minutes, and then you'd look at your watch and see that it was 3:30 or 4 in the morning. Time really flew. I never understood where the time went. There will never be such a thing again as Studio. Were you ever there?

Oh, yes and one night I remember seeing Drew Barrymore, who was maybe seven years old, on someone's shoulders being twirled

around while Studio's famous giant coke spoon swayed in the background. It was the beginning of the end.

They really were wild times. I used to have to go on business to Africa—we had an office in Sierra Leone. On one trip, all of these Africans came up to me. They had tribal paint on, and they were so

I think I was one of the few people that he was really able to talk to about things that he wouldn't say to most people. We would have these dinners night after night after night.

beautiful. They started asking questions. The translator said that they were asking where I was from. And I said, "New York." The next question was, "Have you been to Studio?" This was out in the middle of *nowhere.* Have you been to Studio?

Interview ran what seemed like an entire issue dedicated to Studio 54. It was sort of a swan song to Studio 54 with interviews about it being so sad that it was closing. It went on and on.

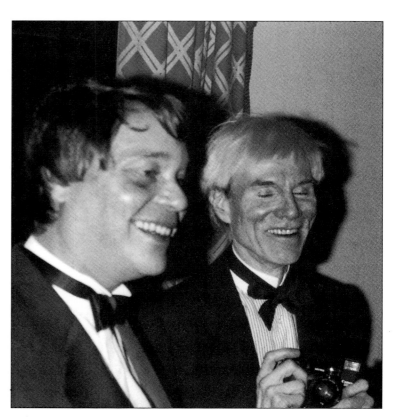

John Reinhold and Andy Warhol, c. 1979.

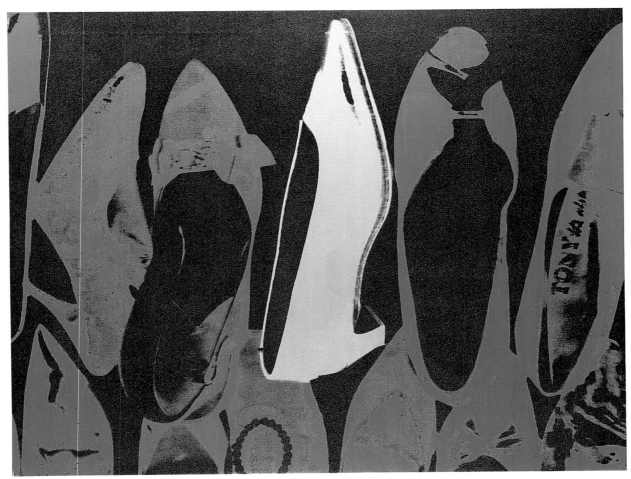

Diamond Dust Shoes, 1980. Synthetic polymer paint, silkscreen ink, and diamond dust on canvas, 90 x 70 in.

The times were different; there was no AIDS. Everybody had loads of money. Money just didn't matter – it was a whole other thing. It was magic, total magic.

In those years at Studio, Andy would actually dance, wouldn't he?

Yes, but he wouldn't necessarily dance with a particular person; he would just be on the dance floor. Not for long. Usually, he would just stand in the back, saying, "This is so great." But once in a while, when he was a little tipsy, he'd dance.

After too many vodkas.

We used to drink so much vodka.

When did you first receive a painting or gift from Andy?

I received my first gift very soon after we met. It was a car in a box, an old car, from the 1920s or 1930s. Andy said to me, "Save the box. Don't throw the box away." And I said, "Why?" And he said, "Because it will have more value." I'll never forget what he said to me about the box. I still have the original packaging.

Did you buy paintings or commission work from him during that period? There were a lot of things in your place on Central Park West. I remember Andy and I stopped at your house once, and two of your Warhols were down on the floor. Andy said, "What are those doing down?" You said, "They fell off the wall. Will you sign them?" And he said, "OK." And then he left. And before we left, I said, "Andy you forgot to sign the paintings." He said, "Shh-hh!" When we got out in the hallway, he said, "I don't want to sign those because he got them somewhere else, *he didn't get them through* me."

I bought those before I knew him. I bought two from Leo Castelli and two from Ivan Karp. I didn't know him when I bought those. What does he want from me?

You also have a five-inch by five-inch Flowers *painting – the four flowers, the little tiny ones – on a side table. Where did you get that painting?*

Well, Andy gave me that first one. And then one day I was so depressed, he asked, "What's the matter?" I said, "I am so depressed. I don't know why." And a couple of hours later, another

Flowers painting arrived, and he had written "Happy" on it. Can you imagine he wrote "Happy" on the back because I was so depressed?

Did you give Andy any memorable gifts?

Well, once Andy said to me, "It would be so good to have pearls that went all the way down to the floor, a couple of strands." So I

I gave him the first jar of diamond dust. Real diamond dust doesn't sparkle, but he played with it. I think what he in fact used was crushed glass.

made a pearl necklace with big pink pearls. The strand almost scraped the floor. I gave the necklace to Andy. But then he in turn lent it to Halston.

To this day, I don't know where that necklace is. I'd say, "Oh, Andy, where are those pearls?" And he'd say, "Halston has them, and he won't give them back."

People have said that Andy would sometimes like to wear jewelry underneath a black turtleneck. He would have a nice necklace or bracelets hidden under his clothes.

Yes, he did. Very rarely would he show peeks of it, but he loved to know that it was there. He adored jewelry. It was his idea to make jewelry out of pennies. The question was, How do you connect the pennies? Andy thought we could drill two holes and then put a wire through them. But I said, "I don't know if we can do that because I think it's illegal to deface money."

So I wrote a letter to the government. The reply was so vague, but it implied that we weren't allowed to do it. And of course, even though it was just a penny, it was an anathema to Andy to devalue money. So instead I made a bezel around the penny, and then he could connect the pennies without defacing them. We made necklaces and bracelets and belts and all different kinds of things.

He gave one of those bracelets to Sean Lennon for his birthday.

Oh, speaking of money, whenever either of us went on our trip, we would divide a dollar bill in half and each keep one half with us. It was insurance for a safe return. When I went away, he would give me half; and when he went away, we would write something on the bill, then tear it in half, and I would give him a half. Actually,

most of the time, I would ask him which half he wanted. He would stare and stare, and he would always pick the bigger half—because you could turn it in and get a whole dollar. I do the same thing now with Marc Jacobs—he's the only other person I do it with.

Your daughter, Berkeley, mentioned an incredible present that Andy once made for her. Can you tell us about that?

He drew a book for her as a Christmas present. It's about forty or fifty pages long. It starts as a partial line drawing, and it continues, and by the very end, but only at the very end, it turns into a dollar bill. It's amazing. I mean, he sat there for such a long time making this book for Berkeley.

So it's like a flip book but bigger?

Yes. There's a little line and then something else is added, something else is added, and so on. And then suddenly, it becomes a dollar bill. It's truly amazing.

I wonder what he would be doing now in terms of his artwork had he survived. People have different theories. Would he be embracing new technology or would he be saying, "Oh God, those kids are doing it better than I am."

He always said that. "These kids are so great. How come I can't do that? What should I do?" He said that to everybody.

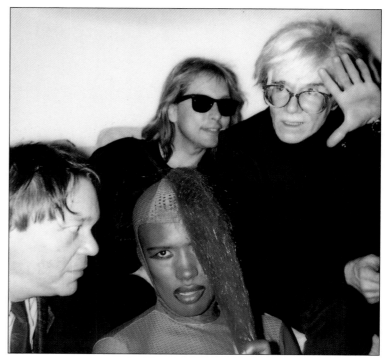

John Reinhold, Grace Jones, Beauregard Houston-Montgomery, and Warhol, c. 1985

Studio 54, c. 1976–78. Synthetic polymer paint and silkscreen ink on canvas, 26 x 14 in.

What are some of your favorite Warhol works?

I love the Flowers from 1964. They are very powerful. Then there are the Shadow paintings.

Did you go to the Warhol Museum in Pittsburgh to see the Shadow paintings?

Oh, yes. Everyone should go see them. The best show I've ever seen—not in terms of quality but in terms of impression. Then there was the Cows installation at the Whitney Museum. I don't

You'd feel like you had been at Studio 54 for five minutes, and then you'd look at your watch and see that it was 3:30 or 4 in the morning.

like the Whitney, but those huge doors of the elevator opened up, and the entire place was filled with cow paintings. It was so unbelievable. Andy had a portrait show there too, but that Cows show! The whole room, the whole floor, was covered in Cow Wallpaper, and the cows were hanging on the surface.

You know, I bought some of my favorite works by Andy before I knew him. I went to business school at Boston University, and I saved my allowance to buy art. I didn't know what the heck I was doing, but I bought two Marilyns from Castelli and two Marilyns from Ivan Karp. My favorite pieces that I own are ten of Andy's Self-Portraits with Victor Hugo's hands strangling him.

I don't know if this is true, but apparently I'm the only one that has the entire suite. They are about eleven inches wide by fourteen inches high, and I hung them on my curved wall with the seventh one upside down. And Andy really got a kick that one was hanging upside down.

There are so many other things that I love. Remember when he did the Gems series? Well, my apartment at that time was big and white. Andy said, "I'll let you have a white and black painting." So he gave me three paintings of an emerald-cut diamond. In fact, I once gave him a diamond that we called the Queen of Sheba.

It was an emerald-cut diamond—very big, amazing, totally black. I forget how many carats it was, six or seven. It was black as night—even blacker. It's very difficult to cut a diamond that's black because it's filled with inclusions. It took years to cut on the wheel.

Andy gave me another interesting painting of Studio 54 tickets. It's one painting with four silkscreened tickets. It's painted in blues.

He did single tickets, double tickets, and I guess triple and quadruple tickets. You got a big one, so he must have really liked you. Was yours covered in diamond dust?

No. But do you know how the diamond dust paintings and prints came about? I gave him the first jar of diamond dust. Real diamond dust doesn't sparkle, but he played with it. I think what he in fact used was crushed glass. It didn't work with real diamonds, but that's when he started to think about the idea.

He picked from everyone.

Yes, he picked everybody's brains. I have one of his incredible Shoes paintings with diamond dust—a huge one, black on black. Mine is really the most elegant because it's black on black. I hate the colored ones. Andy knew my taste and never gave anything to me that was not to my taste.

When Andy painted something in black and white, it was almost a sure sign that the work was going to be a classic.

It's something that Andy felt intuitively. I never asked for anything, and suddenly I'd come home and there would be a new painting. He knew somehow that I would appreciate the thing that was most elegant.

Were there any particular paintings or sculptures that Andy thought were failures?

Didn't he think *everything* was no good? But his real idea of failure, I think, was when something didn't sell well. How do you get

But his real idea of failure, I think, was when something didn't sell well. How do you get things that don't sell well to sell well?

things that don't sell well to sell well? By creating an aura and talking them up. Well I mean, it's obvious isn't it?

Did you ever consider having Andy paint your portrait?

Well, you know, that's interesting. Polaroid would give free **film** to the Factory. One day Andy said, "We're going up to Boston. Come with me." So we went up to Boston to see Polaroid's headquarters. Andy took Polaroids of people using that big, oversized

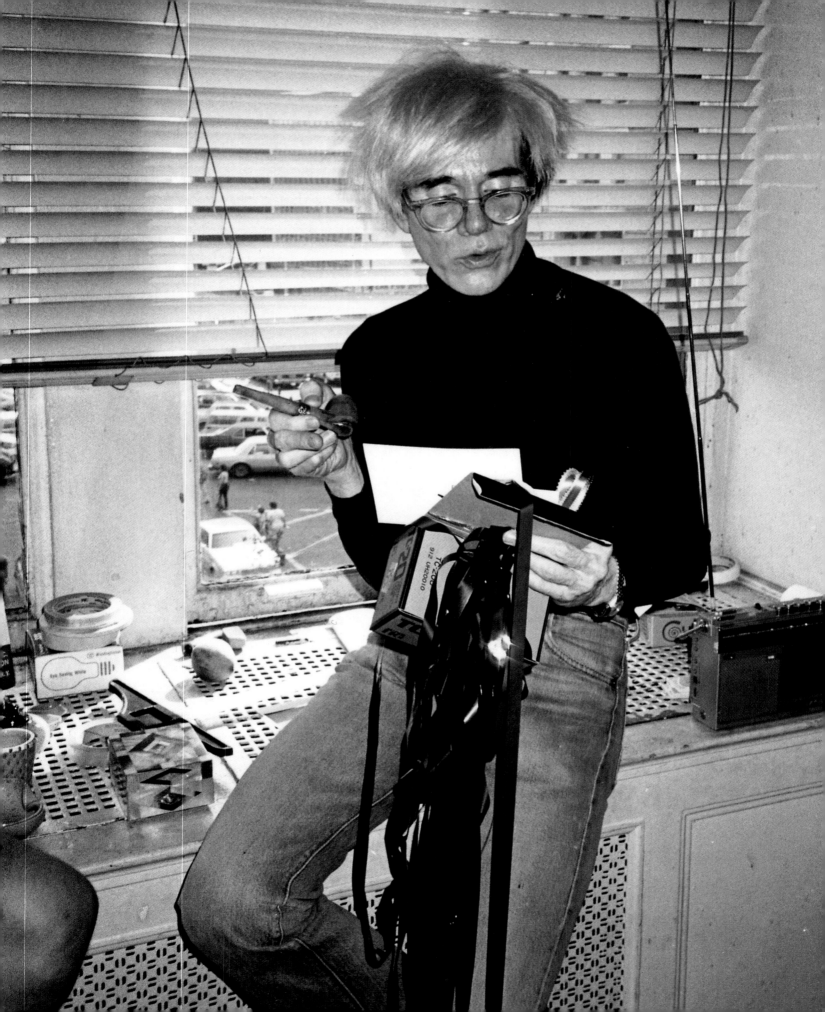

camera that made nineteen-inch by twenty-four-inch pictures. One day months and months after our trip to Boston, he called me up and said, "I just sold you." And I said, "What are you talking about?" He said, "I just sold you to a German. For five thousand dollars. " And I said, " Five thousand dollars? *What* are you talk-

We walked up Third Avenue, but before we crossed the street, he said, "I don't feel well." Andy *never* complained about anything having to do with physical pain.

ing about?" He said, "Well, you know, the Polaroid picture I took of you." Again I asked, "*How* much?" Because five thousand dollars then was a lot of money. Especially for a Polaroid. I wish I knew where that portrait was.

Well, maybe the collector will read this book and call you up.

The German? I doubt it.

Yes. And he'll say that now it's worth a hundred thousand dollars. The night before Andy died, didn't the two of you go to your old haunt, Nippon?

Actually, it was a few days before he died. We went to Nippon, and we had plans to go to a movie. We walked up Third Avenue, but before we crossed the street, Andy suddenly said, "I don't feel well."

Andy *never* complained about anything having to do with physical pain. So when he said, "I don't feel well," I really got nervous. I asked, "Andy, what's the matter?" He said, "Nothing. I think I should go home." We got in a taxi and dropped him off at home. I went home and then called Andy up immediately, and he said that he was feeling much better.

A few days later, I called him again to remind him that I was leaving for L.A. soon. He started slurring his words. I thought, This is very weird. He must be on something. He said, "What are you talking about?" and he got very angry at me. I said, "I told you I was going to Los Angeles." He said, "You never told me." I had told him, but he didn't remember and he was angry. In any case, I went to L.A.

The next day, I called Andy, and one of the maids, Nina or Aurora, answered. I asked if Andy was there. She said, "He's not here." And I asked, "When will he be back?" I knew intuitively something was wrong because he hadn't been talking normally; he had been on some sort of medication. She said, "I don't know. He

On the window seat at the 860 Broadway Factory, Summer 1982.

went away." I said, "What do you mean he went away?" He would *never* go away without telling me. I felt so scared.

I hung up the phone and immediately called Vincent Fremont. And he said to me, "I'm sworn to secrecy, but since you're his best friend, all I can tell you is everything is fine." Vincent was saying that something was wrong, he went to have it taken care of, and he was fine. Which was in fact true. The operation was successful.

I was at Chateau Marmont in Los Angeles, and the phone kept ringing. I don't know how all these people knew where I was. They wanted to know what was going on with Andy. I said, "I have absolutely no idea; all I can tell you is he's fine." Because that's what Vincent had said to me, which I believed and which was, at that time, in fact true.

The next morning David Hockney rang me up and said, "Andy died." I said, "David, don't be ridiculous. Andy is fine." He said, "No, he's dead." I said, "No way. He's fine." But sure enough, I listened to the radio and the news was out. Suddenly, everything was different. People who didn't even know him would come up to me, "New York is not the same. It's not the same." Strangers, people who had never met him before.

It was not the same. The social landscape shifted.

It was very hard; sometimes I would wake up and, half asleep, I'd start to dial the first two digits of his number. Then I'd realize…

After Andy died, I was, like everyone else, completely despondent for weeks at a time; I just didn't know what to do. But I then had a dream about three weeks after his death; it was stronger than a

Not to see him anymore in a room, a club, a restaurant, is just bizarre. Still to this day, I walk into certain places and expect him to be there.

dream really. I was back at 860 Broadway and on all the walls were these paintings covered up in brown paper. And I thought, What is going on? Then all of a sudden, Andy came up and tapped me on the shoulder. I get shivers just thinking about it. I was so happy to just see him. And he said, "It's OK."

I know what you mean. When you talk to someone four or five times every single day and then suddenly that person is gone, it's very peculiar. You feel awful. Not to see him anymore in a room, a club, a restaurant, is just bizarre. Still to this day, I walk into certain places and expect him to be there.

Maura Moynihan

Andy's Girl of the Moment on Their Years Together

After five years working with Andy Warhol, Maura Moyni-han spent a year in India working with folk artists and per-formers. She continues to travel extensively in Asia, and has written several reports documenting the ongoing flight of Tibetan refugees into India. She is on the board of the International Campaign for Tibet and is a consultant to the United States Holocaust Memorial Museum in Washington, D.C. She continues to paint and write music, thanks to the encouragement and support she received years ago from her friend Andy Warhol.

What are some of your first memories of your friendship with Andy Warhol?

I have so many Andy memories; sorting through them brings up twenty-five more. When I came to New York, all I wanted to do was sing in a rock band and pretend I wasn't who I was. Create an al-ternate identity and pretend I wasn't living the life I was living. It was the year Reagan became president. So needless to say, all of my friends were pretty depressed. We used to do things like drink beer and watch *The Love Boat* for hours.

So anyway, I go to New York, I've just graduated from Harvard, and I hit this downtown scene really out of poverty and despair more than anything else. How could I possibly have a 9-to-5 job? It would be too hard on my health, it would be too difficult and de-manding to work all day; I needed to sleep.

One night I was at Xenon, which was the *club de moment*, and someone said, "Andy wants to meet you." I had met Fred Hughes before. Andy was such an elegant person — exquisite, elegant. He had lovely hands. He was sitting there with his funny wig and his vodka — he was very elegant and very poised. I didn't know at the time that he always had to wear that brace because of the shooting.

Meanwhile, I was trying to get an Argentinean polo player and an Indian movie actor to dance with me. I said, "I don't want to meet Andy Warhol."

I was torn off the dance floor, and Andy looked at me and said, "Oh God, that's you." I didn't think much about it. He said, "Come have lunch." And I said, "OK." I almost slept through the lunch. I got up at 12, threw on clothes, ran down to his old studio in Union Square. Andy and I ran right into each other in the elevator. All of a sudden, I was alone with him in the elevator. It was incredible. He gazed at me, almost like a lover. We had this wonderfully chaste, completely platonic relationship. It was more than a friendship. It was a love affair, but it was purely platonic because he was gay. It was as if he chose me, which is what he did with girls. He would pluck you out of the crowd.

> ## I was alone with him in the elevator. It was incredible. He gazed at me, almost like a lover. We had this wonderfully chaste, completely platonic relationship.

Anyway, we had lunch, and Andy said, "I want to take your pic-ture." And he started taking my picture. Then he said, "We have another photographer who's going to take your picture." Peter Strongwater, who did portrait photography for *Interview,* was that photographer.

People were always saying, "Oh, Andy has a crush on you." But I always got the sense that Andy was lonely. I grew up around very sensitive, very accomplished, famous, talented, lost people. Andy

Interview magazine cover with portrait of Maura Moynihan painted by Richard Bernstein, June/July 1981.

was very much like the intellectuals I grew up with. So he made sense to me, he was familiar to me. I could treat him like a friend, but we also had this kind of breathless crush on each other.

I think Andy was a loner – he was lonely for love.

He was lonely for love. I never saw him take a boy home, I never saw him pick anyone up at a club. In many ways, there was something very chaste about Andy. Sex didn't interest him as

> # What he wanted me to do so desperately – and in this regard I utterly and completely failed him – was to have affairs with movie stars and rock stars.

much as romance. That's why all of those years Andy was like my boyfriend – I actually didn't have a boyfriend. I would spend all of my time with Andy, and he protected me from all of those sharks. I am very grateful to him for that. I always had respect for Andy, and I always put some emotional distance between us, which is why I think our relationship lasted so long and was so good until his death.

What was your impression of Andy before you met him? What did you know about him?

I thought that he was completely strange and thoroughly uninteresting.

He wasn't a hero to you at that time?

Absolutely not. I wanted to meet John Lennon, but he had just been shot. I wanted to meet David Bowie or Mick Jagger, which I did through Andy.

What was the fallout from your great Interview *cover story?*

Oh my God, my whole life changed. For one, I didn't even have a house I was so poor. I would jump turnstiles in the subway to go to parties given in my honor at Mortimer's. All of my clothes came from the Sloan Kettering thrift shop. I was living on the punk rock diet, which is lots of coffee and once a day some white bread product – a bagel or Wonder bread.

I'm on the punk rock diet. I'm dressed in Sloan Kettering. And suddenly I'm the "thing," the "moment," the "girl," the "it." The people in my band got so angry and so jealous they kicked me

out of the band the day the cover appeared. So that was it, everything collapsed.

So what was I going to do? I had no one but Andy to rescue me. Because of the cover, I was in a Wally Shawn play. I started doing a lot of acting and performing.

Andy used to call me Cover Girl. Until the day he died, I was his Cover Girl. Andy liked to live vicariously through his girls. What he wanted me to do so desperately – and in this regard I utterly and completely failed him – was to have affairs with movie stars and rock stars. I am afraid to say I let him down most despicably. I didn't *try* hard enough. Mick Jagger or David Bowie or Eric Clapton or Mel Gibson would walk in to some party we were at, and Andy would say, "Oh, go get him, *get* him." I'd say, "Andy I can't. There are fifteen Ford models there." "Don't worry, I'll get you through those girls. Come on, let's go." In those days I was always so poor, so I would be wearing some plastic zip-up dress circa 1967. Taped together with Scotch tape – that's what he liked about me. He was one of the only people who appreciated my unusual sense of aesthetics. So I couldn't really vie for the attention of these stars. I would always fail because I couldn't fight off the 6'4" German cover girl!

Andy really did try to set up situations. Did you ever make up stuff?

Never, I never lied to Andy. There was one incident where I danced with Bowie at a party, a slow dance. I came back over to the table, and Andy said, "You've hit it big, really big. Come on, go for Act II." I said, "Andy, I can't do this." Invariably, I would go home with Andy at 5 in the morning.

I remember one very strange night I was at Odeon with Andy, and Mick Jagger joined the table. He was very articulate and interesting, a terrific guy. I don't know him, but the few times I have met him I cannot speak highly enough for his gentility and his wit. He is quite dazzling company. Anyway, these three annoying, boorish guys I knew from Harvard saw me with Mick Jagger. They came over and said, "Hey Maura man, it's been a really long time." They sat right down at the table. And Mick turned to me and said, "Maura, will you get rid of your bodyguards?" Andy looked like he was going to kill me; I had failed again.

It surprised me that Andy plucked me out of this extremely decadent, wholly undisciplined, and basically uninteresting scene. Truth be told, it was really boring.

It seemed glamorous, but it was boring.

If you were living in upstate New York and reading *People* magazine, it appeared a realm inhabited by deities. But everybody was so freaked out all of the time. Reagan was president, and you never knew who killed JFK. So what were you going to do? Just go to a disco, do something aerobic, and drink a lot of beer.

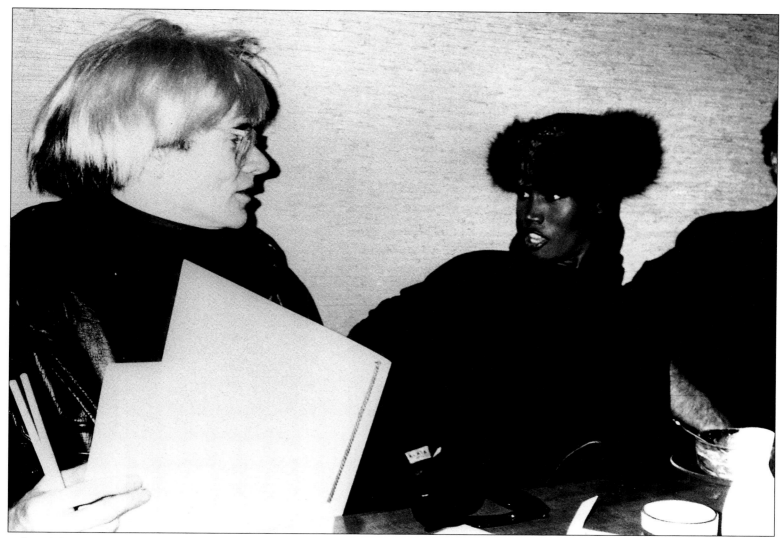

Andy Warhol and Grace Jones at dinner, c. 1985.

The most interesting person in the whole scene was Andy. He went out a lot, but he did not smoke, he did not take cocaine. Plenty of people in the scene did take drugs, but if you were going to work with Andy and be around him, he really did not like you to get high.

I wonder if that was an attempt, after he got shot, to shut out what happened in the '60s?

Could be, could be. He was struggling, that's one thing we all didn't realize and one reason I feel he was so brave. He obviously died from the results of that near death, the Valerie Solanas, incident. He was struggling through his life all those years. He showed me his scars one day, and his brace, and he talked about the shooting. He worked out, he took care of himself. It wasn't vanity; he was trying to survive. Well, actually, there was an element of vanity to it.

He loved being a Zoli model with muscles.

One thing that is often overlooked about Andy is what a brilliant comedian he was. More than a comedian – a humorist, a satirist, the greatest satirist of his day. The idea of a Campbell's soup can painting drove people nuts. I remember a Harvard art history professor arguing about it, and I thought, "What a joke.

In those days I was always so poor, so I would be wearing some plastic zip-up dress circa 1967. Taped together with Scotch tape – that's what he liked about me.

He's laughing all the way to the bank." And then there was the movie *Sleep* – just think, he got all those New York intellectuals to sit there for eight hours and watch the entire thing. It's just so unbelievably funny.

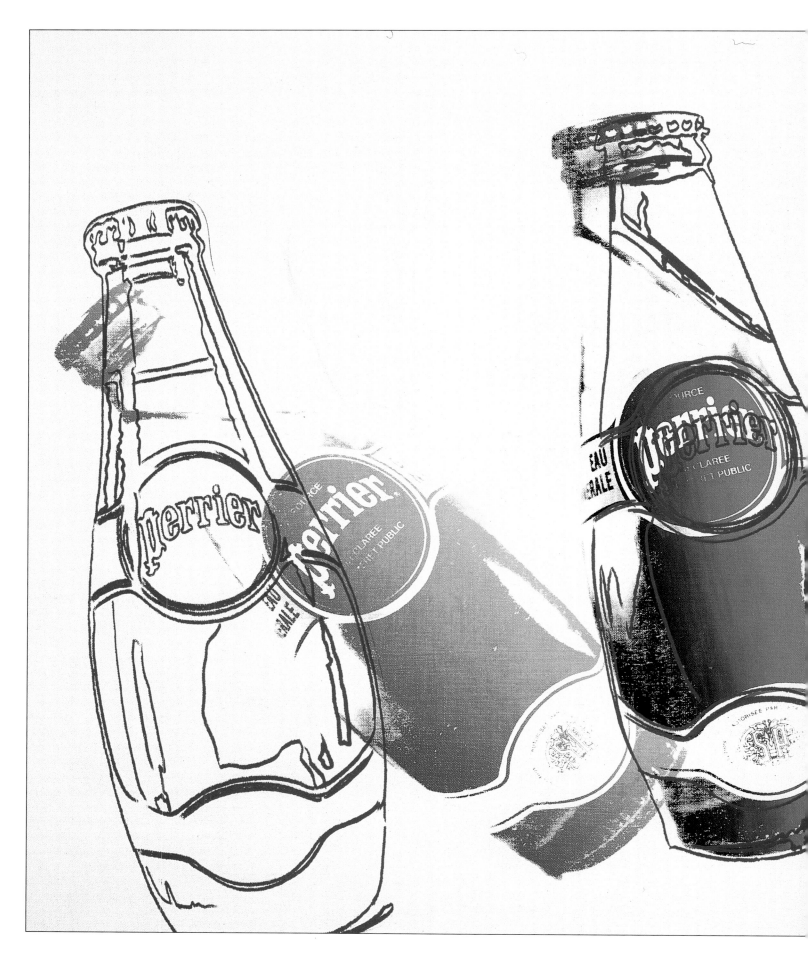

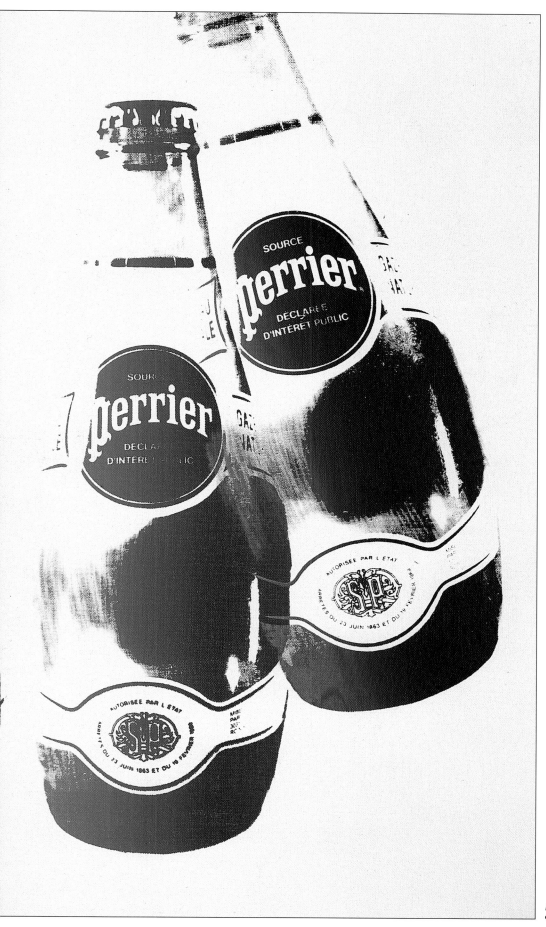

Perrier Bottles, 1983. Synthetic polymer paint
and silkscreen ink on canvas, 20 x 30 in.

Just think of the whole concept behind MTV. It's supposed to be like a fireplace. Just a part of the background. You just glance at it as you happen by. You're not supposed to stand there all day looking at it.

Yeah. But I think what Andy was doing was also parodying and satirizing the shallowness, banality, and stupidity of contemporary

I think what Andy was doing was also parodying and satirizing the shallowness, banality, and stupidity of contemporary art in that period.

art in that period. And it was incredibly shallow and stupid; so much of our culture is.

What was Andy serious about? What was he thinking?

He was deadly serious, and he was playing a joke. He was doing both at the same time. I wouldn't call Andy's message nihilism at all. I would say there was something disturbing about how arbitrary he made images appear.

Did Andy ever critique your musical act?

Yes, absolutely. No one ever gave me more consistent and thoughtful advice about my music, the plays I was in, the movies I acted in. He would say, "You were overdoing it in that scene, you should tone it down. You were better the night before." Or "I liked your old bass player. This new bass player is going to stink." He was very specific. I would call him up and sing songs to him on the telephone. And he would comment on them. I showed Andy my paintings, and he commented on them. He was a very, very good critic—a tough critic.

You finally got a job at "Page Six" of the New York Post *during the middle of all of this, didn't you?*

Yes, and I hated it. But Andy loved it. He went out of his mind. He thought it was the coolest thing I ever did. It was a very interesting job in many ways because I got to do things like talk to Shekky Green and Frank Sinatra's publicist and Jack Benny's sister. I got a glimpse of the last of a fading, dying old Broadway, which was what I wanted. The stories that no one else wanted to write, I loved. Andy loved Hollywood, he loved movie stars. He thought it was the most incredible thing in the world that I was working on "Page Six."

"Page Six" was filled with press releases. You know—Morgan Fairchild seen exiting Mortimer's on the arm of the plastic surgeon who did her breasts. And Andy just loved it.

Andy wasn't a snob; he loved anything. We'd work all day at the Factory. I'd go home to change, he'd pick me up, we'd go to a Broadway play, we'd go to the after party, we'd stop at McDonald's, we'd go to see some performance artist, and then we'd go to Julio Iglesias' birthday party at Windows on the World. And then we'd go to the Death Cellar or some after-hours club where there would be these little punk rockers who worshiped him. And he'd take them in the limo and we'd go have breakfast with them at the Kiev. He'd see everything with the same wide-eyed wondrous fascination. From Julio Iglesias' mother, to the *Solid Gold* dancers, to Beverly Sills, to the waiter. He'd ask the waiter, "Where did you get that ring?!" He had a gift for enthusiasm.

But he liked your enthusiasm, too, because he started asking you to help him with interviewing subjects. Who did you get to interview for the magazine?

Lots of people. We did the covers together for a two-year period, and that was really interesting. We did Jane Fonda, Dolly Parton, Matt Dillon, Brooke Shields, Richard Gere. I don't know, the list goes on. Timothy Hutton, Chris Atkins of *The Blue Lagoon*. Who can forget that? I thought the early *Interview* was the best. The early *Interview* was without question so original. And I think it's great now, too. But, you know Andy was always documenting—even when it wasn't for his magazine. He went out every night—when I turned twenty-five I felt that I'd grown too old to keep up with him —and though he appeared to be merely eating, drinking, or talking, he was in fact working. He was documenting every moment. He had the little tape recorder running—I can't believe people didn't notice the damn thing—I certainly noticed it. He took photographs

Well, he let me do most of the talking because the persona he had cultivated was expressionless.…I was really in a sense Andy's vehicle.

and observed everyone. He remembered what people were eating and wearing and who said what about whom. He had a phenomenal memory. I recall going to the Factory one morning after a dinner with Andy and seeing a stack of eight by ten black and white prints of the dinner alongside a transcript of the conversation. It wasn't an especially interesting dinner—it was only myself, Andy, three Danish art dealers who spoke no English, and a fairly drunken

model who kept begging Andy for Mick Jagger's phone number. Nevertheless, Andy sat at his desk and studied the prints and transcripts. Everything was work.

Actually, Maura, you did most of the talking in those interviews.

Yes, but Andy understood the celebrity caste system in America. Whereby fame, or fame by association, is the only thing that justifies your existence. These movie stars could be incredibly arrogant and rude. But in Andy's presence, in the presence of the guru or the master, they tried to impress *him*.

I've done other interviews for other magazines and the way they reacted to Andy was very funny. In a way, he knew he had them. People often liked to perform for him. They would say all kinds of outrageous stuff. I was never, ever permitted to edit the interviews before they appeared in the magazine. The juicy stuff came out

Andy Warhol with look-alikes at Fiorucci, New York, c. 1982.

Richard Gere and Pat Hackett, c. 1986.

and went into the diary. And Andy would say things like, "Oh, I don't want to print anything they won't like because then they won't come back and commission a portrait."

I remember at that point Interview *had a couple of lawyers, and they were worried about being sued by somebody for defamation of character. So they did edit the interviews carefully.*

You know, those people, with all they said about sex and drugs and rock and roll, were just trying to impress Andy. But you didn't have to do that. He was a regular guy; you could really just talk to him.

Tell us about Andy's "regular-guy-ness."

Well, once for Christmas, I gave him a vegetable steamer that I bought for $2.00 at Woolworth's, and he said, "This is exactly what I want, thank you." All of these other people were giving him Cartier watches.

But you knew him. He would order steamed vegetables at Odeon for dinner. You gave him the perfect present.

Did you do interviews for Andy Warhol's TV *in addition to those you did for the magazine?*

Yes, I did. It was wild. We did interviews with Pee Wee Herman, Brooke Shields, even Madonna. We did all kinds of things. It was

People weren't ready for him yet they couldn't understand him. They just didn't get it. He was very sensitive about his art, and he didn't talk about it that much

an interesting moment in television because it was the beginning of MTV and music videos were coming into their own. I acted in a music video that Andy produced—although it never made it onto MTV—it was four girls dancing on the pier by the Hudson River. It was also the end of an era of vinyl albums and the beginning of compact disks.

How involved was Andy in the show?

Well, he let me do most of the talking because the persona he had cultivated was expressionless. But it was really fun because he would whisper in my ear what to say and what to do, and I would do it. I was really in a sense Andy's vehicle.

What do you think is one of Andy's greatest works — the one that really speaks to you about who he was?

That's a very good question. When I saw the retrospective at the Whitney in 1989, the room that impressed me the most was the

He was a Democrat and was very interested in Democratic politics. But…he wouldn't hit you over the head with it, so you really had to pay attention.

one with four huge portraits of Liz Taylor, Marilyn Monroe, Jackie Kennedy, and Chairman Mao. The joke is — nothing matters. You can be a Hollywood starlet, a president's wife, or a Communist responsible for the murder of 80 million people. As long as you're smiling for the camera. That room at the Whitney showed how meaning has been extricated from image by technology, by the ideologies and dogmas of communism and Hollywood. I was speechless. Everything about Andy's work was so subtle, he showed how everything can be an icon. Anyone can be on the cover of *People* magazine or *Interview* magazine.

Many people confuse the message with the artist and think that Andy didn't understand what he was doing. Tell us about the duplication of images — what do you think that was about?

The machine age, the tool age — he's commenting on the industrial age.

I always thought that maybe what he was attempting by duplicating all of those things was allaying himself of his fear of them — of killings or accidents. He was a scared sort of person; he was very fragile. Maybe by duplicating all of those things, he was turning his fears into wallpaper. Wiping out the meaning of the image itself and just saying, "It can be beautiful."

And isn't that what television has done? Look how television has also stripped acts of violence of their meaning, of their morality. It has demoralized society in such a profound way; and he

understood that first. That's why I think Andy was truly a genius. I think many of his ideas were just the gift of genius.

Was Andy a harbinger of things to come?

He really was. People weren't ready for him yet, they couldn't understand him. They just didn't get it. He was very sensitive about his art, and he didn't talk about it that much. That was one part of himself he kept very private.

But I remember one conversation about architecture that my father had with Andy. My parents had wanted to meet my "boyfriend," Andy Warhol. They had this incredible conversation about architecture. They're both such brilliant men, and I was sitting at the end of the table watching them discuss nineteenth-and twentieth-century styles. And Dad said later, "This Mr. Warhol is a very bright fellow."

Did you ever see Andy's charitable side?

Several times Andy donated pieces for me for an antinuclear fundraiser or a homeless fundraiser. He never said no. He always worked for the Democrats, the Kennedys, he always gave them pictures. He was a Democrat and was very interested in Democratic politics. But he was very civil and private about these things. He wouldn't hit you over the head with it, so you really had to pay attention.

But Andy also had his definite likes and dislikes. He really liked some people, he really didn't like others. He was so upset that Jacqueline Onassis had barred him from a Christmas party. "You don't know what she said to me — she wouldn't let me and Fred come to her Christmas party."

In many ways it's funny. He could be naive and childish. He was trying to get the commission for a painting of the Trump Tower. He thought, "I'm Czechoslovakian, and Ivana is, too." On that basis alone, he thought the Trumps would commission work from him.

He used to say to me, "Oh, you and I like each other so much because we're Leos and we're Catholics." In interviews, he'd say, "Maura and I are both Leos and Catholics." As if that is supposed to mean anything to Mel Gibson or some other star. "Oh, really, Maura? I didn't know."

Were you worried that your friendship with Andy was fading as you became busy with other work?

I saw less of him in the last year when I went off to spend a year in India. But Andy always was so sweet. I never, ever felt I couldn't see him, speak to him, get him on the phone, confide in him, or spend time with him. His sudden death came as a big surprise.

Debbie Harry

Pop Artist on Pop Artist

Born in Miami, Debbie Harry started her professional singing career in the late '60s with a folk band called Wind in the Willows. In 1973 she met Chris Stein and in 1975, they created the band Blondie, which became one of the most successful groups of the late '70s and early '80s. Debbie began working with Warhol's video team on the production of *Andy Warhol's TV* **in the '80s. She released several solo albums, acted in television shows and movies, including the John Waters film** *Hairspray.* **She continues to pursue acting and her recording career.**

You first arrived on the underground scene in New York in 1977, didn't you?

Yes. I worked as a waitress at Max's Kansas City. Andy used to come in there with the whole original crew. Taylor Mead, Tiger Morse, all the acid queens. The scene was very underground, very controversial, very arty. In a way, it was like a club. People would float in and out, of course. It seems lately that I see more of those people resurfacing. The ones that are still alive, of course.

So many are gone. A lot of the history is unrecorded because those people are missing.

I'm not a very good recorder of history. I'm a floater. I sort of wallow around in this sort of sensual kind of existence. And every once in a while I reach out and nail something down, but most of the time I'm just sort of feeling my way around.

Did you know Andy when you were working at Max's? Or did you meet him later?

I didn't know Andy then, but later he may have recognized me from then. He was very good with faces, you know. I think that we had also seen each other on the street, walking around Lower Manhattan. Chris Stein and I always saw him. Of course, even though we were the punk people, we were getting local press. And Andy always had his ear to the ground. I don't think we were formally introduced until 1974 or 1975.

Tell us about the photo shoot Chris Makos did of you for the cover of his book White Trash.

Chris Makos was hanging around taking pictures. I had on that little knit dress. I guess he just took a close-up of the crotch thing where this razor blade was hanging down and put it on the cover.

And how did the Interview *cover of you come about?*

I guess they just decided to use me on the cover because I was getting so much coverage. I had a record deal by then. I was

I'm not a very good recorder of history. I'm a floater. I sort of wallow around in this sort of sensual kind of existence.

getting some worldwide attention. That was in 1979, right before my album *Parallel Lines* came out.

I remember seeing a photo of you and Andy at Studio 54 with huge blowups of Interview *covers, and yours was right behind everyone.*

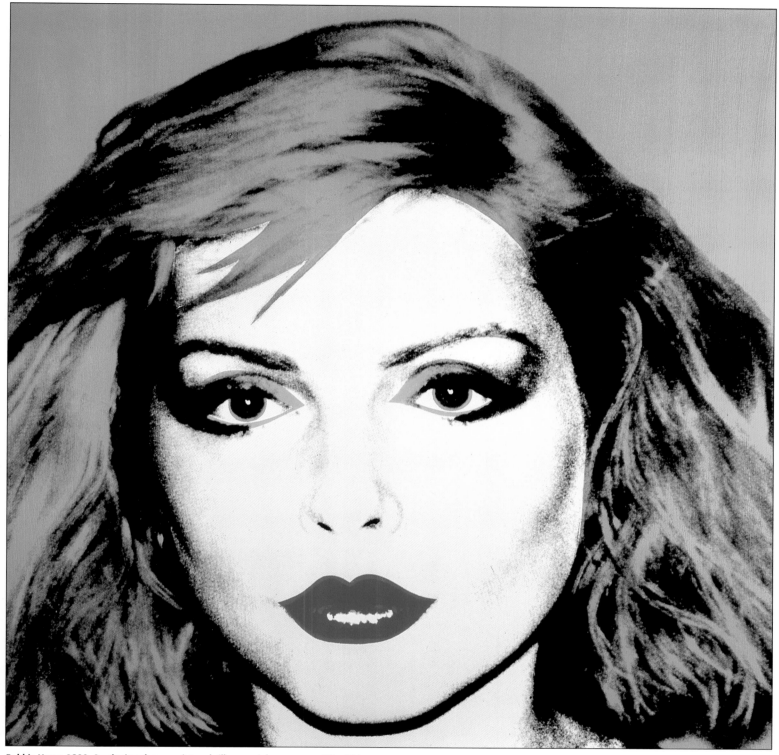

Debbie Harry, 1980. Synthetic polymer paint and silkscreen ink on canvas, 42 x 42 in.

That was a party for the issue, and for me. They threw an enormous publicity party. I talked to Truman Capote a little bit there. It was a very wonderful experience. But, of course, the music was so loud that conversation was difficult. Still, it was quite a night. Andy seemed to like the idea of my being on the cover of his magazine, but I don't know how much input he had at that time.

Andy and I were really excited to see you in your play, Teaneck Tanzai *in 1983. Andy loved it.*

It was such a good play. It could have been such a hit. It was so popular with the audiences. People would jump up and down and take sides and scream out scenes. It was great. The audiences really participated. And the critics hated it, they *hated* it. They

Debbie Harry with Warhol's skin specialist, Janet Sartin, c. 1985.

killed it. They couldn't have killed it any deader than they did. It was just a complete squash. They shit on it completely – but, the show was great.

After that play we went out to a celebration dinner for you at Century Café. All Andy could talk about was "your look" as he called it. He was so excited by the way you looked. Did he ever comment to you about your appearance?

> # Of course, people that were aggressive with him never got along with him. So I was never very aggressive with him.

Not especially. He would compliment me. I think he was sort of fascinated because of the strange combinations in my looks. That's probably really what fascinated him.

He did some of the same things with his looks as you did. He had the light wig with the dark hair showing through. He was always putting people on edge that way. I think he liked that about you.

We definitely had the same sensibility about those things. But we weren't really close friends. He always seemed mysterious to me, and, of course, very fascinating and wonderful. I was totally in awe of him.

But, then when he talked to you, it was just so normal. It was scary. Here was this person who did all these things. He was like an historic figure. My God, he had lived through that terrible shooting. He had this tremendous history and real style and great lifestyle. And then he'd talk to you, and it was like talking to an aunt or something.

He paid attention to you.

Yes. It was really wonderful. Of course, people that were aggressive with him never got along with him. So I was never very aggressive with him. We sort of hit it off. I remember when Chris was sick, he was very attentive. He really listened to me.

Andy had this ability to turn on and turn off his understanding. He could really tune into another person's wavelength or physical reality. He was a very sensitive person and a very smart person.

What was the most striking moment of your relationship with him? Does anything stand out?

Well, we were down at that restaurant, Il Cantinori. We were talking. The table wasn't ready yet, so we were standing around at the bar talking. And Andy was listening *so carefully* to what I was saying. I was so distracted by things that were happening around me that I was just talking stream of consciousness. But he was right there. And then all of a sudden I noticed that, and it snapped me into reality. It was this very funny experience. I also remember how instructive it was to watch him "do a room." I think he learned

Debbie Harry with Stephen Sprouse, c. 1985.

Interview magazine cover with portrait of Debbie Harry painted by Richard Bernstein, June 1979.

Levi's, 1984. Synthetic polymer paint and silkscreen ink on canvas, 40 x 40 in.

everything from Muhammad Ali—you know, float like a butterfly, sting like a bee. He did have different ways of working a room.

At one opening we went to he just didn't want to move. I said, "Andy, look over there, there's so and so." And he said, "Oh, that's great." But he wouldn't move. I said, "Don't you want to walk…" "No, no, everyone will come by us eventually. Just stay in one place."

When you hit the big time, you had to move away from the underground scene a bit and do more mainstream things, like appearances on American Bandstand *and music videos. How did Andy react to that?*

I didn't see him as much then, but I think he was a media man. I think nothing really surprised him about any of it. He would just

comment saying that he had seen my appearance on *American Bandstand* and liked it. On that show, I was wearing a little thing that Steve Sprouse did, a trapeze dress. It was just a wonderful thing. I can't imagine what's happened to it. I think I had gold boots on, too.

Toward the end of Andy's life, Steve did all of his clothes. Andy loved them. I think that Andy thought of you as a pretty female version of himself. He wanted to look like you.

He did actually say that once, and it got back to me. I thought wow, that's really flattering.

You had your portrait done in 1980. Can you describe what your portrait session was like?

Well, it was done upstairs on 14th at Union Square. Andy wanted to make it as simple as possible. "Oh just sit there." Of course,

I also remember how instructive it was to watch him "do a room." I think he learned everything from Muhammad Ali – you know, float like a butterfly, sting like a bee.

he had his team of assistants. And they would do whatever he wanted. I sat in the chair that he liked to pose people in, and I stood against the wall as well. Andy had those funny long Polaroid box cameras. We talked about the camera and how he had discovered using this Polaroid portrait camera. Evidently, he came across the camera accidentally, but he really liked the results from that camera the best.

Did you ever appear on Andy Warhol's TV*?*

Oh yes, of course. I was the voice-over. "It's Andy Warhol's TV with the stars!" I was very involved in it. And Chris Stein did the music. A couple of new shows now borrow from that show for a lot of their content and style.

Of course, now some of those shows are going in a different direction and are losing some of the real impact, the visual impact. Nevertheless, I think that the team who worked on *Andy Warhol's TV* was really a creative force. Especially Don Munroe. Don was quite remarkable.

Did you ever consider having Andy direct or produce one of your music videos?

Debbie Harry photographed by Chris Stein, c. 1982.

We had talked about it, of course. We talked about using the portrait Andy had painted as an album cover. We talked about many possibilities, about working with Stephen Sprouse.

Stephen actually was the art director for my very first music videos that were shot by Bob Gruen. Later, everything got out of my hands because it became corporate. That's when the frustration began.

What memory or characteristic best exemplifies Warhol for you?

Right before Andy died the worst thing happened. Andy asked me to come down and do something for the TV show, and I was a bit sick and didn't feel like going. Chris said, "You should go. You should go." I said, "Oh, I feel awful, I look awful, I can't go." I didn't go. The next thing I heard Andy was dead. I felt really, really awful. And I'm sure he wasn't mad at me either.

I think that the team who worked on *Andy Warhol's TV* was really a creative force. Especially Don Munroe. Don was quite remarkable.

But one day, we were driving on the New Jersey Turnpike on our way back from Washington. And there was this huge accident involving an eighteen-wheeler trailer truck. The truck was jackknifed. The back doors to the truck were open, and all over the road were Campbell's soup cans. And I thought, "My God, I can't believe this." I thought Andy would have died if he could have seen it.

Paige Powell
On Warhol's All-Important Work Ethic

Paige Powell began work as an advertising associate at *Interview* in 1981. When she left the magazine in 1994 to work on other projects, she held the title of advertising director. Powell is now the publisher of the on-line magazine *Ark*, dedicated to the prevention of cruelty to animals, which is based in Portland, Oregon.

How did you arrive at the Factory?

I'd been living in Portland, Oregon, where I was born and raised, and in December of 1980, I wanted to move to New York and do something that was indigenous to the city – work for either Woody Allen or *Interview* magazine. If I was going to have a generic job, I might as well stay in Oregon and have a healthy lifestyle. So, to move to New York, it had to be something very specific to the culture of New York. Like *Interview*, which I had seen at a friend's house. It was such a beautiful, on-the-pulse, uncompromising publication. There was nothing like it. It was very exciting.

Did you know that Andy was involved in it?

No, and I wasn't that interested in Andy's work either. In fact, I walked out of one of his movies in the '70s. I think it was *Empire*. So, I wasn't up on him. I didn't think he had any affiliation with the magazine. I didn't even make a notation that his name was on the masthead until I arrived in New York – by then his name was removed off the *Interview* cover. Even then, I just thought they were using his name on the masthead.

When you first arrived at the Factory, do you remember who you interviewed with?

First of all, I made some phone calls to find the office – it was in Union Square, and I was apprehensive to go there because I'd heard that there were daily gang shoot-outs in Union Square Park. But finally I got up the nerve to go down to the office, and it was very odd because of the surveillance camera and small bulletproof peek-through window. I knocked, and someone, maybe Ronnie Cutrone asked me who I was there to see. I just picked someone's name off the masthead at that moment and said, "Bob Colacello." And they said, "Well, come on in." They were so fascinated that I would just pop in direct from Oregon to find work at the magazine.

I asked them if I could apply for a job as a writer, and they said, "Oh, no one has a full-time job as a writer." At the time, the full-time staff consisted of very few people. A very intimate little office. It was right after a deadline, and they just sat around asking me questions. I couldn't believe all the attention that they gave me. They asked if I had ever sold any ads; and I said, "No, I haven't." They said, "Well, have you ever sold anything?" I said, "When I was at the Washington Park Zoo in Portland as the public affairs director, I promoted the elephant manure in a lot of the gardening publications like *Sunset*, and we had a four-month backlog of orders." So I think they thought, "Wow, if she can sell elephant dung, she *must* be able to sell ads for *Interview*."

Their biggest concern more than anything, even more than selling ads, was whether I had a drug or partying problem. Catherine Guinness, the ale heiress, would stay out all night and show up in the morning in her ball gown. She really didn't want to sell, and didn't exactly need the revenue. Andy and Bob Colacello were beginning to realize that *Interview* could be making a profit. They really needed to gear up in order to turn a profit. Bob kept on asking me, "Do you stay out all night and party? Do you do drugs?" And I said, "No. Look, I work out. I'm a jock from Oregon, I just bought these dumbbells." I pulled these weights out of my bag that

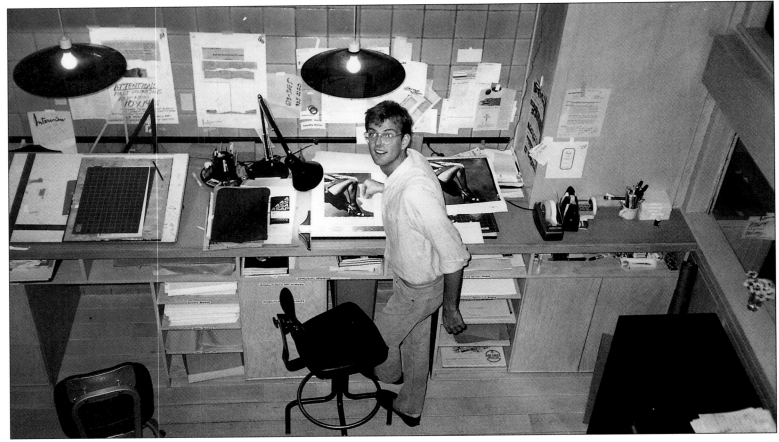

John O'Connor in *Interview's* art production department, 1984.

I had just bought at Bendel's. I think that's what finally helped get me the job.

I had to go through four interviews, and during two of them, I saw this man with white hair. The light was coming in very strong from the windows, and he looked transparent, sort of angelic – like someone from the heavens. He was wearing a pair of black jeans.

I pulled these weights out of my bag that I had just bought at Bendel's. I think that's what helped get me the job finally.

And he had this very diminutive profile. And I thought, "That's Andy Warhol." I was so surprised. He just kept eavesdropping on my conversations with Bob and Barbara Colacello.

When you started working there, what was the magazine like?

At the beginning, it was a real family-style operation. As far as selling ads, I was given the low-man-on-the-totem-pole accounts on one hand, and the impossible accounts on the other. But the ad director, Barbara Colacello, was so helpful and nurturing really.

The biggest coup for me was that I immediately got Hasselblad cameras as a first time account. Bianca Jagger came to lunch and the president of Hasselblad was *really* impressed, dining with *Andy* and *Bianca*. We had these advertising lunches, but then somehow they expanded into dinners, too. The dinners were better because the lunches during the day were pretty distracting for Andy. Some people would stay for hours, and Andy would want to go do his work. Eventually, he would just get up and leave. One advertiser, a record executive, would come and stay for at least three or four hours, get smashed on scotch and leave at around 5 o'clock.

Some people have said that the lunches were tremendously boring, but I remember celebrities coming in and being really excited.

The idea was to have a celebrity/advertising mix. The balance was always more on the celebrity side so that the celebrities wouldn't be deluged by a bunch advertising people and the advertisers would be thrilled to dine with the stars. But, ultimately, I think that Andy found the advertisers more fascinating than the celebrities. He felt that they were hardworking and doing something more unusual. He loved different categories of work. There was one particular advertiser that really fascinated him. He worked for a condom company in the Midwest that made these condoms with two layers. Now, this was late 1985, and no maga-

zine would run condom advertisements. Even *Cosmo*, which made money off sex, refused to run condom ads. But I talked this company into advertising with us. Then we went another step. I asked Andy if he would be interested in doing a condom painting for the company. Andy loved the idea. So we had lunch with them. So here we were, these two big conservative Midwestern businessmen sitting across the table from us eating pasta puttanesca. Andy asked them, "Well, because of its two layers, can you use the condom twice without taking it off?" And one of the big businessmen leaned across the table and said, "If you're man enough." Andy shrunk in his chair and went "Ohhhh!"

So, Andy would always grill the advertisers?

He was so intrigued with young advertisers. He loved to sign *Interview* magazines for the young kids that worked at the agencies rather than for the big executives. Once at Scali McCabe, he was disappointed because he wanted to visit the little cubbyholes and see all the twenty-year-olds who were slaving away and sign issues for them. Instead, he was put into a conference room with a few top executives and had to sign a pile of magazines. They clearly didn't want Andy walking around and giving out *Interviews!* Very hierarchical.

What would Andy look at when issues came in?

He looked at the ads. He *counted* them, and admired them—especially if they were in color, because they cost more. He would beg me for more Pioneer ads. He suggested that I sleep with the account executive to get some more, and he'd pay me a couple hundred dollars. Of course, he was half joking because he knew that it wasn't going to happen, and he liked to torment me about it. But he would have paid me if I did.

For him, the magazine was great disposable art. He could give it out freely, whereas his paintings had gone up so much in price.

Bianca Jagger came to lunch and the president of Hasselblad was *really* impressed, dining with *Andy* and *Bianca*.

The magazine afforded him the opportunity to be accessible to people, to pass it out to policemen on the street. Once, when we started serving at the soup kitchen at the Church of the Heavenly Rest, Andy wanted to bring magazines to give out to the transients and indigents. I said, "Well, Andy, you know, it doesn't feel right to do that." And he said, "It's a present to give them." So he brought stacks of current issues to pass out to these people at their Easter, Thanksgiving, and Christmas breakfasts. And they sat there reading

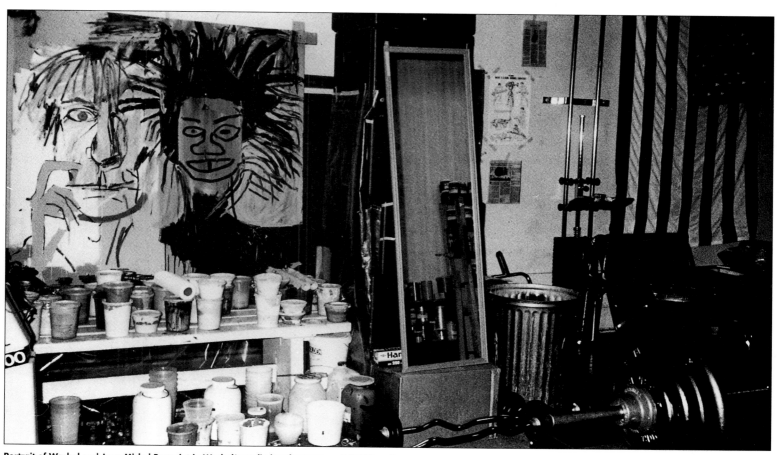

Portrait of Warhol and Jean-Michel Basquiat in Warhol's studio/workout space at 860 Broadway.

Rob Robinson, *Interview's* assistant fashion editor, amidst clutter at 860 Broadway.

them—staring at the Bulgari jewelry advertisements and the Valentino gowns.

You worked at Interview *from 1981 to 1994. How did the magazine change during your tenure?*

Well, by the end, it was no longer this small, intimate place. I think we started turning a profit in 1982. By 1986, with the direct-mail campaign, we were making more money than we knew what to do with. Toward the end of Andy's life, the magazine was doing so well that we had to scramble to figure out how to spend money at the end of the year before the tax people came in. Some of the issues were up to more than three hundred pages, with over one hundred fifty pages of ads. Andy was completely overwhelmed. By that time there were so many people working at *Interview* the Christmas party would come around, and Andy would say, "I don't know the names of all the *Interview* people any more. I can't deal with Christmas." At that point, he realized it was a *real* business; it wasn't just a hobby anymore. He didn't need to sell a painting to pay the printing bill as he had in the past.

Andy seemed to take a greater interest in the magazine during this period. What were some of Andy's contributions to the magazine in the mid-to-late '80s?

His main contribution was helping to get ads for the magazine. He would go to any advertising appointment that I had. He'd go to all the advertising parties and help organize dinners. He taught me how to do a proper seating arrangement. On the editorial side, he gave his eye. He'd walk through the place and take a look at almost everything going into an issue.

Once I did a photo essay for *Interview* on Harlem. The subjects were restaurant owners, museum curators, musicians, artists, and club owners—just different people who lived and worked in Harlem. I remember Andy got involved in the project. I was looking through the photographs downstairs at the magazine offices on 32nd Street with Marc Balet, and Andy came in and said, "You need to set it up to make every person look like they're very important; you have to go in, crop, profile them, give detailed captions, and make each person look individual and significant."

Andy was constantly searching for ideas, but also *had* great ideas. The health issue we produced—that was Andy's idea and one truly ahead of its time. It was around 1985, and Andy wanted to do something with psychics, healers, crystals, nutritionists—a big issue on alternative medicine, alternative religions. Shirley MacLaine was on the cover. That was pretty prescient.

Tell us about how you started getting involved in Andy's art and the New York art world.

Jean-Michel Basquiat painting a portrait of Paige Powell as a black woman, c. 1985.

Well, I went up to Fashion Moda, which was an alternative art gallery in the Bronx in 1981 or 1982, and I saw some great, original, interesting works of art. It was the early part of the graffiti period, but I wasn't as interested in the graffiti part as I was in the intricate little drawings that would emerge from the surfaces of these found boards or found objects. I was so excited about this gallery and would tell people about it, but no one really wanted to go up there. So I thought, well, maybe I'll bring this artist, A-1, whom I really liked a lot, and show his work in the apartment that I was living in on West 81st Street and Central Park West. It was so interesting to me—this new kind of drawing that was happening simultaneously with the graffiti movement. I just thought that it had to be fascinating to other people, too.

I really loved Jean-Michel Basquiat's paintings. I thought Jean-Michel's drawings were very sophisticated and poetic. They really pulled on my emotions. Jay Shriver took me over to meet Jean-Michel at his place on Crosby Street, and I told him that I was showing A-1 and asked him if he would like to be part of the show. He said yes right away.

I worked so hard to organize the show outside of the office, and no one knew about it. Then I went to Tiffany's and had these beautiful embossed invitations made up for the show, and I remember giving one to Andy. At that point, he was exercising at the office on his bicycle. He took one look at it and he was so upset. He thought that I wasn't going to work for *Interview* any more. He said, "You better stay working at *Interview* because if you don't, I'm not going to give you the 'Worst of Warhol.'" I said, "What do you mean?" He said, "Well, I'll give you a show that you can curate, but only if you stay and sell ads for *Interview*."

How did the opening of the show go?

Well, there were three openings over a month. We had great parties. I was a freelance photojournalist for *Brutus* magazine to supplement my income at *Interview*. *Brutus* was a men's architecture, art, literary, and fashion magazine from Japan, and it was very hip. The editor, Kyoichi Tsuzi, later went on to become the editor of Japanese *Esquire*. Kyoichi had this ability to break all cultural barriers; he really understood American sensibilities. I told him that I was doing this art show in my apartment. And he had the idea of having a sushi party and photographing it for *Brutus*. Andy and Jean-Michel agreed to it, so we had another opening party. So many people came to that; Francesco and Alba Clemente, Edit de Ak, Julian Schnabel, Debi Mazar, you two were there, and so were the artists Rammellzee, Donald Baechler, Futura 2000, and a few big art collectors like Mort and Rose Neuman from Chicago.

The people from *Brutus* really knocked themselves out. They brought in these huge vats of sake, two sushi chefs, scrolls and decorations. And what shutterbugs, taking so many photographs! They asked to do a formal portrait of the party with Andy and

Jean-Michel in Japanese kimonos. I asked Andy if he would mind putting on a Japanese kimono, and he said he would only do it if they paid him a hundred and fifty dollars. He said, "You can have 20 percent. And tell them it has to be cash and it has to be now."

I told Kyoichi, and he said no problem. He pulls out a hundred and fifty dollars in cash. I started to give the money to Andy, and Andy said, "No, no, not here!" We went into the back kitchen

I asked Andy if he would mind putting on a Japanese kimono, and he said he would only do it if they paid him a hundred and fifty dollars.

closet, in the pantry. He said, "Don't ever bring money out like that in public! Here's your cut." And then he put the kimono on. Jean-Michel absolutely refused.

You have said that Andy wasn't really interested in meeting Jean-Michel at first, that he was scared of him.

He was afraid of him, but he didn't have many friends like Jean-Michel, especially with dreadlocks! When I brought A-1 up to the office to show him where I worked, Andy pulled me aside and said, "Paige, Paige, you have to be careful with these guys. You can't bring them up; they're going to be writing all over my artwork." He was really serious about it. It made him nervous, but I kept bringing street kids into the office anyway. They would break-dance on the floor and everything. They thought Andy was cool.

The liaison between Jean-Michel and Andy happened when I started going out with Jean-Michel. Andy had met him a couple of times before through Glenn O'Brien and Bruno Bischofberger but he never hung out with him. Andy was really intrigued—he wanted to know where we were going and what we were doing. Jean-Michel would give me little presents to give to Andy. And then their friendship slowly evolved. The paintings and sculpture Jean-Michel made for my art show were in homage to Andy. It was the first time, to my knowledge, that he used a multitude of duplicated Xerox images as the foundation for many of his paintings and painted on them. Jean-Michel kept asking, "Do you think Andy will like them? Will he like this one? What about this one?"

I remember a dinner at Barbetta restaurant with Francesco Clemente, Jean-Michel, and Andy. There the three of them began to discuss doing collaborative paintings. Andy loved being associated with younger artists. For Andy, collaborations like that weren't necessarily about youth; they were about new ideas,

experimentation and originality. He wanted the affiliation and the energy exchange of a collaborative effort with two artists he admired so much. And it sort of kept him in the loop of new movements. He was already making lots of money from commissioned portraits and gallery exhibitions. This was a fresh thing to do.

Did you ever watch Andy and Jean-Michel work together?

Well, what usually happened was that one of them would do part of the painting and bring it in for the other to work on. But Jean-Michel would often come up to Andy's studio and paint his contribution there. Often Andy might be working on something else at the time.

Did Jean-Michel find anything in Andy's aesthetic that he seemed to pick up on?

I think the main thing he learned from Andy was how to be a professional artist – how to be a businessperson, how to schmooze the collectors – and hold the line with dealers. Andy's little policy was "cash and carry."

What did Andy take away from working with Jean-Michel?

Jean-Michel grew to become a big star of the art world, and I think that Andy liked to be in the forefront of what was going on. He felt maybe a bit responsible for some of Jean-Michel's success because of his association and the fatherly advice he gave. Jean-Michel was very high voltage. He was always doing really eccentric things, and Andy loved to observe that kind of thing.

When did their relationship fall apart?

It was a pretty sharp cut off. After the Tony Shafrazi show of the collaborative paintings, an art critic said that Jean-Michel was too influenced by Andy and that his work wasn't as good. Jean-Michel went into a big state of depression and started cutting himself off immediately from Andy. If anyone said anything critical to Jean-Michel about his work, it would devastate him. For instance, he went through a period in the fall of 1983 in which he wasn't doing any drugs, and he made these beautiful whimsical paintings of animals in pastels. Jean-Michel was so happy and relaxed. He went off to show them in Basel, Switzerland. He called me from Amsterdam from some heroin house drugged out two days after the opening. He was angry and depressed; some people at the show had told him that his paintings were getting too soft, they weren't interesting enough, and they suggested that he painted better when on drugs.

What do you think some of Andy's unrealized ambitions were?

He loved Keith Haring's Pop Shop. I think in the back of his mind, Andy always wanted to have a little soup kitchen, a little hangout. A sort of hole-in-the-wall, simple restaurant. Andy was basically a simple person; he liked simple things. He always had a tiny, cracker box office.

Also, I think he wanted to make films; he wanted to take a crack at Hollywood again and do films. He was getting really interested in video and filmmaking toward the end. I think he would have loved knowing Gus Van Sant and his work.

He was also elated by his photography show at the Robert Miller Gallery and the terrific review in the *New York Times*. He talked of doing more shows, and had a strong interest in doing more commissioned artwork for advertisers like the Absolut ad that's now so famous.

In the early '80s, Andy still had a fascination with the deb of the decade scene, with rich, well-connected girls. Then all of a sudden he seemed to switch to a downtown crowd with male artists and fashion people like Stephen Sprouse. How did that transformation take place?

Well, the very early '80s phase had to do with the Republicanism at the office and the tony girls from those swish families. The uniform at the office was early prep before preppy was defined as preppy—Levi jeans, a white Brooks Brothers button-down shirt, loafers without socks. You got your hair cut at the Astor Place barber shop. *I* even did that for a few years. Everyone there had that kind of look. Fran Leibowitz is the only one who's really kept it up. I think that's typical of other offices, too. Once you start working with people, you tend to do all the same things or buy the same clothes.

I think Andy got bored doing those commissioned portraits. For a while, it was a way to make money and it was glamorous, but he got bored. All of a sudden, though, things just started happening downtown. Downtown met uptown. A lot of uptown people would be going downtown to clubs and parties, and the mix was starting to happen. It was really exciting then. Steve Sprouse knew Debbie Harry, and Andy knew Debbie; it was cool, it was new, and it was electric. So when this movement started happening downtown, Andy wanted to participate as he always did. He changed a lot, but then he was always evolving. That was just part of what he did. Even the lunches changed.

There had always been wine and liquor available at the lunches, but then they became replaced by Perrier with Rose's lime juice on the side. The food was much more health oriented, and for a while, we had a macrobiotic cook. Fred Hughes and some of the advertisers complained about that so we stopped. Then we had Amy Heater, a former actress from Andy's *Frankenstein*, catered from Il Conditti, her restaurant on East 58th. Her food was the most popular of all.

Was that at the time when the blind date club started up?

Yes. Tama Janowitz, Andy, and I each had to get a date for one of us. Andy's rule was that at least one of the dates had to be an advertiser. But then once in a while, there would be some cute guy that Andy wanted to meet, and he would sort of hint to me. And I would say, "But Andy, he's not an advertiser." And he would reply, "Well, that's OK this time." He'd bend the rules in his favor.

Did Andy ever get any real dates out of these dinners?

Yes, he did. I witnessed the whole thing. His name was Dr. Barry Gingel. Tama found him by canvassing an apartment building in the West Village. It was really our last resort because it was late Sunday afternoon and we needed to get Andy his date by that evening. He was a nutritionist and a doctor. And he actually looked like Andy in a way. He was very fair, pale eyes, ivory skin, very soft-spoken, and big glasses. And Andy just thought this guy was terrific and started courting him. I remember at the restaurant Indochine one night, Andy wrote just his phone number—without his name—on a scrap of paper and gave it to Barry across the table. *You* know how rare it was for Andy to give out his home phone number to *anyone*. And he said, "Now you call me." Later, I was with Andy—we had to go to some function uptown for an art opening. Barry was supposed to meet us at the dinner that night. Andy thought he was going to be his date. It was a seated dinner, and Barry arrived with his boyfriend. Andy was so upset. Barry seemed nonplussed, and Andy immediately dropped him. It was bound to happen. The week before when we had dinner with Barry at the Odeon, Andy was mad and perplexed because Barry had ordered a crème brûlée for dessert. Andy felt nutritionists shouldn't eat rich desserts like that and that the doctor should be setting a better example.

Many people never saw Andy's more spiritual side. Can you tell us about that?

In the last two years of his life, I would often meet him at St. Vincent's Church at 66th and Lexington. He'd go every Sunday, even though he didn't stay for the whole mass. He sat in the back far left pew. Adolfo, the designer, sat in the same row, but on the far right. It seemed almost like fate. He was doing those paintings of the Last Supper. He wanted to help more with the underprivileged. He was feeding the pigeons. He wouldn't go out to clubs as much. He liked to eat dinner more frequently in his neighborhood at Le Cirque or Nippon. He'd put on a tie. He did the advertising dinners, but he just wouldn't stay out late at the clubs—if he went at all. He was more into dinners, the movies, and going home. There was something going on there. It was as if he knew he was coming full circle.

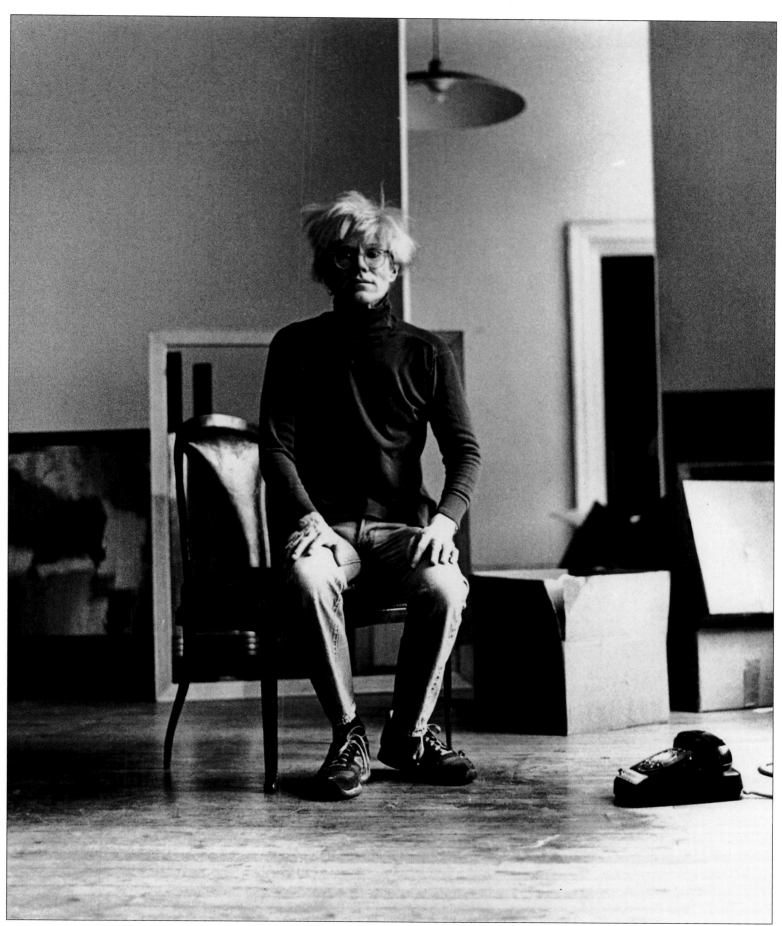

Warhol during the last days at 860 Broadway before moving to the 22 East 33rd Street Factory.

Tama Janowitz

The Author on Warhol's Blind Date Club

Tama Janowitz won a National Endowment for the Arts grant for her first book, *The American Dad* (Putnam, 1981) in 1982. After moving to New York, she wrote *Slaves of New York* (Washington Square Press, 1986), which became a film produced by Ismail Merchant and James Ivory. She completed *A Cannibal in Manhattan* (Crown Publishers, 1987) for which Andy Warhol, Brigid Berlin, Gerard Basquiat, and others posed for photos, and *The Male Cross-Dresser Support Group* (Crown Publishers, 1992). Janowitz is still writing and living in New York.

How, as a struggling writer, did you come to New York?

I had been living in very remote Provincetown during the winter. The Provincetown Fine Art Work Center gave me a tiny apartment and a couple hundred bucks a month. That year, 1982, I won a National Endowment for the Arts grant, $12,000 or $13,000, so I thought I'd come to New York. Writing is so isolating, and at least in New York I'd *see* other people.

So I went to New York. I never have been too lucky with apartments, and I finally found an apartment for around $700 a month. It was actually a pretty big apartment, and it was the only thing I was able to find at any price. But if you deduct $700 from the $12,000 that I earned that year, there wasn't much left to live on.

I would walk up and down Columbus Avenue. If you don't know people, New York is the emptiest city in the world, despite the fact that it is so crowded. You can't just go over to somebody and start sitting at a cafe table, especially if you're shy, and start talking to them. Even if I went out to a bar, I would sit on a stool and have a drink alone and go home.

Eventually, I found out by accident that if you were in SoHo on a Saturday there was almost always an art opening taking place that you didn't have to be invited to. And people there were actually quite friendly. It wasn't like going to a bar, trying to get picked up. Nobody in my whole life ever tried to pick me up, anyway. At the openings, you got a glass of cheap white wine and somebody would ask you how you liked the paintings and would invite you to a party that night.

Finally, I had some avenues into New York. Most people meet people at work or have their college friends. I didn't have any of those things.

When did you first hear of Andy?

I had known of him from childhood. I grew up in Amherst, Massachusetts, and when the '60s hit town, we finally got a few shops like the Hungry U bagel shop. I remember there was a big

So I called him up and said, "...Do you know a doctor who would go out with Andy?" Because Andy loved doctors and liked to hear about diseases.

poster of Andy's flowers hanging on the wall. And my mother and I decided it was the most beautiful thing we'd ever seen. I set to work making a reproduction to hang on our wall because we couldn't even afford the poster. I will never forget that. Those brilliant, colored flowers on a black field.

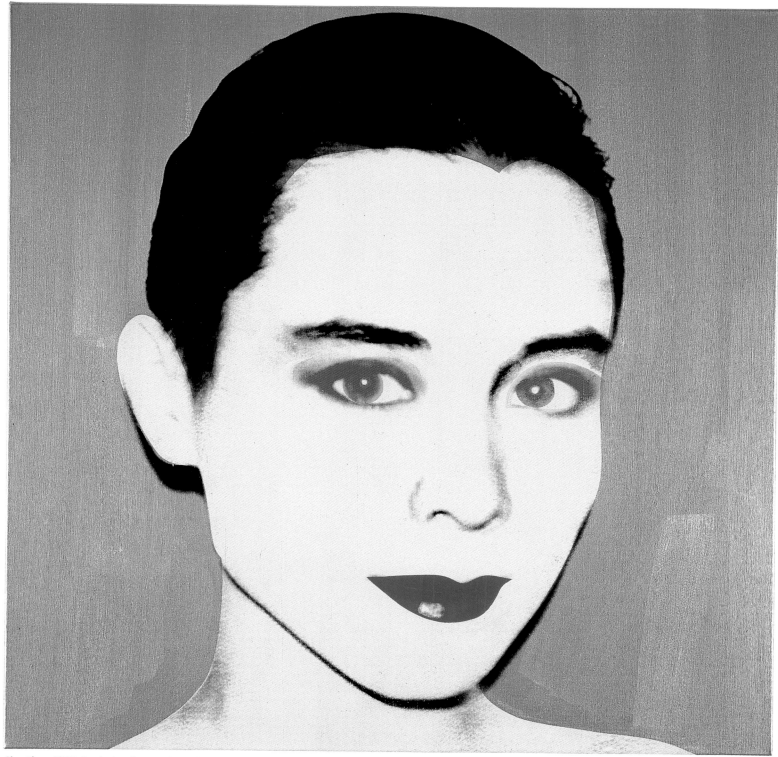

Tina Chow, 1985. Synthetic polymer paint and silkscreen ink on canvas, 40 x 40 in.

I finally met Andy in 1985. That was when my stories had started coming out in the *New Yorker*. At that time, Paige Powell called me. I didn't know Paige at all, although I had seen her over the years. She was so beautiful, and she was always wearing the most extraordinary creations. I would see her in a nightclub in a huge ball gown, and she was always surrounded by an admiring throng. It seemed that a spotlight was constantly on her. I never would have dreamed that she would deign to speak to me. And then she called me. She was working at *Interview*, and Jeff Slonim, my cousin, had started working there. Actually, Jeff called up and said, "Listen, Paige has a blind date this evening, and she thought you might like to join her." And I said, "That's so nice of her, but why would she want *me* to come on a blind date with her?"

Finally, I agreed, and he told me the date was at the restaurant Odeon. Well, believe me, my income had not gone up, and I was quite nervous about going out to dinner. But Jeff assured me that it was going to be Paige's treat. He called back a little later and said, "It turned out that while I was calling you, Andy was walking by and he wants to come on the blind date." Jeff said that Andy was going to bring five people with him.

We showed up at the restaurant at nine o'clock, and there was the blind date. He was like a blind date from Central Casting. He

He didn't want anybody to know that they were blind dates because he would have been really embarrassed had they known.

was so offensive. It wasn't just the Hawaiian print shirt unbuttoned to below his hairy navel or the gold chain around his neck or the fact that he was bald but trying to cover the bald with hair sweeping over it. None of those things in and of themselves were so terrible. But he never shut up, and he was extremely boring. He bragged the entire time about his screenplay, his brilliance, his Mafia connections. He had positioned himself between me and Paige, and he seemed to be oblivious of the fact that it was no longer just Paige and him on this blind date arranged through a mutual friend, but it was Paige, him, me, and all these men.

And Andy sat there saying, "This is really great." Here I was just about dead from nervousness because I didn't know Paige, I didn't know the blind date, I had scarcely been to restaurants like that in my life. I mean, should I pick the salmon? That's $13.95; I'd really rather have the steak, but that's so expensive. Before, I would take a bus from my apartment because the bus cost 90¢, and I would go to One University, Micky's Place, and I'd get just one beer, and then I would go home. So it was traumatizing for me on so many different levels, but the next day Paige said that Andy had loved it and wanted to do it again next week.

So that was how it began. And it continued on every week, sometimes twice a week, for the next two years or so. The basic core group was Paige, Andy, and I. We would have to bring blind dates for one another. It was terribly awkward because I didn't know that many people, and sometimes you'd be required to supply two other people with a date. I very quickly ran out of acquaintances.

I remember very clearly once Andy said to Paige, "I have a really great date for you tonight. He's a model, and he's really great, really cute. I just met him the other day." The guy walked in the door of Mr. Chow's, where we were having dinner. Paige turned to Andy and said, "My gosh, you've finally come up with somebody for me. That guy is really cute." Andy got a strange look on his

face. He was jealous. And as soon as the guy sat down, Andy drew him over next to him and said, "Would you like to come with me to the big Kennedy wedding this weekend? I'm flying up in a private plane." Well, of course, the guy didn't even *speak* to Paige after that. Paige was so mad.

Every week something went drastically wrong. Paige wouldn't know that the date she was supplying for me was a happily married man. Sometimes we'd be so desperate that the dates would turn into outings with twenty people. There was one disastrous date that I remember in particular. At 6:30, Paige called me in a panic and said, "Andy's date has just canceled. What are we going to do?" We had been doing the blind dates for two years at that point, so there was nobody left to beg. I said, "All right, you get to work on your end, I'll get to work on my end."

There were two cute guys who lived in my building. I knew that they lived together, but at this point dinner was in twenty minutes. I didn't care. I knocked on their door and said, "I know you don't really know me that well except I see you when we walk our dogs together, but we have a Blind Date Club with Andy Warhol. Would one of you guys come out and be Andy Warhol's date in twenty minutes at Café Luxembourg?" They looked at each other, and they knew it would be the end of their relationship. They said no. Then I remembered a guy Andy had quite liked, a doctor, although nothing had really clicked. So I called him up and said, "Jim, Jim, could you help me out? We have another blind date here. Do you know a doctor who would go out with Andy?" Because Andy loved doctors and liked to hear about diseases. Andy didn't realize that we were recruiting practically virtual strangers out of the phone book. I said, "This guy's got to pretend that he knows me and that we're old friends. Tell him my name's Tama, I've got long black hair. When he comes into the restaurant, he should greet me."

Meanwhile, Paige had miraculously come up with somebody, and there he was sitting on one side of Andy. All of a sudden Barry, the guy I recruited, walked in. He sat down on the other side of Andy. Well, Andy had strict rules about the dates. He didn't want anybody to know that they were blind dates because he would have been really embarrassed had they known. We always had to say they were business dinners, which was probably partly for tax purposes. But that was only part of it. Andy didn't want anybody to know that he was gay and that we were fixing him up with guys. Other rules were that you couldn't have more than one date on these evenings and that you had to know the person. But now Andy had two dates, and the only way he could deal with it was just act like one guy wasn't there. He just completely snubbed the poor guy who Paige had dragged out from whatever he was doing. But Andy absolutely loved Barry, he just adored him. He was a nutritionist, and he looked just like Andy. People kept whispering, "Is that his nephew?"

When did Andy start getting interested in Slaves of New York?

He had read my stories in the *New Yorker*, and before the book came out he wanted to option them to make them into a movie. He offered me $5,000. I said, "That doesn't seem like very much. Could you get me an apartment, instead?" I didn't need the money. I needed a place to live. Then he offered me a painting instead. What was I going to do with a painting? I didn't have anywhere to live. Finally, I told my agent that Andy was going to give me $5,000, and my agent told me to take the offer because nobody else was ever going to buy my stories to make them into a movie.

Some agent. So you took the $5,000?

Mmm. At that point, Andy told me that I had to write the stories into a screenplay. I didn't want to write the screenplay. I had written these stories, I had rewritten them, and then gotten more assistance from my editor, Gwyneth Cravens, at the *New Yorker*. So I told him to hire someone else to do it. But he didn't know any screenwriters and neither did I. Finally, in desperation, I got one of the blind dates to do it, and he just wasn't right – at all. Andy got back on my case to do it, so I wrote it. "You've got to," he said on the phone. "It'll be good for your career." "What career?" I said. But I broke down and did it. It wasn't so bad. I gave the script to him in December of 1986. Andy called me back in late January really excited and enthusiastic and supportive. He died a few weeks later.

Andy never gave me much money, and I didn't have any clue of how rich he was, but he was extremely generous in so many ways, particularly in terms of his enthusiasm and support for me, for designers, for musicians, for young people. Most artists, if they live to be fifty and have made it, don't give a damn what young people are doing.

Did you and Andy ever discuss what he found most interesting about Slaves of New York?

He said, "Tama, I thought the stories were really great. I wish somebody had been writing about the art scene in the 1960s the way you are writing about it in the '80s." I think he liked the fact that I wasn't glamorizing the art scene. I saw it as a bunch of kids who wanted to "make it" and get rich. Andy had done that, and he was a great artist too. Therefore, there was a lot of hatred and so much contempt for him. When I went out with him sometimes, a wave of hostility confronted me – directed at him. Once Andy was doing a book signing, and a woman ripped off his wig. I thought, "My God, he should get out of here. They're going to hurt him."

Still, whenever he went anywhere, the whole atmosphere of the room changed. "Here he is, he's in the room!" A sort of electricity went off. He was like the Statue of Liberty, he *was* New York. Suddenly you felt that you weren't in this dingy place any more. Everyone knew they had come to the right party.

He wore the same outfits he had always worn, and he was the same person, but there was nothing dated about him. He continued to represent something of sophisticated cool hipness that didn't diminish. When he died, something left the city.

He offered me $5,000. I said, "That doesn't seem like very much. Could you get me an apartment, instead?" I didn't need the money.

You mentioned that Andy was always quick to help out young, up-and-coming artists. Did you ever see anything of his more spiritual or religious side that a number of people have mentioned to us?

Well, he always went to the soup kitchen. He would work in the soup kitchen on Easter, Christmas, and other holidays. I went with him a number of times. Often I left early, though. They had a ton of people working. After you realized that you were fighting with somebody in the kitchen over who's going to pour the homeless their coffee, you saw that you weren't really doing much to help anybody except feeling good yourself. But for Andy it was different. He was a huge star, an artist, and just his presence there was significant.

Tama Janowitz and veterinarian Dr. Steven Kritsick, one of the "blind dates."

Details of Renaissance Paintings (Paolo Uccello,
St. George and the Dragon, 1460), 1984. Synthetic
polymer paint and silkscreen ink on canvas, 48 x 72 in.

What did you see of Andy's artwork during that period?

His art at that time was so put down. He couldn't get the *Last Supper* paintings exhibited in New York at all. He never had a major retrospective in his lifetime. People were always saying, "Oh, well, he's just a pop artist of the '60s." Really, they were so nasty about it. And now, except for Norman Rockwell, he's

> ## Still, whenever he went anywhere, the whole atmosphere of the room changed. "Here he is, he's in the room!" A sort of electricity went off.

the only American artist with his own museum. There have been museum exhibitions worldwide and endless publications regarding his work.

During his lifetime, he was able to enjoy being a celebrity—he was invited to places, recognized, ushered in. But the fact that he persevered in the face of an overwhelming number of negative and very vicious attacks on his work is to me a sign of a real artist.

Looking back, is there one painting that is most truly representative of Warhol for you?

No. I think his work continues to look different to me as time puts a layer on top of it and things change for me personally. But if I had to pick one, I would still choose that painting of the flowers that I saw when I was six or so years old—that somebody could paint vividly and crudely, but make it happy, electric, hyper-real. I don't know if it's affected me the most, but it has certainly affected me the longest. It's hard to think of another artist whose work you can recall so instantly. To be able to take images that are part of everyday day life that you don't even look at—a soup can, a celebrity, just another image flashing past your eye—and pluck those images out and show people, "Look, this is what's right in front of your eyes every day that you pass without thinking that it has much significance."

Can you tell us a little bit about the book party that Alan Rish threw for you at Petaluma for Slaves of New York? *I believe that Andy mentioned it in his diaries at the time as being a really great one.*

For me, it was a nightmare. I wasn't accustomed to having a party thrown for me. I had had one book come out, nothing had happened. Then all of a sudden they're having parties for me

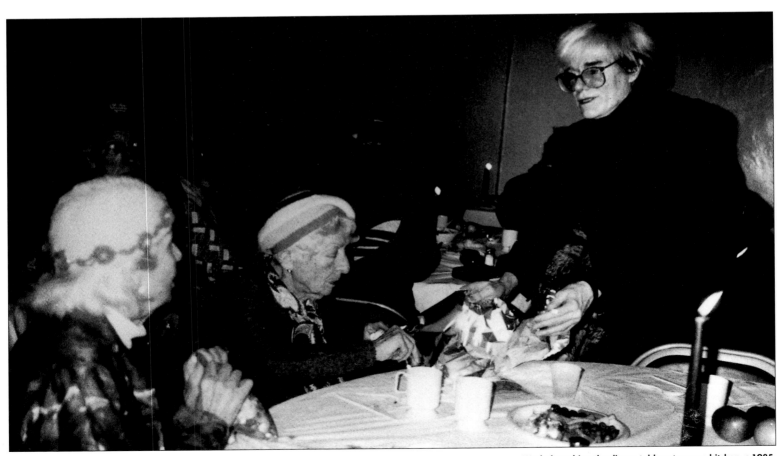

Warhol working the dinner tables at a soup kitchen, c.1985.

Demi Moore and Andy Warhol, c. 1985.

because I have this new book coming out. I just wasn't prepared for any kind of attention at all.

But I remember that I thought, "I want to give everybody a little present; maybe that will make them have fun." So I got a lot of things at a joke store. They were all the dumbest tricks in the world, like a buzzer that buzzes when you shake hands, and a lightbulb that goes on when you put it on your head, and an arrow that looks like it's going through your head. I passed them out as everybody arrived. I had invited such a mixture of people. The party was big and crowded and noisy, I couldn't really speak to anybody, and the dinner was endless in arriving.

I don't know why the hell Andy would have had fun at that party. I remember that I kept thinking, He goes out every single night of the week. Why? I'd be so happy to stay home, watch TV, go to sleep. He goes out for business. But he was not going out just for business. He was going out because he loved going out. He just loved it. He didn't want to be home alone.

You're right. At parties, Andy would say, "Oh, I have to talk to so-and-so; oh, look, look what she's wearing; oh, she's so great. Well, it's all business, it's all work." But he said it with that little grin.

My best memory of Andy is of the New Year's Eve of 1986-87, just before he died. Steven Greenberg invited us out to the River Cafe. We were in the middle of a lavish meal when Andy announced that he had agreed to host *another* party at a Brazilian restaurant. So we told Steven that we had to go – it was just before midnight. Steve said, "Take my car." It was a big, old Rolls-Royce.

His art at that time was so put down. He couldn't get the *Last Supper* paintings exhibited in New York. He never had a major retrospective in his lifetime.

Just as it turned midnight, Andy, Paige, and I were crossing the bridge in this old car driven by Harold, Steven's driver. The fireworks went off, and the Rolling Stones' "Here Comes Your Nineteenth Nervous Breakdown" started to play on the radio. We just started to laugh.

Another year had gone by – another year of endless, unsuccessful blind dates. But we were all together, having fun, New York twinkling on the other side. We were all laughing as we crossed the bridge with the fireworks going off. It was such a perfect moment.

Kenny Scharf

The Painter Shares His Memories of Warhol

Kenny Scharf was born in 1958 in Hollywood, California. After completing his B.F.A. at the School of Visual Arts in New York, Scharf went on to have multiple one-man exhibitions at the Galerie Bruno Bischofberger, Zurich, and several shows at the Akira Ikeda Gallery in Tokyo. Scharf was also included in *Biennial 1985* at the Whitney Museum of American Art in New York. His work is in many public and private collections including the Ludwig Museum, Cologne. Recently he has exhibited at the Museum of Fine Art in Miami, where he now lives.

When was the first time you heard of Andy Warhol and pop art?

I was going to college at UC Santa Barbara in 1977 or so. Eileen Guggenheim taught a class in modern art and I was her student. She was really fun, really gossipy. The class started with expressionism. Jackson Pollock. And then all of a sudden she started talking about pop art and Andy Warhol and the Factory. And when

> ## I knew about Jean-Michel Basquiat hanging out with Andy, and I was kind of jealous, but I didn't want to be pushy.

she started describing it all, I said, "I'm *out of here*. I'm going to New York." I wanted to be a part of it. I knew that it was a '60s scene and that the '60s were over, but whatever it was that happened there could never happen in Santa Barbara. I was off. I told my parents I was going to New York. They insisted that I go to art school. I wanted to go to art school, but I wanted to go to art school in New York. Luckily, I didn't get accepted anywhere but the School of Visual Arts, which takes anybody. The School of the Virtually Artless. It was great. I met Keith Haring and John Sex and Jean-Michel Basquiat. I met everyone at that school.

When was the first time you spotted Andy in New York City?

It was at the opening of Peppermint Lounge, right after the New York/ New Wave show. Andy and I were both in that show. I got so excited seeing him at the Peppermint Lounge. I went up to him and said, "We're in the show together." That's what I said. He said, "Oh." He was very "queeny." He had his whole entourage with him, and he kept trying to get one of the boys who he was with to make out with me. I was so thrilled to be anywhere near him— he was actually talking to me and paying attention to me.

That was it. I didn't see him again for a long time. I knew about Jean-Michel Basquiat hanging out with Andy, and I was kind of jealous, but I didn't want to be pushy. I wanted to get in there, but I didn't really want to be obnoxious about it. I couldn't ask Jean-Michel to take me to see him because he would never have. But when Keith Haring finally started becoming friends with Andy, then I could say, "Keith, I'm coming with you." We came to the Factory for lunch. I was so in awe and so nervous that it wasn't that much fun for me. I didn't know what to say, and Andy was quiet. It was very uncomfortable but thrilling.

Then one night Andy invited me to dinner. I was in heaven. This was it. I was going to dinner. We went to some Southwestern restaurant uptown. Keith and Jean-Michel were there as well as a few other people. I was so nervous that I started to drink just to loosen up a little. Andy wanted me to sit next to him, which of course thrilled me. And Jean-Michel had a fierce

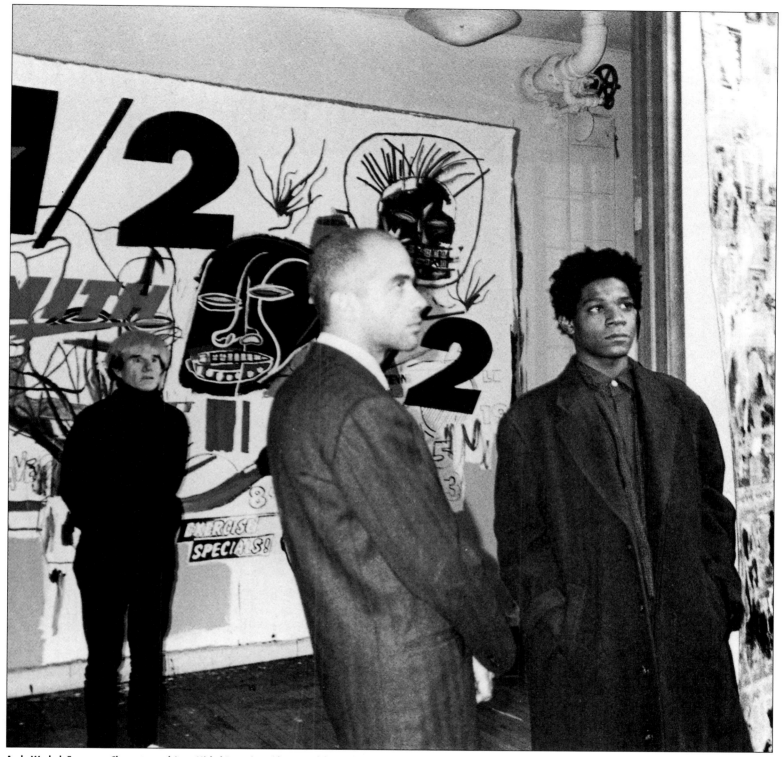

Andy Warhol, Francesco Clemente, and Jean-Michel Basquiat with some of their collaborative works, c. 1984.

jealousy attack. He hated me, and he was always trying to push me down. So he was freaking out, but Andy insisted that I sit next to him. I think I had about six or seven drinks – tequila or something. I got really drunk, and I was having a great time. I finally felt like I had arrived. Then Jean-Michel takes out a joint. One hit when you're drunk and you're gone. I took a hit, and the room started spinning. I had to leave. I slipped away from the table, ran out of the restaurant – I couldn't walk. I puked all over my new Armani suit, staggered over to the door of a building two doors away. It was really cold outside, so I went inside and I lay on the floor of the entrance to the building. I think I lay there for about two or three hours. I couldn't move. I remember opening my eyes and seeing people step over me. Then I managed to pick myself up and hail a cab at 5 in the morning.

Mechanical Terrier, 1983. Synthetic polymer paint and silkscreen ink on canvas, 14 x 11 in.

Every two blocks I got sick. The cab driver was so nice. He kept pulling over for me.

I had to catch a plane to Brazil that morning. I managed to get on the plane. I arrived green in Brazil. So they never knew what happened to me until I came back four months later. It took me a

I got to *live* at the Whitney – I stayed there until 5 in the morning. We were bonging and doing mushrooms and playing really loud music.

long time not to be nervous around Andy, and it was actually really wonderful when I finally got to be myself with him and he got to be himself with me. I felt like we really were friends. The formal stuff wasn't there any more. He was always very friendly and generous with me.

I once had a birthday party for Tereza, my wife. We had a picnic in Central Park, and Andy and Stuart Pivar had picked up all these antique religious figures. Off in the distance, I saw Andy and Stu walking through the park in the sunlight, coming toward us holding these big religious figures. When they got to us, Andy gave Tereza this enormous figure of St. George slaying the dragon. Wonderful.

Didn't he also give you some canvases over the years as presents?

Oh yes. He gave me a *Hamburger* painting, one entitled *Be Somebody With a Body*, also a *Jesus Christ* portrait. I got his *Self-Portrait*, dated 1964, which is one of my most cherished possessions. He traded me that for my big *Mad Glad Man*. That big purple thing. It appeared on *Andy Warhol's TV*. The self-portrait of Andy has him wearing dark glasses. And it's purple, pinkish purple. He gave me a choice between that and a *Jackie Kennedy* canvas. And I said that there was no question of which one I wanted. *I want you.* I don't want Jackie.

Did Andy ever paint a portrait of you?

Andy did two things that surprised me: he put a big "GE" over our image as a sort of graffiti tag because at the time I was doing GE tags. There were two portraits, one with Tereza and Zena, my daughter, and one with me and Zena. Because of divorce, he said he always made them separable. Everyone looked beautiful; with Andy, no matter how ugly you were, he made you look beautiful.

Did you ever talk to Andy about your work?

Kenny and Tereza Scharf at home, c. 1987.

He was incredibly supportive. Any inspiration or idea that you had, he would say, "That's so great, you should do it." Or you would tell him about something you just did and he would say, "Oh wow." Every time something happened, I would have to tell him because he would make me feel so good.

I've been to your studio with Andy. Do you remember those visits?

One time I remember distinctly was when I was painting the telephone booths for the Whitney Museum's Biennial exhibition. So I called all my friends, and I gave them all the phone numbers at the phone booths so they could call me. I was getting called all the time and inviting people over. I took a week to do the thing, and

Off in the distance, I saw Andy and Stu walking through the park in the sunlight, coming toward us holding these big religious figures.

it was the most fun week. I got to *live* at the Whitney – I stayed there until 5 in the morning. We were bonging and doing mushrooms and playing really loud music. Well, I guess the people at the Whitney thought it was disrespectful, but for me it was heaven. I remember calling Andy, and he came by with Jean-Michel and some other friends. It was just so much fun and Andy visited me there often.

Paige Powell, Kenny Scharf (in drag), and Andy Warhol, c. 1985.

You were the only person in that show who did a total environment. Was it well attended?

Well, subsequently, they called the 1985 Biennial the Biennial that critics loved to hate. It's the most critically panned but the

I think Andy loved being around young artists with a lot of energy, and we loved him so much – we definitely gave him energy.

highest attended Biennial of all time. I'd rather have all those people come to see it and the critics hate it – that means I did something good.

Didn't you create something for Ian Schrager and Steve Rubell at the Palladium nightclub?

Keith did a huge, huge mural that would lower and raise on the dance floor. Francesco Clemente did a room – that's so rare. It was a big frescoed room, beautiful. And my contribution was the shortest lived. I did the phone booths and the room between them. I was always doing phone booths and bathrooms. I was the toilet artist that year. Ha ha. I still am. They promised me a guard, but there was never a guard there. And the phone booths got ripped to shreds in no time. When I saw people putting their cigarettes out in the paintings, I had to roll it up and say that it was finished.

There was another group show that you and Andy were in at the nightclub called Area.

When Palladium did their thing, Area did their thing. I did these big polyurethane heads. One goofy one and one monster; they were connected to the same body, hanging by strings from the ceiling. Andy did what he called the *Invisible Sculpture*. It was perfect. All of a sudden I got this urge – you know, of course, that Andy never danced. But a really good song came on, and I had a

flash – I'm going to disco with Andy. So I took him and said, "You're coming, you're going to dance with me. I want to be able to say that I danced with you." So I made him get onto the dance floor, and I'm dancing away and he's just standing there, of course, not moving. I remember laughing my head off. I just wanted to say that I had disco danced with Andy Warhol. He had fun. He liked the scene, he really did like the scene.

He was always attracted to scenes and creative people with a lot of energy.

I think Andy loved being around young artists with a lot of energy, and we loved him so much – we definitely gave him energy. I remember telling him one thing that may have influenced him a bit. He had been doing some brush painting by hand. I told him that I really loved the paintings, that I loved to see his brushwork, his hand – he was only doing photo silkscreens at that point. And after that, he started doing a lot of handpainting again. I think maybe I had something to do with that. There's nothing like the hand, his hand – the vibration off the surface instead of a flat, dull surface.

So you weren't partial to the silkscreens?

Actually, I was not too excited by the work that he was doing in the late '70s. I wasn't into the Studio 54 scene and definitely wasn't into the society scene. So when I went to the Whitney to see his portrait show, and there were all these portraits of Madame Blah Blah Blah and So and So. I looked at them thinking who the fuck cares about these people? And it was really refreshing when he started painting interesting things again, like the *Last Supper* series. I'm really glad that happened before he died.

I remember laughing my head off. I just wanted to say that I had disco danced with Andy Warhol. He had fun. He liked the scene, he really did like the scene.

He came full circle. His early paintings like 72 Cent Cooking Pot *are painted in the same manner as the later handwork you speak of. Which Warhol works would you like to own in addition to the ones you already have on your walls?*

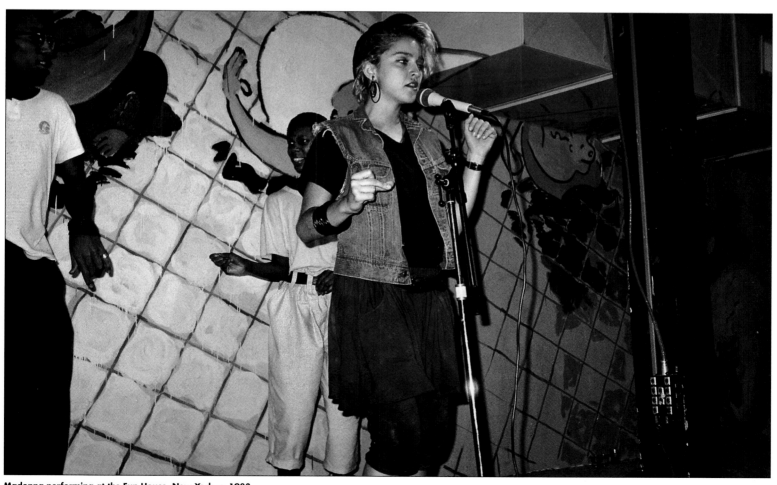

Madonna performing at the Fun House, New York, c. 1983.

Hamburger, c. 1985. Synthetic polymer paint and silkscreen ink on canvas, 16 x 20 in.

I think the electric chairs are pretty intense. And the auto crash. They're so powerful – the statement behind them about the media and what it does to our senses. There are so many. All the pop ones: *Marilyn, Elvis* and all the rest. Those are just classic beauties. They're so beautiful to look at. The piss paintings – they're very avant garde.

Did you ever see Andy without his wig on?

Without his wig on? One time, and I felt really bad for him. Someone ripped his wig off his head at a Rizzoli book-signing party. I felt so bad. I just wanted to scoop him up and get him out of there. He was very good about it – he just pulled up his hood – but I could tell that it really shook him up.

You've been to both 860 Broadway and 33rd Street. Did you see a difference when Andy moved from one work space to the other?

Well, the new one had much more the feeling of money. 860 Broadway still had that flavor of downtown – kind of funky, kind of fun. The new one was serious – all the different floors. Until you went to his storage floor. When I saw the storage floor, I thought, This guy is so nutty. For him to horde stuff in the most expensive real estate in the world and just fill it with junk. I thought it was brilliant. Every time he finished opening a present, he would just throw it right in there. If you gave him something, it would end up on top of a pile. I wonder whatever happened to his camera that I customized for him. I wanted to customize his camera because that was the thing that he always had in his hand. So I painted

the whole thing—little characters and jewels and lots of colors. And the fun thing about a customized camera was that every picture you took, almost everyone would be smiling, because they would be surprised looking at the camera. It would change the photograph.

Did he ever use it?

or him to horde stuff in the most expensive real estate in the world and just fill it with junk. I thought it was brilliant.

Yes, he did. He used it for about a week, and then he said it broke. It did *not* break.

It's probably in a time capsule.

I'd love to know where the portrait I did of him is. I went to Scotland in 1982. While I was there, I did a series of watercolors called *Stars in Scotland*. I had bought all these rags at the airport—*Star, Enquirer*. I would take a picture of say, Marie Osmond, I'd do the portrait, and then I'd put her in front of the scene that I saw that day in Scotland. So there was Marie Osmond with a castle behind her or John Davidson with lambs and the ocean.

I turned the paintings into this series called *Stars in Scotland*. The John Davidson portrait looked exactly like Andy. It was Andy's head. I kept it for a long time, and then one day, I took it out of the series and gave it to Andy and said, "This is a portrait I did of you." Because it really looked like him. I would love to know what happened to it.

Andy collaborated with a lot of artists. Did the two of you ever collaborate on any paintings?

A lot of my contemporaries did paintings with Andy. It was *the* thing to collaborate with Andy. And I really thought about it. I thought, Well, maybe I should do a collaboration with Andy, too. I could have easily gone in there with a canvas, painted something, and asked him to do something, too. But I remember deciding not to because I felt that it would be too pushy of me. And I felt that I really got so much from him, anyway, just by being around him. I didn't want to take advantage.

Did you ever see the more health conscious side of Andy?

Towards the end of his life, he was getting into crystals, and he'd always wear them inside his shirt. And he would take a

crystal and wave it over his martini to make it benign or something. It was so funny—waving a crystal over vodka. He was serious about it, though.

I remember one time he had crystals in the Factory kitchen to get rid of cockroaches. One day I said, "Andy, there are roaches all over that kitchen." And he said, "Oh no, don't tell me that. That means the crystal doctor's a fake. I don't want to know." When was the last time you saw Andy?

Andy died while I was in Brazil. Keith and I were in Brazil together. Keith went into town to make a phone call and found out that Andy died. He came back to my house to tell me. We were just so shocked.

I remember very distinctly the last time that I saw him, the last four or five times that I saw him, right before I went to Brazil. He was having gallbladder problems. We got to talking about it. Maybe he knew something was up, because I got this very intense feeling from him.

All of a sudden, I felt really close to him. I'd walk into a room, and there would be lots of people, and Andy would be way off at the other end of the room. And he would look at me and I would look at him, and it was as if everyone else in the room was blurry.

He seemed different. He seemed really spiritual. I always felt like he was my father—I used to call him Papa Pop—but I really

And he would take a crystal and wave it over his martini to make it benign or something. It was so funny – waving a crystal over vodka.

felt something stronger than ever. I remember it as a very intense, very intense closeness. Maybe he knew he was going to die. I don't know. At that point in his life, he just seemed to be on another wavelength.

I didn't get back in time to go to the funeral in Pennsylvania, but I did make it to the enormous memorial service at St. Patrick's Cathedral. You've never seen so many amazing people under one roof. That was the last great party. Everyone showed up, just every single person that had been in the Factory from the '60s up to the '80s. It was as if we had entered a nightclub in the late afternoon.

It's funny. After Andy died, I started silkscreening. It sounds strange, but I honestly felt that Andy was communicating with me. I know it sounds crazy, but I really felt that.

Stephen Sprouse photographed by Andy Warhol at the Council of Fashion Designers of America awards dinner, January 1985.

Stephen Sprouse

The Designer Who Inspired Warhol's Look

Stephen Sprouse began his career in fashion as Halston's assistant. Sprouse has been designing his own collections since 1984 when he received the award for Best New Designer from the Council of Fashion Designers of America. He is known for his rock and roll inspired fashions, and his designs have been worn by many of the most cutting-edge artists of the 1980s and 1990s.

When you were growing up, how did you first hear of Andy?

I grew up in the Midwest, and there was nothing to do. I remember reading about Andy in magazines from New York, seeing pictures of Edie Sedgwick and him in *Vogue*. And I remember seeing an ad for his movie *Trash* in the *New York Times*. Everything said "Andy Warhol Presents." Andy Warhol presents Edie Sedgwick at a museum party in *Vogue*, or Andy Warhol presents Joe Dallesandro in the *New York Times*, bare-chested like a rock star. So I got curious. Then my best friend in high school bought me an Andy Warhol book from the Indianapolis Art Museum. One of those coffee table art books.

When was the first time you two met?

I moved to New York in 1972. And there was some fancy party that spring on the East Side, I think. And it was really just a boring party. Andy came in with a couple of people. I didn't go over and introduce myself, but it was him. I knew it was him. The whole feeling of the party changed for me when he walked in. I don't know if it did for anybody else, but for me it did.

The first time I actually talked to Andy, a friend of mine, Berry Berenson, had given me tickets to the Rolling Stones at the Garden and to an after-party. I had never seen the Rolling Stones before. It was a great concert. My friend who went to the concert with me couldn't go to the after-party, so I went by myself. The party was for Mick Jagger at the St. Regis Hotel. It was the type of party where strippers were coming out of cakes and things. I was around eighteen or nineteen, and I probably had been smoking pot. And all of a sudden, I was at the party and sitting at Andy's table. The next thing I knew, I was sitting between Andy and Truman Capote. I just sat there – I was pretty stoned – and listened. Truman Capote didn't say a word, but Andy started talking to me.

I told Andy about this dream I'd had the night before about Robert Mapplethorpe. I didn't *know* it was Robert Mapplethorpe, but I had seen him at these parties. He looked like a rock poet with long curly hair and Edgar Allan Poe-type suits. So I had this dream about him, but I didn't know who he was. I didn't know his name. But I knew Andy would know who he was. So I started describing him to Andy, and he said, "Oh, that's Robert Mapplethorpe." And I said, "Oh, how old is he?" And Andy said, "Oh, about twenty-five." And then Andy said, "Well, did you come? In the dream?" I knew exactly what he meant, but I wasn't sure I had heard him right. I got really nervous, and, soon after, I left the party.

So that was the first time I ever talked to Andy. But he didn't tell me his name; I didn't tell him mine. I was finally introduced to him at a big party for Debbie Harry and Blondie at Studio 54 in around 1979. Debbie was on the cover of *Interview*. By then, I was making clothes for her. And we had shot Debbie wearing my clothes for Andy's cable television show on the Madison Square Garden network. Andy knew about me because he had seen the footage. And then Debbie introduced me to him at the party.

So gradually we started to hang out. One night after dinner, we went out to a café place. It was really late one night, and the place had big high ceilings. Andy started telling me these stories – I had asked him about Edie Sedgwick and the '60s and all that. And he

191

Andy Warhol on display in his *Invisible Sculpture* installation at the nightclub Area, c. 1985.

went on and on for an hour—he wouldn't shut up. He was telling me all this great stuff, but the place was so crowded with people talking and music, I couldn't hear a word he was saying. It was all this stuff that I had wanted to know about since I had read that book in high school, and I *couldn't hear a thing*. But I was still kind of shy around him, and I didn't know how to say, "I can't hear you."

Well, I guess I can confess now that Andy used to ask me if you liked him. You could become fairly quiet, too, at times. The two of

> ## The next thing I knew, I was sitting between Andy and Truman Capote. I just sat there – I was pretty stoned – and listened.

you would talk in lulls. Sometimes he would ask me whether he and you were having this great talk or not because he really couldn't tell.

I wish he were around now because I've learned to talk more these days. Back then, I could hardly talk, especially to him.

Later you started to dress him. Can you describe which of your clothes he liked to wear?

Yes, I dressed him right up to the end. He always wore black turtlenecks, always black jeans. Then there was the motorcycle jacket. He had a lot of suits. He wore those out to parties. He kind of changed his look in the '80s to the black jeans. He went black with light sneakers and glasses.

And the wigs changed too then.

I remember when he did the *Camouflage Self-Portraits* with his hair sticking straight up like a rock star. I like to think I inspired the camouflage look because I used to wear this black and white camouflage T-shirt when we'd go to the hard-core clubs. It was around the summer of 1985. I was working all summer, and Andy never went away during the summer. There were all these dead weekends, so I started taking him to the hard-core club, the Rock Hotel. By then I could talk to him. I thought, "This is crazy, Andy Warhol watching these kids mosh at what was the only hard-core club in New York City at that point." He thought it was great, and the kids were cute, and we'd stand right outside the mosh pit. And the kids were too busy moshing to notice Andy Warhol.

Camouflage (Detail), 1986. Synthetic polymer paint and silkscreen ink on canvas, 80 x 80 in.

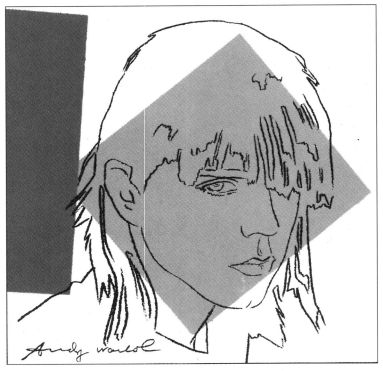

Stephen Sprouse (Detail), 1984. Silkscreen ink on paper, 14 x 11 in.

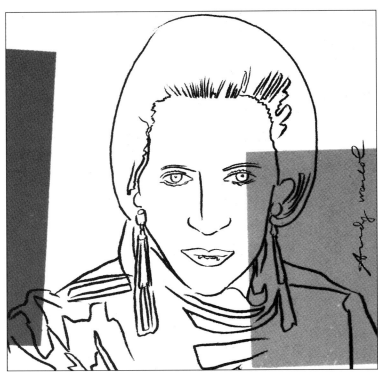

Diana Vreeland (Detail), 1984. Silkscreen ink on paper, 14 x 11 in.

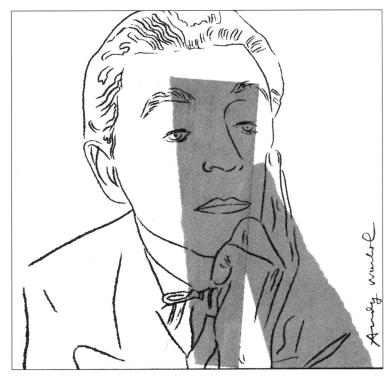

James Galanos (Detail), 1984. Silkscreen ink on paper, 14 x 11 in.

Bruce Weber (Detail), 1984. Silkscreen ink on paper, 14 x 11 in.

It was so hot and sweaty – mid-summer weather – so we would go sit outside the club. We would sit on the curb, on the floor, on the street, on the sidewalk, and lean against the building just like all the kids, and cool off.

One night we were sitting out on the street leaning against the building cooling off, and a car came by full of New Jersey kids. Somebody stuck their head out and yelled, "Oh, that's Andy Warhol. You Andy Warhol?" And he said, "Yes." And then they got out of the car, and one kid asked, "Oh, will you draw us a soup can? Please draw us a soup can." And there's Andy at two in the morning on a Saturday night, sitting in the street, drawing a soup can, and signing it for this kid. The kid said thanks, got in the car, and drove off. And I thought, Wow, they just got a great piece of art. An original *Campbell's Soup Can*.

Instant art. I'm curious, did you and Andy ever talk about music at all?

Oh yes, we talked about music a lot. That was one way I could fill up conversations – I could just endlessly talk about bands. So, we'd talk about bands and rock stars. We talked more about the new bands, the hardcore bands. We kept current.

We never talked about clothes. I would just make them. I would send them down to him. He would wear them. But we would never talk about them.

Did Andy go to the showing of your collections?

He went to the one we had at the Ritz nightclub in 1984. It was wild even out on the street before that show began. The only other show he came to was this little one we did for *Vogue* with the hippie collection. It was just this tiny show.

In 1984, Perry Ellis commissioned Andy to do ten portraits for the Council of Fashion Designers of America awards book, and you had won an award that year for best new designer of the year. Did Andy take an existing photograph to create your portrait or did you sit for him?

He took my picture at the Factory at 860 Broadway. I went there for lunch. And then after I just went into the bathroom, put on a bunch of eyeliner, and put Erase all over my face so it'd be really white, and then he took the Polaroids.

Can you tell us, when was the first time you ever saw Warhol's Camouflage *paintings?*

I didn't see him actually paint them, but I saw the paintings at the Factory when it was at 33rd Street. They were amazing. At some point during that time, I said, "Do you think I could make

camouflage clothes using your Day-Glo camouflage from the paintings?" Andy and I talked about it. But he had to talk to Fred Hughes about it in order for me to use the image. Much later, he told me that he had talked to Fred and that Fred had said it was OK to do the camouflage. I wanted to use it for the clothes in my next collection. So I said that we should go over everything soon. And he said, "Yeah, maybe this weekend." And then he said goodbye. I never saw him or talked to him again. That weekend he died.

But you did get the permission to do the clothes.

Yes. I used the *Camouflage* print in one of my shows in 1987. Tama Janowitz brought Ismail Merchant and James Ivory, who had a movie option on her book *Slaves of New York* to the show. They loved it, and they wanted me to recreate it for the movie. So we used that fabric again in *Slaves of New York*, but it was even better because they filmed it at the Fillmore or The Saint. They made this big runway, and Rachel Williams was there in the camouflage. All these models had a car crash pileup on the runway in Andy *Camouflage*-print clothes. It was like a football huddle or a car crash; we called it a car crash.

I still used that camouflage material in the early '90s. Kenny Scharf asked me to do clothes for the *Bungle in the Jungle* show

We never talked about clothes. I would just make them. I would send them down to him. He would wear them. But we would never talk about them.

at the River. I had leftover fabric, so I made clothes for that show. One of the pieces was a cape which had a twenty-foot train of camouflage.

But the first time I used the camouflage print was when I made the camouflage tablecloths that were used on the big round tables at the Paramount Hotel party just after Andy's memorial service at St. Patrick's Cathedral.

Do you know how many people stole *those tablecloths? They were quite an item.*

Not till the other day. Somebody just gave me one. I also designed the clothes that the waiters wore – those camouflage butt-flap things. Those were the first Andy Warhol clothes, really, but since they were made after he died, he never got a chance to see them.

NEW YORK POST

TODAY
Variably cloudy, 80s

TONIGHT
Fair, humid, low 70s

TOMORROW
Partly sunny, mid 80s

Details, Page 2

TV listings: P. 75 — TUESDAY, JULY 9, 1985 — 35 CENTS — R © 1985 News Group Publications Inc., Vol. 184, No. 199 — AMERICA'S FASTEST-GROWING NEWSPAPER — ABC AVERAGE SALES EXCEED 900,000

MADONNA: 'I'M NOT ASHAMED'

Rock star shrugs off nudie pix furor

STORY PAGE FOUR

RAUNCHY STAR Madonna in action: No secrets, no shame.

PREZ ON WARPATH

Blasts terrorist attacks from 'outlaw states run by misfits, looney tunes and squalid criminals...'

STORY PAGE 5

MANTLE'S BAFFLING ILLNESS

STORY PAGE 3

Julia Gruen

On Keith Haring's Interactions with Warhol

Longtime friend of Keith Haring and an acquaintance of Andy Warhol, Julia Gruen worked for Haring from 1984 until his death. She has been the executive director of the Keith Haring Foundation since 1989. She has recently overseen the release of the *Keith Haring Journals* (Penguin USA, 1996).

Keith Haring was a crucial part of the resurgence of "downtown" as a major art force. And that contributed to the resurgence of Andy's work in the 1980s. Lay the groundwork for us. Can you tell us how you and Keith came to know Andy?

Actually, my family knew Andy from day one. My father's a writer and my mother's a painter, and they knew Andy way back when. My mother, Jane Wilson Gruen, was actually in one of those Warhol films called *The 13 Most Beautiful Women in the World* or something like that. And my father was an art writer.

Anyway, in terms of how Keith and I got to know Andy, I should probably start with how I met Keith first. We met in a haphazard way. We were both around twenty-four. I had been looking for a job. I looked in the *New York Times*. I saw an ad. The ad asked for someone to work for a gallery and to be an artist's assistant. I went to the Tony Shafrazi Gallery, and I interviewed with them, and they said "Well, we think you'd be great as the assistant to Keith Haring." Keith Haring was in Italy. Keith was becoming more and more well-known and had more and more work to do. The gallery simply couldn't handle all of it anymore. In those days, the mid-'80s, the gallery had Keith Haring, Jean-Michel Basquiat, Kenny Scharf, and James Brown. It had a full stable of very active, young artists.

So the gallery hired me to work for Keith. About a month later, Keith came back from Italy. I went to his studio. I had never met him before. I had barely heard of him. I knew he was the guy who did these graffiti-like things in the subways, and I had seen people wearing buttons with little babies on them and wondered what it was and how I could be part of that club. What is that symbol? What does that mean? It seemed to be the symbol of what was coolest on earth. So, I met Keith. And we got along.

How did he explain to you what you were supposed to do?

That's a good question because it's a question that can't be answered. He didn't. He asked me. He said, "What are you supposed to do for me?"

Meeting Andy… and being invited up to the Factory showed him the way. Keith was sort of the master merchandiser and self-promoter from the beginning.

I think that Keith observed Andy's loose structure of organization very closely while he was at the Factory. He got a sense of how he should do it himself.

I think you're probably right. He certainly observed the way businesses were run, and I think he always liked the idea of having a little empire. That always appealed to him once he realized the kind of artist he was going to be. Meeting Andy in around 1983 and being invited up to the Factory showed him the way. Keith was sort of the master merchandiser and self-promoter from the beginning. He needed someone to draw a web around him so he wouldn't

Andy Warhol and Keith Haring, Madonna/Sean Penn Wedding Gift. 1985, Mixed media, 14 x 11 in.

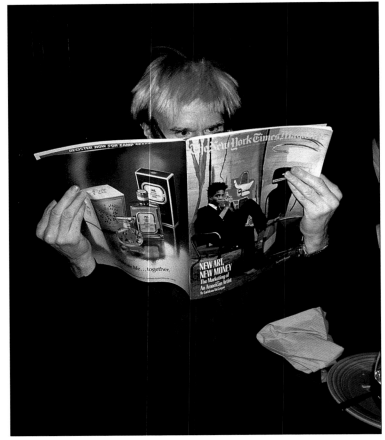

Warhol reading about the new young painters, February 1985.

be so easily accessible. People couldn't get at him quite as easily as they had in the past.

People say that without Andy there could have been no Keith Haring. It's probably true in the sense that Andy made it possible for someone like Keith Haring to exist. Andy was a master at the "art business." For years and years and years, he had been assembling people and archives and happenings and just constant activity around him. With time, the feeling at Keith's studio was much the same. It was never as big as the Factory, but it was an open studio. Twenty-four hours a day, people came in and out constantly. Keith was always seeing people, talking to people, drawing things for people. All this on top of the work he had to do to make his living.

Did Keith talk about Andy with you? Did he ever refer to Andy as his mentor?

What he really admired about Andy was his generous spirit. He was aware that there was a great divide between his view of Andy and what most people saw: someone who was very materialistic and perverse and peculiar and voyeuristic. Andy was all those things too, but there were sides to him that Keith thought were underappreciated. And that probably made them a lot more valuable, too. But Keith always spoke about how generous Andy was.

Andy was always generous with Keith in terms of the time he gave him. For instance, when Keith decided to open his Pop Shop in New York City, he wouldn't fully commit to doing it until he had talked to Andy. He really felt that Andy was the father of this whole monster. Keith was one of the tentacles, and he needed to know what the big guy was doing and what he would say about Project X, Y, or Z.

You know, Keith also talked about Andy's spiritualism. He felt very close to that side of Andy. And he thought that Andy's public persona was contrived, which it was.

When you talk about spiritualism, are you referring to the Andy who always went to church every Sunday or the Andy who went to a crystal doctor?

Actually, neither. I think it's more about just the spirit of Andy and not so much about the outward manifestation of "I am spiritual and therefore I do this or this or this."

Did Keith ever mention the more personal conversations about, say, his love life that he had discussed with Andy?

Absolutely. Absolutely. Keith was so involved in so many different levels of the gay scene in New York. He and Andy really did like to get together and talk girl talk. But they also loved to talk about the people in the art world, the people who were always around, the people who were the flavor of the moment.

Were you around for Andy and Keith's collaborative paintings that were given to Madonna as a wedding gift?

I wasn't, unfortunately. The paintings were done in the studio, but Keith worked fast. Andy worked fast… sometimes. This would

Andy was a master at the "art business." For years and years, he had been assembling people and archives and happenings and just constant activity around him.

happen so many times over the many hours, weeks, and years I worked with Keith: I would go home at 6 or 7 one night, and I'd come back the next day and there'd be all these finished things there. Amazing.

What were some of Andy and Keith's other notable collaborations during that period?

They collaborated on a Montreux Jazz Festival poster in 1987. The poster is quite simple. Andy drew a musical staff, basically a page of staffs and bars with notes on them. And then Keith drew his little men figures sort of jumping all over the place.

Also, there was talk about getting Andy involved more with the Pop Shop by selling his wares. When Keith first opened the shop, you see, there was a more democratic spirit to it in the sense that he was selling work by a lot of other people, maybe four or five different artists. There was an Andy self-portrait T-shirt. The self-portrait behind the camouflage with the hair. And then Andy did a portrait of Keith, which was also put onto a T-shirt. It was just Keith in his glasses, photographed from a strange angle so that his forehead looks absolutely enormous. It was screened in bright aqua-blue and orange.

Let's talk a little bit about your impressions of Andy. After all, you must have a unique perspective, knowing him growing up and then as an adult.

When I was growing up, Andy was a great myth. I would see pictures of him, Andy Warhol. That was during the time of the early Factory when he was making the movies and so on. For someone as young as I was at that time, that was grown-up stuff. I didn't know what was going on.

And then as I got a bit older, around sixteen or seventeen years old, I was photographed and profiled for *Interview*'s "View Girl" column. I don't remember clearly what it was like to be a "View Girl" or meet Andy under those circumstances. But I just remember finding in later years when I was working with Keith, I always found with Andy, much to my surprise and much to my pleasure, that as long as I didn't expect very much, which is a hard lesson to learn sometimes, I was surprised at the results I would get. You could never go to Andy and start blabbing and say now this and this and this and this. Because he would just look at you and go, "Oh?" But if you kept it simple and just made a statement or started a conversation, you really got back. I can't tell you exactly what he might have said at one time or another, but he always had this aura of being such a mysterious and such a difficult person. He created that myth himself in so many ways, and then it just fed on itself and grew superhuman in size. He did always run around saying, "Great" or "Oh, Wow" all the time. But it wasn't the only thing he said. To call him a voyeur is accurate. But that's not necessarily negative. Warhol was an observer—he watched everything and digested it. And then he spat it back out in some fashion, either on canvas or in conversation or in whatever medium.

But I think that his whole persona, his whole presence became so mythologized in the last few years of his life that I, at least, thought of him as being virtually unapproachable. And also in those last years he became so much more glamorous, hanging out with the crème de la crème; he was one of those people.

There is a contradiction there, too.

Yes. The private Andy and the public Andy were two completely different stories.

Do you think that Andy influenced Keith artistically? Did he talk about any Warhol paintings that he really liked?

One of the pieces that he loved the best, he absolutely loved it, was a late piece, the single Jesus head painted as part of the *Last Supper* series. That he thought was one of the most beautiful, gorgeous, wonderful pieces. But earlier on I think, he just saw this

I would go home at 6 or 7 one night, and I'd come back the next day and there'd be all these finished things there. Amazing.

amazing appropriation of popular culture and that had been turned into something that had another layer of meaning.

Did he ever comment on Andy's evolving style? Or on his own?

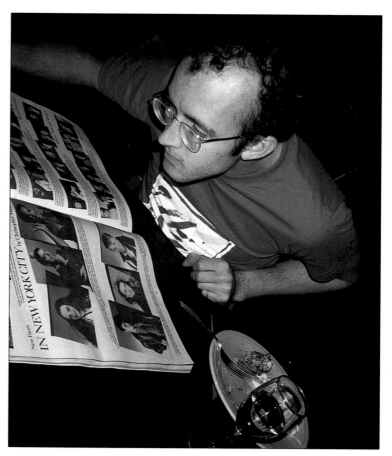

Keith Haring at lunch in the Boardroom of 860 Broadway, 1983.

Diana Vreeland's pink elephant, repainted by Haring for Warhol, c. 1985.

Both Keith and Andy, as they got older, investigated the possibilities. But they never totally left behind what they came from. In 1989, Keith could make a piece with strong graphic qualities and he could also make an exceptionally drippy expressionist work. It was only in the later years, certainly in Keith's career and also in Andy's, that the work stopped being so hard edge.

Warhol was an observer – he watched everything and digested it. Then he spat it back out in some fashion, either on canvas or in conversation or another medium.

They let go a little bit more.

Yes, exactly, exactly. Let go. The style that Keith developed that made his work so amazingly accessible and appealed to so many people across the board was this very hard-edged sort of cartoon line with very bright colors and so on and so forth. And it's almost as if later on he could comment on that style. He could create work that had this sense of letting go and yet never quite departed from

what people knew as Keith Haring. And I think that the same was true for Andy.

Some people see Andy's last period differently. Sometimes an artist can wind up being a caricature of his art. And that's when people start criticizing you because it seems like you're just repeating everything that you've done before.

Yes. Well, I think there were some very big differences between Keith and Andy. The most fundamental difference, and I'm just going to say this plain out without prejudice, is that Keith created a language. Andy used existing things and went from there – whether it was a portrait of somebody, a Brillo box, or an electric chair. It was nevertheless totally magic to take these familiar icons and turn them into these even more iconographic images. But Keith, he created a language that nobody had ever seen before.

Keith seemed much more down to earth than Andy, and I also think he had a guerrilla tactic or approach to art. Andy didn't have that. He had a different sensibility, coming out of the advertising world.

Keith was just rebelling against everything the minute he left his home town. Which is, I'm sure, what Andy was doing too. They came from similar backgrounds, small-town Pennsylvania.

One thing is kind of interesting. I'm working on Keith's journals right now, notebooks that Keith kept sporadically from 1978 until his death in 1990. There is some illustration, but it's mostly writing. Needless to say, somebody will draw comparison to the *Warhol Diaries*. I think that comparison will last for about as long as it takes to open the first page because they're completely unlike each other. In terms of how they put the books together. I mean, Andy had so many people working on his. But, you know, the spirit of Andy lives in that book in a way that the spirit of Keith lives in his book. But because Keith was so young and had only had a career of about nine years before he died, he could never have gotten away with the kind of stuff that Andy put in his book. He just didn't have the stature of someone like Andy. In other words, Keith's journals have some interesting little gossipy tidbits, but they are nothing like Andy's book. His book is mostly introspection. For instance, when Andy died, Keith did a lot of reflecting on Andy.

Like Andy, Keith kept everything; everything, everything. It's great to do a project like these journals because I find things like a hand drawn invitation to a show at Club 57. It's great to have that kind of information. But the fact that we found that piece only means that there are five hundred pieces like it somewhere else. Do we have the time, the energy, to start searching things out when for the moment one will suffice? I don't know. What a pack rat.

Keith was not as obsessive as Andy in terms of hoarding information. Would he tape conversations and things like that?

No. He didn't. He was pretty lax about certain things. He didn't date correspondence and things like that. But he recorded himself, as it were, in so many different media since the beginning – photographs, videotape, tape recordings. So we have this

Keith was just rebelling against everything the minute he left his home town. Which is, I'm sure, what Andy was doing too. They came from similar backgrounds.

enormous archive of this guy who had a nine-year career. It's just outrageous, it's so strange. You tend to think it's completely off balance. The guy was so self-involved. I guess he had to be.

I think all artists recognize their own mortality, and the importance of the preservation of their work and their image.

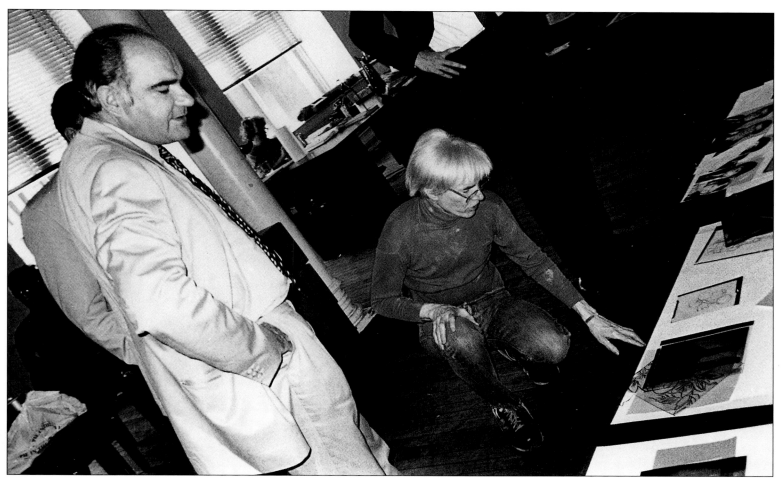

Michel Roux and Warhol discussing work in progress, c. 1984.

It's amazing reading Keith's journals from when he was around nineteen, and he knows exactly what he's going to do. He sets out to do it and he gets there—it's amazing, it's amazing. It's what separates the men from the boys, I guess. Andy stood for that same sort of determination—"I'm going to do this, I'm going to set out to do it, I'm going to do the best that I can."

When Andy died, how did you experience the loss?

I don't know. It just seemed like someone and *something* that had for twenty-odd years represented the avant garde—even when it got not so avant garde—had vanished. And without it, there was this enormous void. Is there something that is going to fill this? Is there someone who can fill this space?

After Andy died, a lot of people, journalists and others, asked Keith, "Well, since you're the heir to the Warhol legacy...." And Keith always answered, "Listen, he was a good friend and a mentor

Robert Mapplethorpe, 1983. Synthetic polymer paint and silkscreen ink on canvas, 40 x 40 in.

The Last Supper (Detail), 1985–86. Synthetic polymer paint and silkscreen ink on canvas, 116 x 225 in.

and I loved him and I can't believe he's dead. But I'm not his executor." Keith did not want to take up the mantle of Andy Warhol.

Andy dying took the heart out of a lot of things for a while. Keith's death in 1990 also sealed off something. It was the beginning of a new decade and it was just before the art market crashed. Andy died, Jean-Michel Basquiat, Robert Mapplethorpe, Keith Haring. It was just one after the other. That whole period was just swept away.

Acknowledgments

We offer our gratitude to all those who patiently participated in the interviews included in this book and who put up with the countless calls, checking on facts, and requests for photographic information afterward. Their recollections and sifting through boxes helped shape an oral and visual history that, without their help, would not have come to be. Special thanks go to Paige Powell and Billy Name for the use of their extensive photo archives.

The staff at the Andy Warhol Foundation also deserves our thanks for their cooperation in our research efforts, especially Beth Savage, who helped coordinate and classify many of the paintings and objects that appear in this volume.

We applaud our production and editorial team in Boston, Massachusetts. Kate Pestana, Judith A. Ross, Katherine Andrews, and Kristen Langdon worked tirelessly under tight time constraints. Also, we could not have managed the production of this book without the fine transcription work of Connie Procaccini and the staff of Mulberry Studios.

We would also like to thank our publisher, Rizzoli International Publications, especially Judith Joseph, who saw the value of this project from its inception. Our thanks also to Elizabeth White, associate publisher, for seeing the book through its initial stages to its final form, and to David Morton for his support. The thoughtful work of Belinda Hellinger, production manager, and Heather McClure, production assistant, kept us on schedule. The media savvy of Amelia Durand, publicity manager, cannot go uncredited.

Finally, our thanks to Chrissa Theodore, Anne Rogers, and Liad Krispin at K.R.T., who, with the excellent work of Amelia Durand at Rizzoli, coordinated the complicated publicity effort that a book of this complexity requires.

The following individuals have also made contributions to this book. We apologize for any inadvertent omissions.

The Andy Warhol Foundation for the Visual Arts, Inc.: Martin Cribbs, Vincent Fremont, Tim Hunt, Dara Kingsley, and Beth Savage

Andy Warhol Museum: Thomas Sokolowski

Commissioned Photography: Warren Faubel, Greg Gorman, Takao Ikejiri, Rob Mustard, Tony Rinaldo

Harvard University Art Museums: Marjorie Cohn

Harvard University Department of Instructional Design: Jenny Connelly, Joanne Devereaux, Scott Zieser

Johnnie Walker Black Label: A special thank you to Lourdes Santin and Peggy Bernstein for their vision and generous support of this project.

Typographic House: Peter Brotman, Tom Delgiacco

And the other individuals who have provided various acts of generosity, guidance, and support: Bruno Bischofberger, Todd Bishop, Mary Ann Bowers, Gavin Brown, John Cheim, Stephen DeVincent, Catharine Mary Donovan, Fred Dorfman, Todd Eberle, Caroline Ellis, Francesca Forrest, Carol Franco, Marjorie King, Hilary Lewis, David A. Light, Jonathan Marder, Perry McIntosh, Gina Nanni, John and Winifred O'Connor, Catherine Olofson, Elsa Peretti, Richard Pine, Doria Reagan, Helen Rheem, Rob Robinson, Wilfredo Rosado, Jane Sarkin, Jay Shriver, Sharon Slodki, Tom Sokolowski, Leslie Stein, Nan Stone

Credits

Index